HILLARY

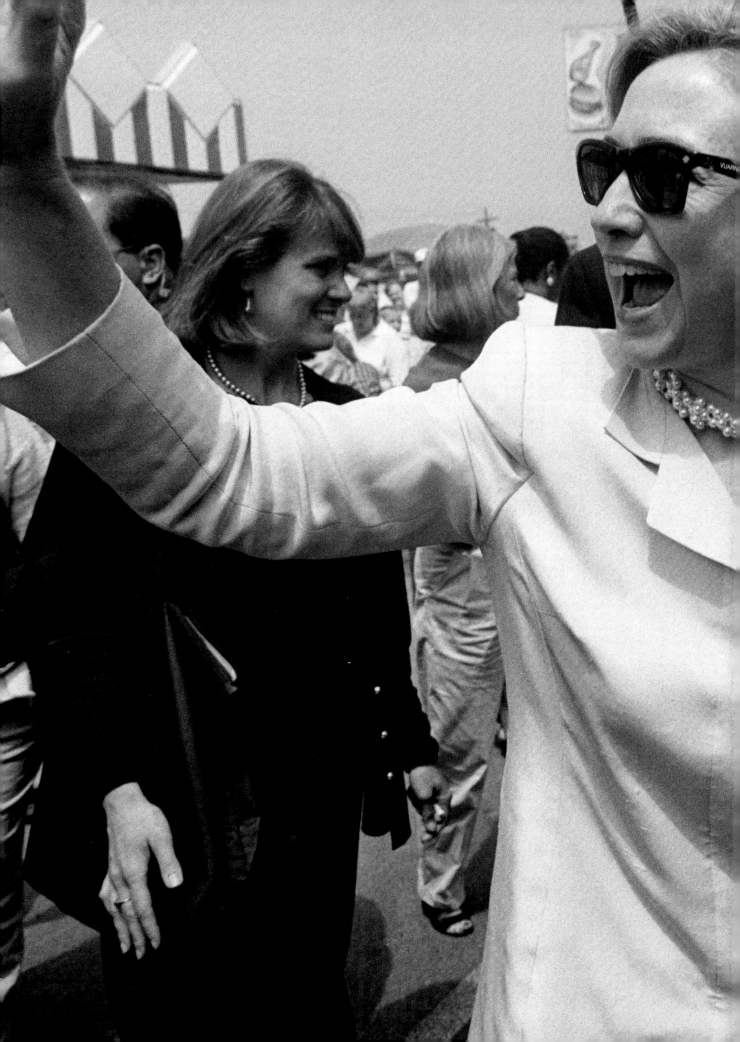

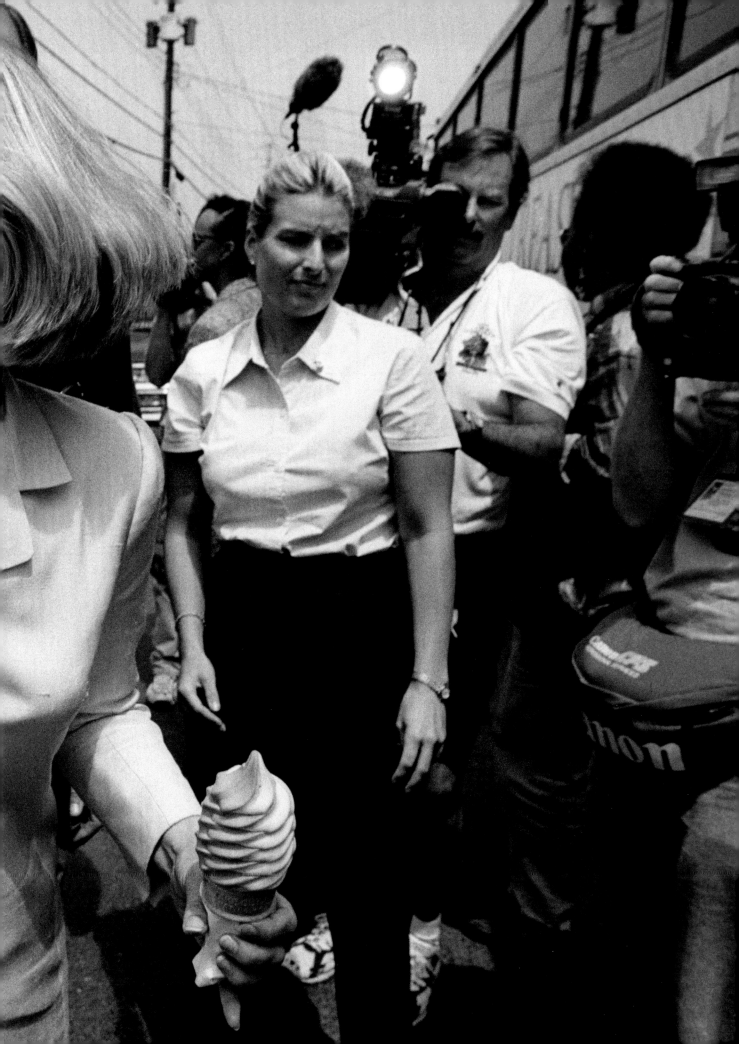

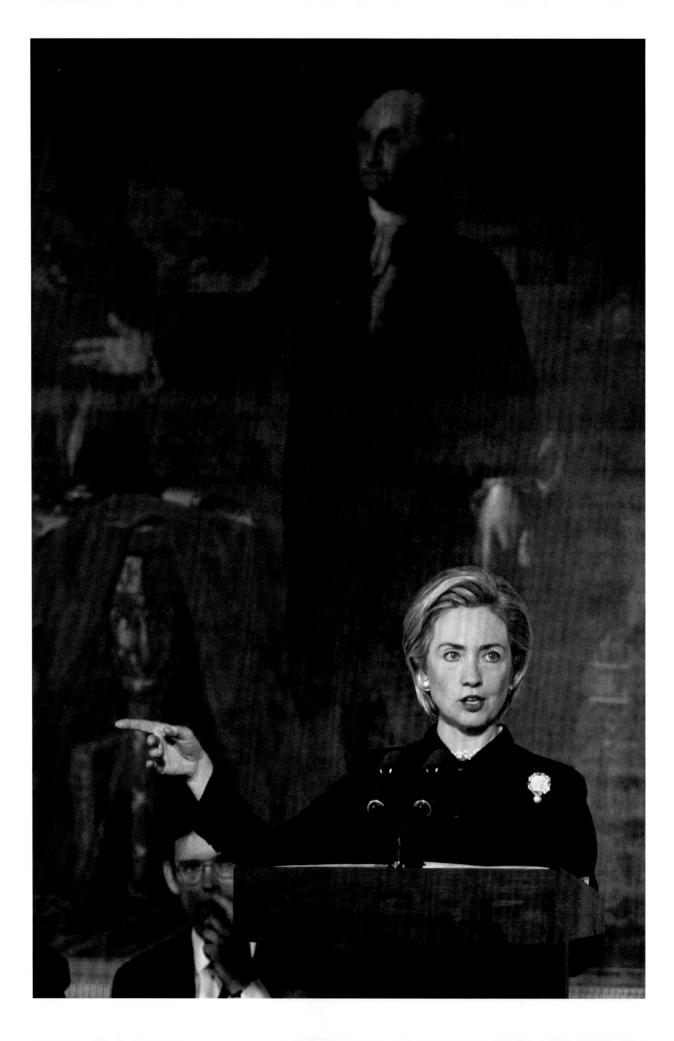

HILLARY

THE PHOTOGRAPHS OF
DIANA WALKER

Foreword by Walter Isaacson

90

New York London Toronto Sydney New Delhi

Simon & Schuster
1230 Avenue of the Americas
New York, NY 10020

First Simon & Schuster hardcover edition October 2014

SIMON & SCHUSTER and colophon are registered trademarks of Simon & Schuster, Inc.

For information about special discounts for bulk purchases, please contact Simon & Schuster
Special Sales at 1-866-506-1949 or business@simonandschuster.com.

The Simon & Schuster Speakers Bureau can bring authors to your live event.
For more information or to book an event, contact the Simon & Schuster Speakers Bureau
at 1-866-248-3049 or visit our website at www.simonspeakers.com.

JACKET AND INTERIOR DESIGN BY YOLANDA CUOMO DESIGN, NYC
ASSOCIATE DESIGNER: BONNIE BRIANT
PICTURE EDITOR: MICHELE STEPHENSON

Manufactured in the United States of America

10 9 8 7 6 5 4 3 2 1

Library of Congress Cataloging-in-Publication Data
Walker, Diana (Diana H.)
Hillary: the photographs of Diana Walker / introduction by Walter Isaacson.
224 p. 21.3x27.6 cm.
1. Clinton, Hillary Rodham—Portraits. 2. Clinton, Hillary Rodham—Biography.
3. Politicians—United States—Pictorial works. 4. Women presidential candidates—United States—Biography.
5. Women cabinet officers—United States—Biography. 6. United States—Politics and government—2009– I. Title
E887.C55W35 2014
327.730092—dc23
[B]
2014016427

ISBN 978-1-4767-6337-8 / ISBN 978-1-4767-6338-5 (ebook)

Pages ii–iii: With an ice cream cone in hand, Hillary waves to the crowd in
Weedsport, New York, as she heads to the Harriet Tubman Home for the Aged in Auburn, New York,
one of the stops on her Save America's Treasures tour. — July 14, 1998

Page iv: Hillary unveils the Dolley Madison silver dollar commemorative coin in the East Room of the
White House. This Gilbert Stuart portrait of George Washington is the one
Dolley Madison saved when the British burned the White House in 1814. — January 11, 1999

Pages viii–ix: Hillary walks with Tajik president Emomali Rahmon at the Palace of the Nation in
Dushanbe, Tajikistan, followed by security, staff, and media. — October 22, 2011

This book is dedicated to my friends and colleagues at *Time* magazine, and those who have given me years of great assignments. From the late Annie Callahan to my friend and former director of photography Michele Stephenson, thank you.

It's been a great ride.

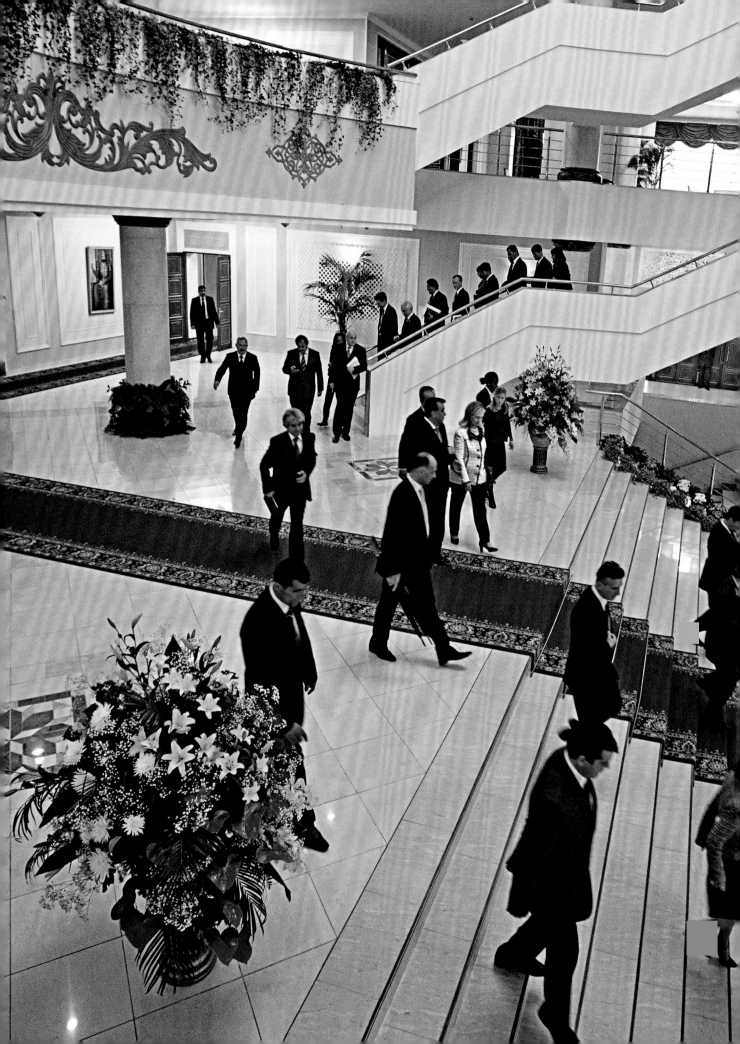

FOREWORD by Walter Isaacson

Well before her journey has concluded, and perhaps even before it has reached its destined peak, Hillary Clinton has earned her place as one of America's great historical figures.

We should know her well by now, yet she remains elusive. What combinations of ideals and ambitions truly drive her, what lies behind the laugh? She is highly disciplined, unlike her husband, but she is also able to let loose and relax and make fun of herself. To her opponents, she can come across as conniving, yet in person she is earnest and motivated by issues that move her deeply. It's often hard to communicate all her facets using words. But sometimes a camera can.

This is especially true if Diana Walker is wielding the camera. No one has been better positioned to capture Hillary's intelligence, grace, dedication, and humanity. That is because Diana herself has all of those qualities. It's also because she has been well positioned in a literal sense: she was a photographer for *Time* who began covering President Clinton and the First Lady in 1993, and—as has been true with so many of her subjects, from Ronald Reagan to Steve Jobs—she has come to understand and relate to her subject in a deeply human way.

Diana knows that all journalism is personal. We understand our world through the people who make it. Combining the skills of both an artist and a journalist, she has the ability to use her lens to reveal truths. But her genius comes from adding a personal component: her own ability to relate to people and share their emotions. As a result, her pictures convey honest and intimate glimpses that cause us to smile, nod, and know.

One of my favorite pictures in this book, on page 175, gives us a backstage view of Diana in action capturing one of these moments. It shows Hillary earnestly working on her BlackBerry, her hands all serious, her studious face reflected by a full-length mirror—and Diana behind her shoulder, up close but unobtrusive, doing her magic. In their work they both convey a seriousness of purpose without appearing self-important.

Like many of us who have been colleagues and friends of Diana, I find myself forever charmed by her. She has an enchanting personality worn lightly. Whenever I'm in her presence, I feel more natural. I can't help but smile and want to open up to her. And that is the essence, I think, of her talent as a photojournalist: almost everyone who encounters Diana feels this way, including her subjects, which is why her pictures—rarely posed—are so revealing. Her own inner magnetism makes her pictures become MRIs of the soul.

All of these talents come into play in this portfolio of her photographs of Hillary Clinton, a woman who has become a symbol of her generation, and with good reason. The saga of the baby-boom cohort—both its idealism and its ambition—is writ large in her personal and public tale. She is the woman lawyer seeking to excel as she juggles both career and family, with all the triumph and turmoil that can entail, and on a very public stage. It's as if she has heeded too well Jacques's monologue in *As You Like It*. All the world did become her stage, and in her time she has played a dizzying array of parts. She began her public role as a Wellesley valedictorian from suburban Chicago playing First Lady of Arkansas. She also became a dedicated mother, a high-powered partner in a law firm, and the first person with a graduate degree and professional career to become First Lady of the United States. In the White House she played the role of senior policy adviser, personal counselor, and (perhaps most difficult of all) loyal and forgiving spouse.

During the tumult surrounding her husband's scandals, she was able to play the beaming hostess at a gala dinner for Tony and Cherie Blair and dance with her husband as if they were on a first date. They had one of the most publicly probed marriages of modern history, and yet, as Diana's pictures show, it was deeper and more real than outsiders could fathom. Look at the picture of them dancing on page 35, just hours after being told of some damaging testimony that was looming in the Monica Lewinsky case. They are next to Al and Tipper Gore. Diana's lens gives an eerie and unexpected foreshadowing of those marriages—and of which one was actually destined to endure.

During that tumultuous period, the Clintons went together on a twelve-day visit to Africa. I was editor of *Time*, but I abandoned my desk to join Diana in covering that trip. We were standing together on a boat on the Chobe River near one of Botswana's game preserves when I watched Diana click away for what became one of my favorite series of pictures: the Clintons touching each other and then holding hands as they took in the scenery. Was it just a show, as many people suspected? Or was it real? As Diana's pictures indicate to me, it was a complex and tantalizing mixture of both, as was often the case with the Clintons.

Also on that trip, the Clintons traveled with Nelson Mandela to the tiny cell on Robben Island where he had been imprisoned for eighteen years. For a few minutes, less momentous matters were put into perspective.

As Hillary moved on from her supporting role as First Lady to her leading roles as senator, presidential candidate, and secretary of state, Diana's photographs portray a series of transformations that played out before our eyes but would have been less visible without the aid of Diana's lens. Her still pictures capture Hillary in a way that neither print nor video can. We see that she takes her duties very seriously but also knows how to kick back and have fun. She can laugh, and even laugh at herself. We even sense her absorbing, over time, some of her husband's emotional expansiveness, as she connects with people in a more comfortable and engaged manner.

Part of Hillary's charm is that she is a woman of many layers. Looking through these pages for a second or third time is like flipping through the transparencies in an old science textbook. Each encounter reveals a different level.

The first time you are apt to notice the surface traits of Hillary that have so often fascinated casual observers. Her dresses evolve from Arkansas frumpy to frocks worthy of the cover of *Vogue*. There are those hairstyles that launched a thousand magazine photo galleries, from bobs to shoulder length replete with scrunchies and headbands. And, of course, there is the most relentless progression of pantsuits the world has ever seen.

On your second journey through this collection, you are likely to become focused on Hillary's face. Whether leaning forward with a look of concern or roaring back with a laugh, hers is one of the most expressive faces of our time. It becomes a canvas upon which she registers her emotions, and then, in less-guarded moments, the emotions register themselves.

When I took my third ramble through this collection, something else caught my attention: her hands. They reveal her moods and emotions almost as clearly as her face does. At times she is smiling, but she seems to be wringing her hands. At other times her hands are reaching out to touch someone, a gesture that becomes more frequent as her journey progresses. Her palms turn up and they turn down, conveying curiosity and delight. She uses her hands to tell stories, to point. And she uses them to touch her husband's shoulder, tug him along, and sometimes hold his hand.

During her tenure as secretary of state, she visited 112 countries, more than any of her predecessors. Instead of launching signature strategic initiatives or trying to achieve negotiating breakthroughs, she focused primarily on promoting the United States and its values, most notably in the areas of human rights, the empowerment of women, and the needs of children. By the end of her tenure, you can see the fatigue in her face, in her body, even in her hands. But in the photographs of her with ordinary folk around the world, particularly with women and children, you can see what makes her come alive. Her idealism and ambitions rekindle her.

In all, hers has been an amazing journey—and this portfolio presents a narrative that does not feel concluded. As Hillary put it in the short bio she used when she first opened her Twitter account, "Wife, mom, lawyer, women & kids advocate, FLOAR, FLOTUS, US Senator, SecState, author, dog owner, hair icon, pantsuit aficionado, glass ceiling cracker, TBD…" Not surprisingly, she chose to accompany those words with a photograph that Diana Walker took.

FIRST LADY 1993 – 2001

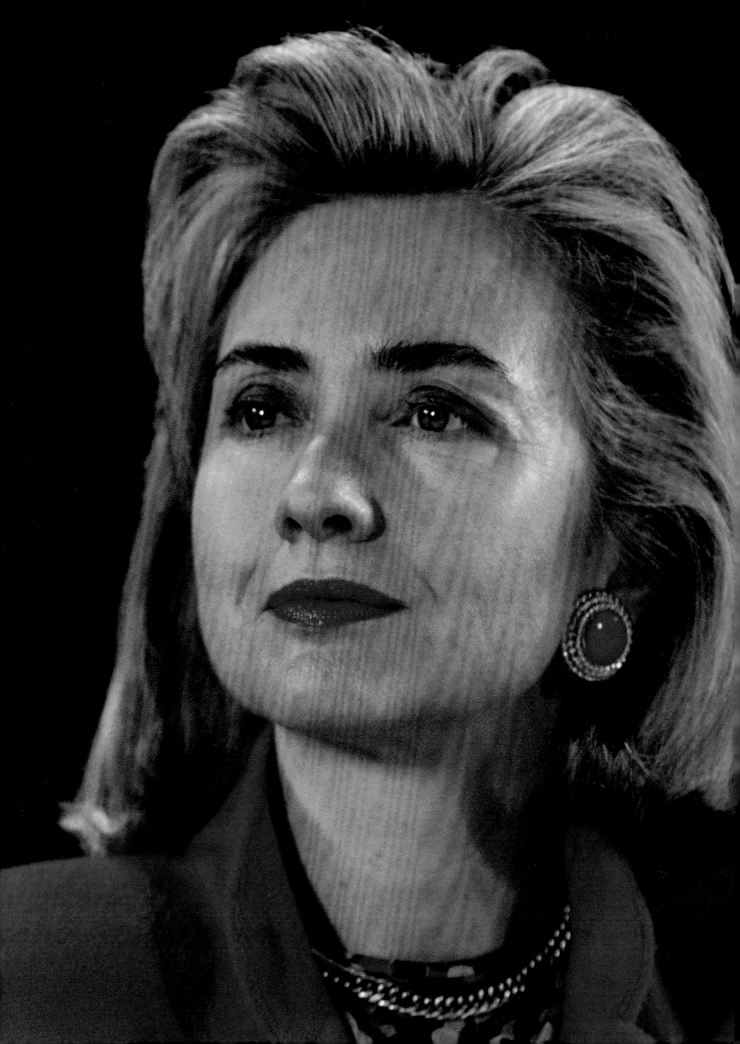

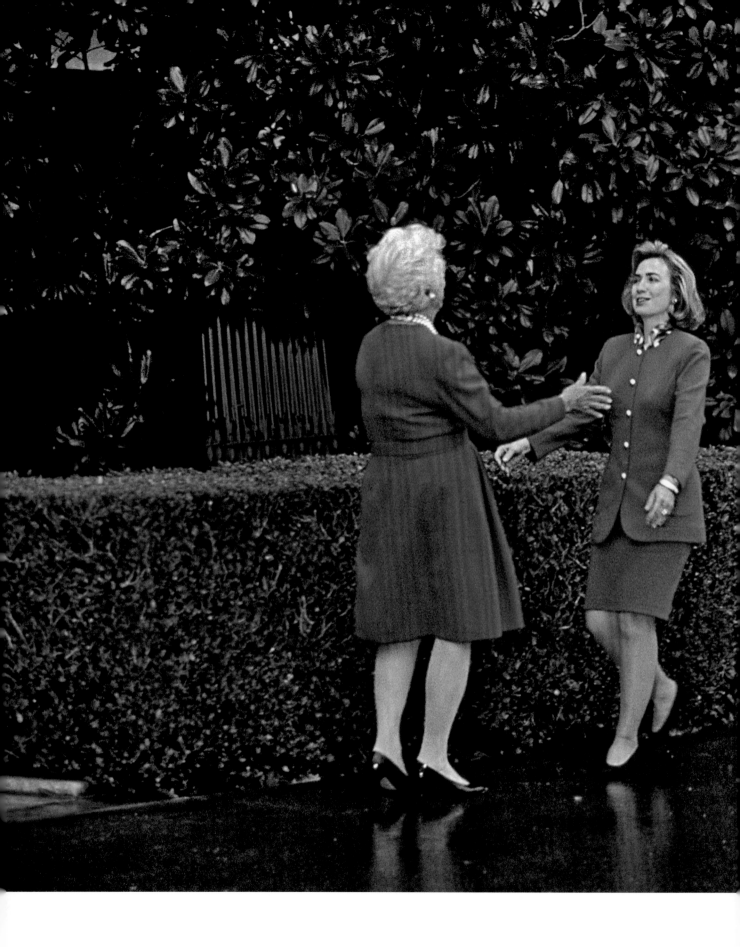

Previous spread:
Hillary, as head of the President's Task Force on Health Care Reform, kicks off her first Conversations on Health forum at the Tampa Convention Center in Florida, the first of four health-care forums to be held that month. — March 12, 1993

Left: The outgoing First Lady, Barbara Bush, greets Hillary outside the White House, where Mrs. Bush jokingly warned Mrs. Clinton to avoid the media "like the plague." — November 19, 1992

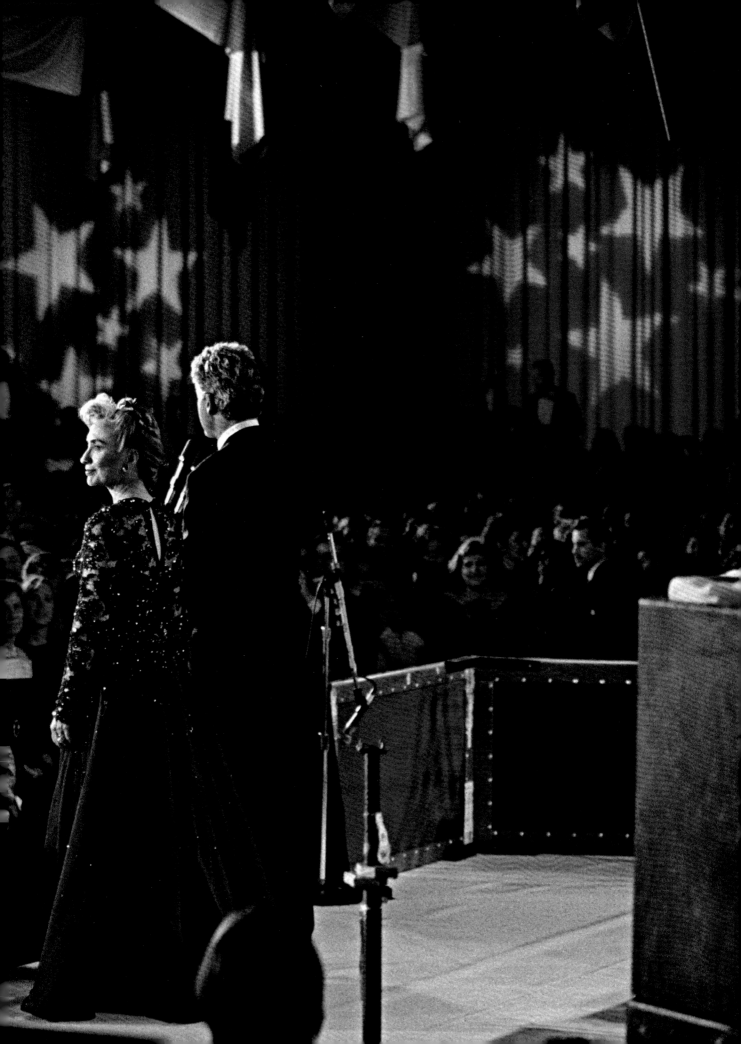

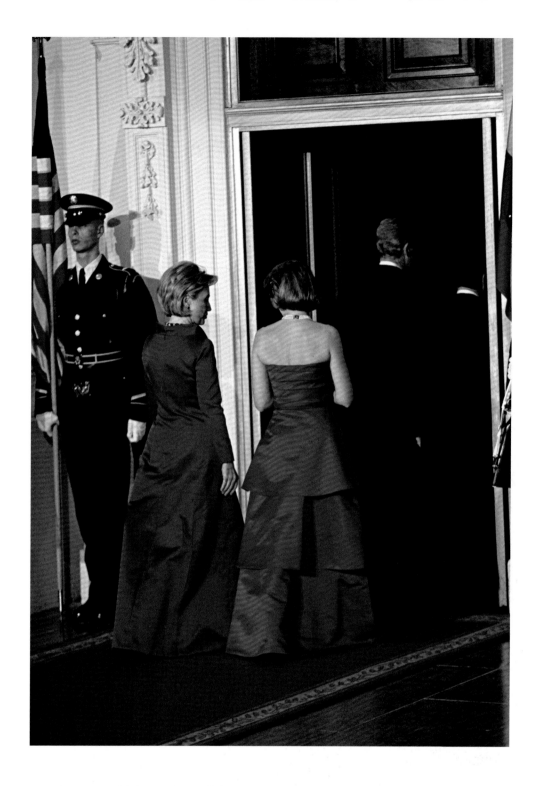

Previous spread: The President and the First Lady greet revelers at their first inaugural ball.
— January 20, 1993

Above: Hillary escorts Nohra Puyana, wife of President Andrés Pastrana of
Colombia, through the North Portico of the White House to attend the state dinner in
honor of the Colombian first couple. — October 28, 1998

Opposite: Hillary with her chief of staff, Melanne Verveer, her press secretary,
Marsha Berry, and her personal assistant, Missy Kincaid, waiting to walk into the East Room
for the Kennedy Center Honors reception. — December 6, 1998

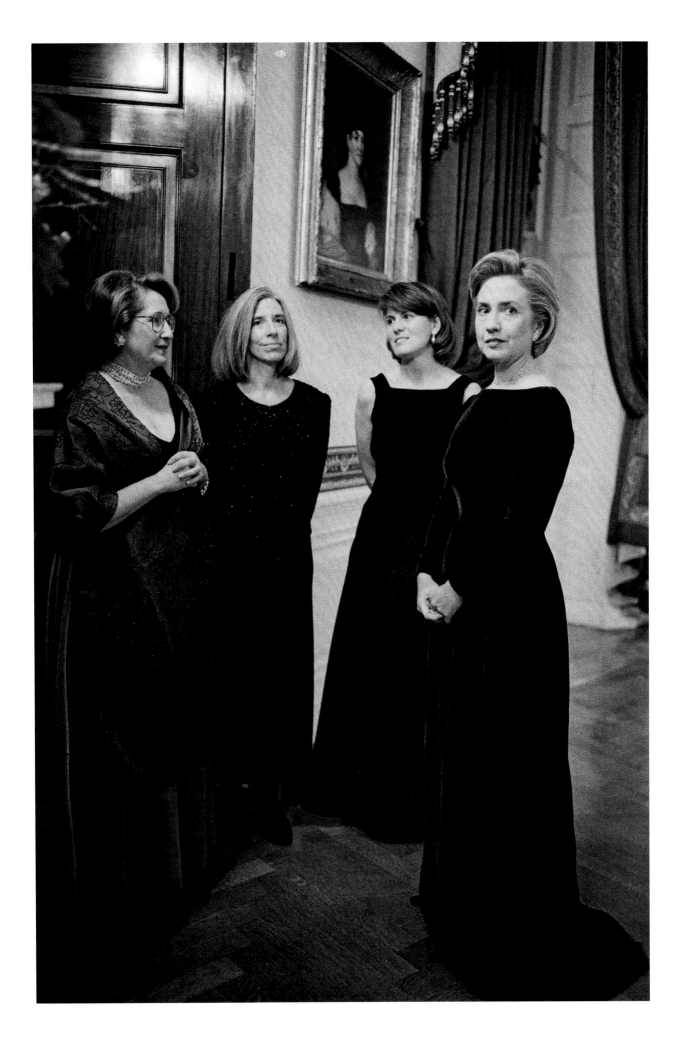

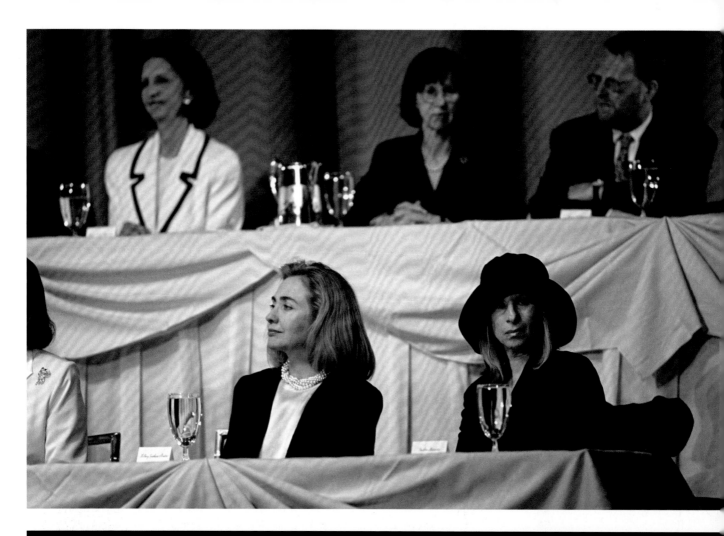

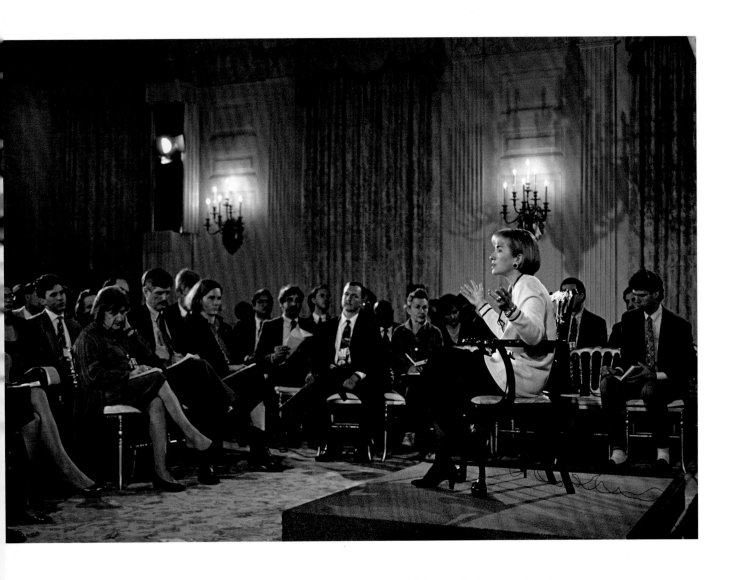

Opposite, top: Hillary and Barbra Streisand attend a Jewish National Fund brunch featuring President Clinton at the Beverly Wilshire Hotel. — April 9, 1995

Opposite, bottom: Hillary talks with three hundred citizens about how to reform health care. The conversation covers topics ranging from workers' compensation and long-term health care to high drug prices and preventive medicine. — March 12, 1993

Above: Seated in the State Dining Room at the White House, Hillary holds a highly unusual White House news conference to try to set the record straight on the Whitewater land deal and on commodities investments. — April 22, 1994

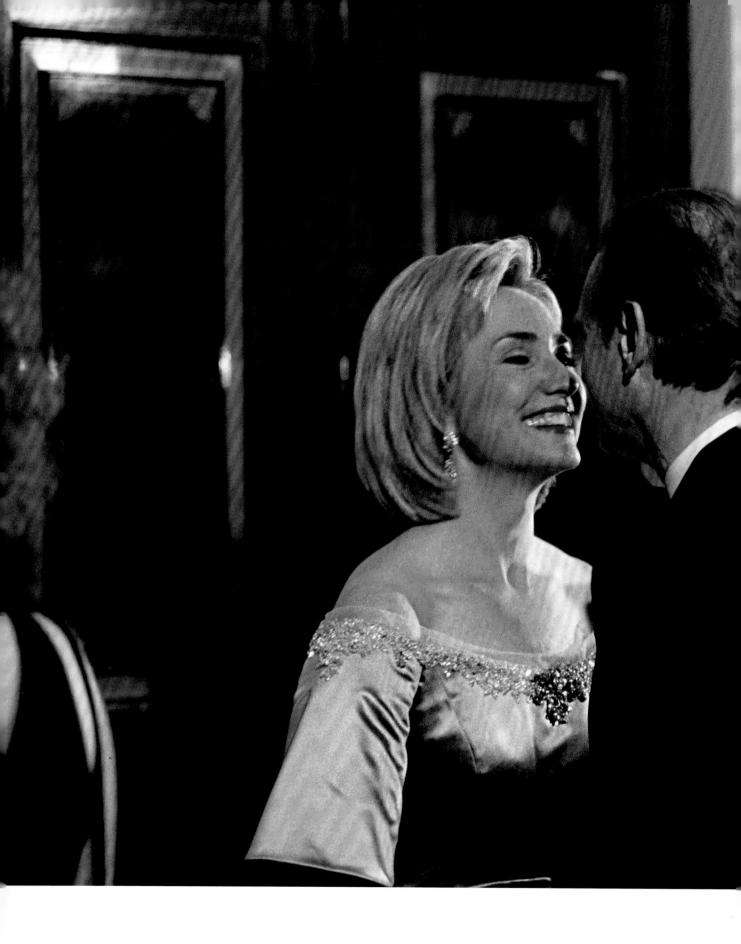

Hillary greets Harold Ickes,
former deputy chief of
staff to President Clinton,
in the receiving line for a state
dinner honoring President
Jiang Zemin of China.
— October 29, 1997

Hillary waits in the
East Room before speaking
at a reception that would
mark the launch of the
Library of Congress's
bicentennial celebration.
— October 7, 1997

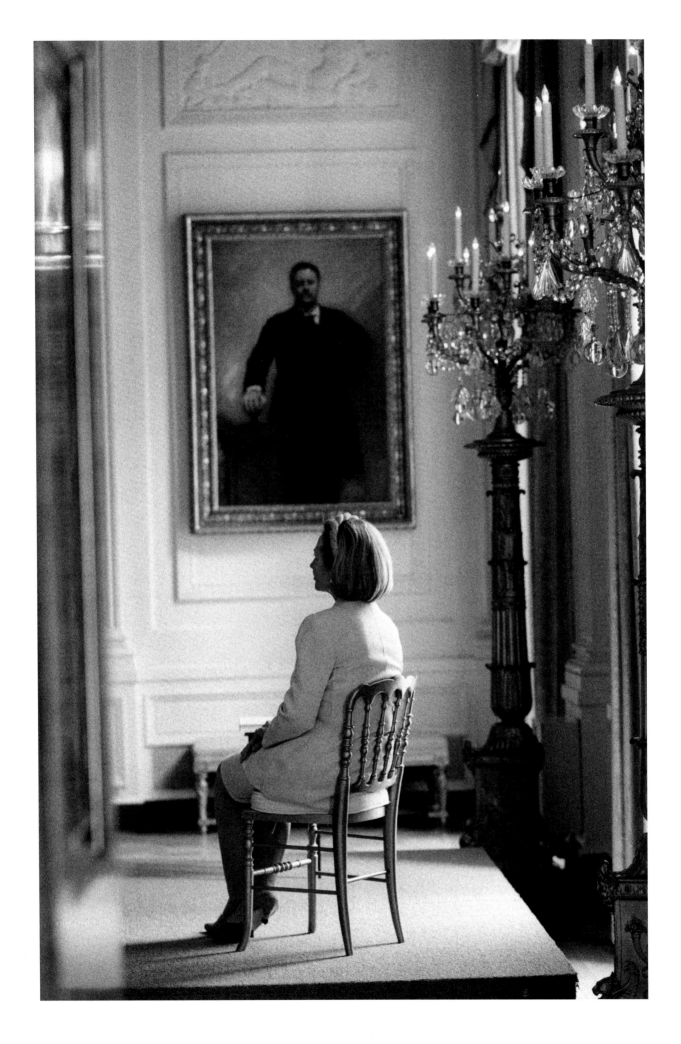

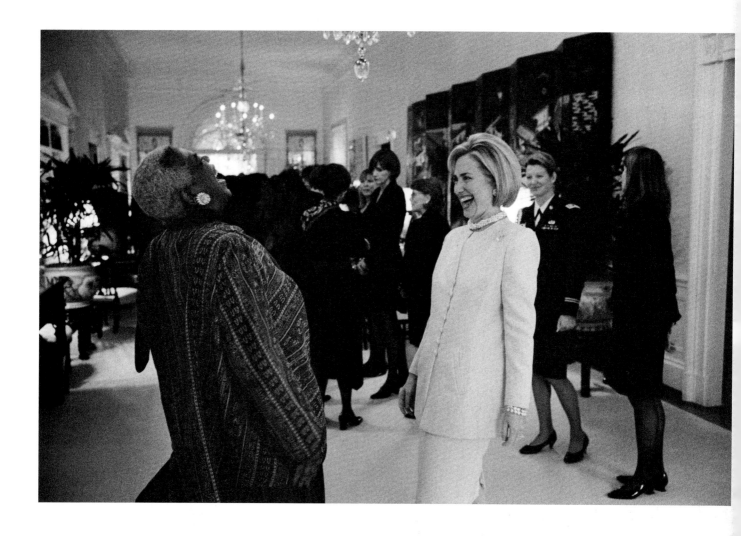

Above: Hillary enjoys a laugh with Elaine Jones, president and director-counsel of the NAACP Legal Defense Fund, at a luncheon upstairs in the private quarters of the White House for Cherie Blair, the wife of Britain's prime minister, Tony Blair. — February 5, 1998

Opposite, top: Hillary laughs while telling stories about outgoing press secretary Neel Lattimore at his farewell party. When asked to give his reasons for leaving the White House, Lattimore told the *Washington Post*, "When we had been through fifty-seven hairstyles and saw it come back full circle, I knew it was time to go." — October 7, 1997

Opposite, bottom: Hillary, accompanied by Socks and Buddy, tapes a short interview to promote her book *Dear Socks, Dear Buddy: Kids' Letters to the First Pets*, the proceeds from sales of which were donated to the National Park Foundation. — December 7, 1998

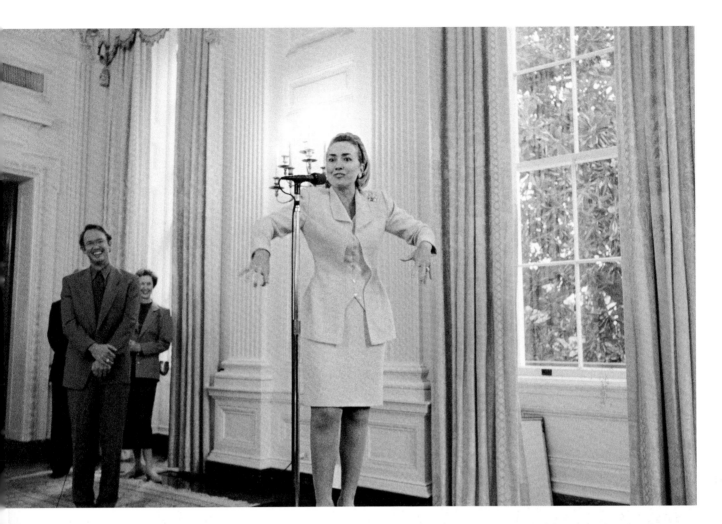

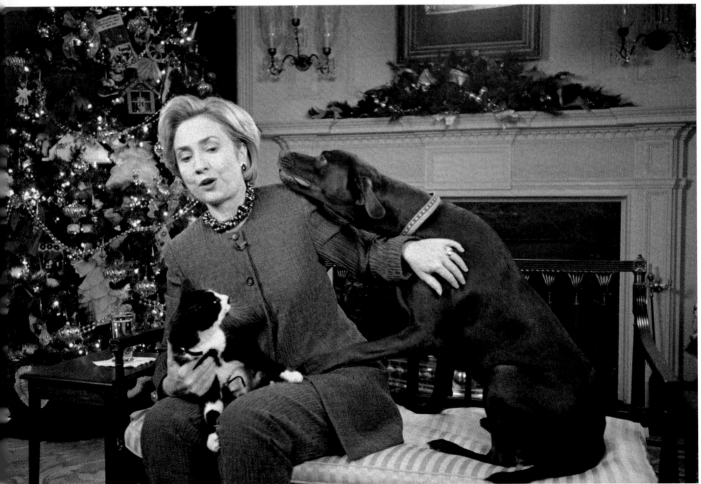

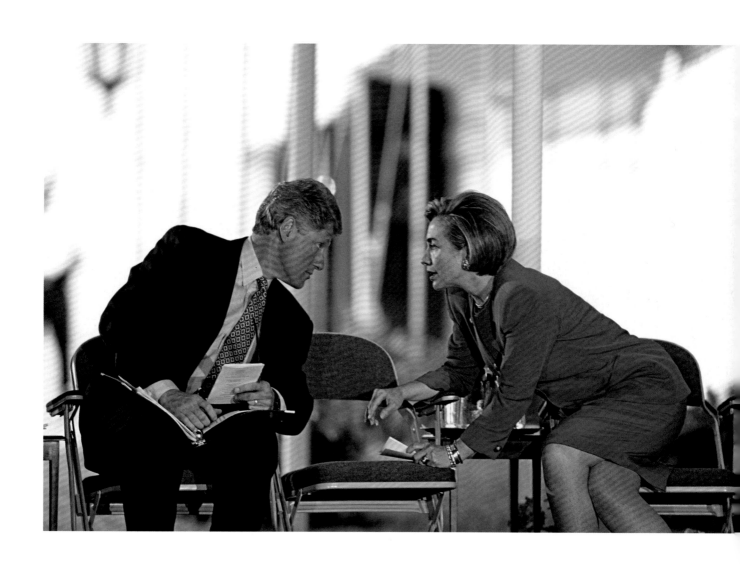

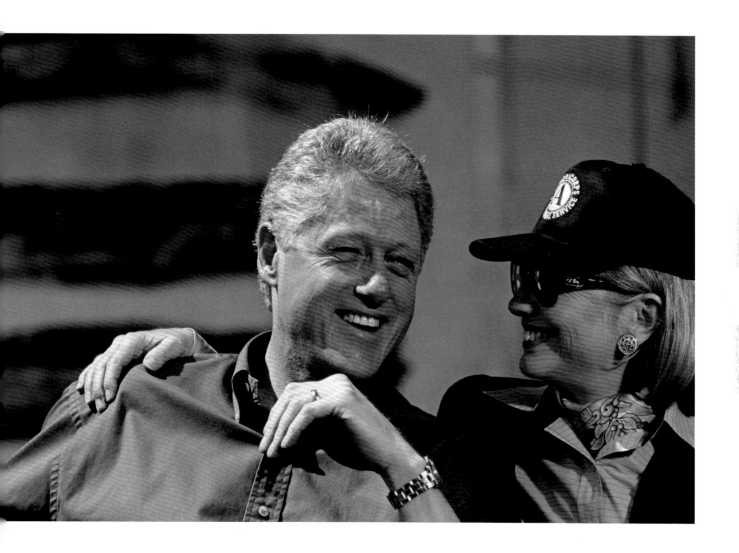

Opposite: Prior to holding a historic meeting with hundreds of tribal leaders on the South Lawn
of the White House, the Clintons compare notes. — April 29, 1994

Above: The Clintons, joined by former presidents Jimmy Carter and George H. W. Bush
and their wives, attend the opening of the Presidents' Summit for America's Future,
starting with a speech to rally ten thousand volunteers at Simon Gratz High School's Marcus
Foster Stadium in Philadelphia. — April 27, 1997

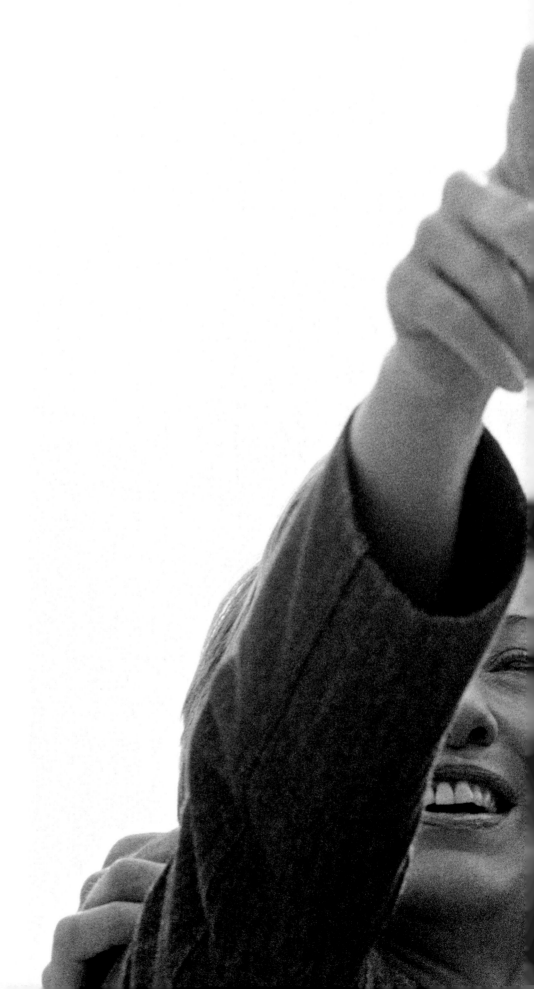

A day after his farewell speech to Democrats at their convention in Los Angeles, President Clinton and Hillary appear at the Gore 2000 rally in Monroe, Michigan, to hand over the reins of the party to Al Gore.

— August 15, 2000

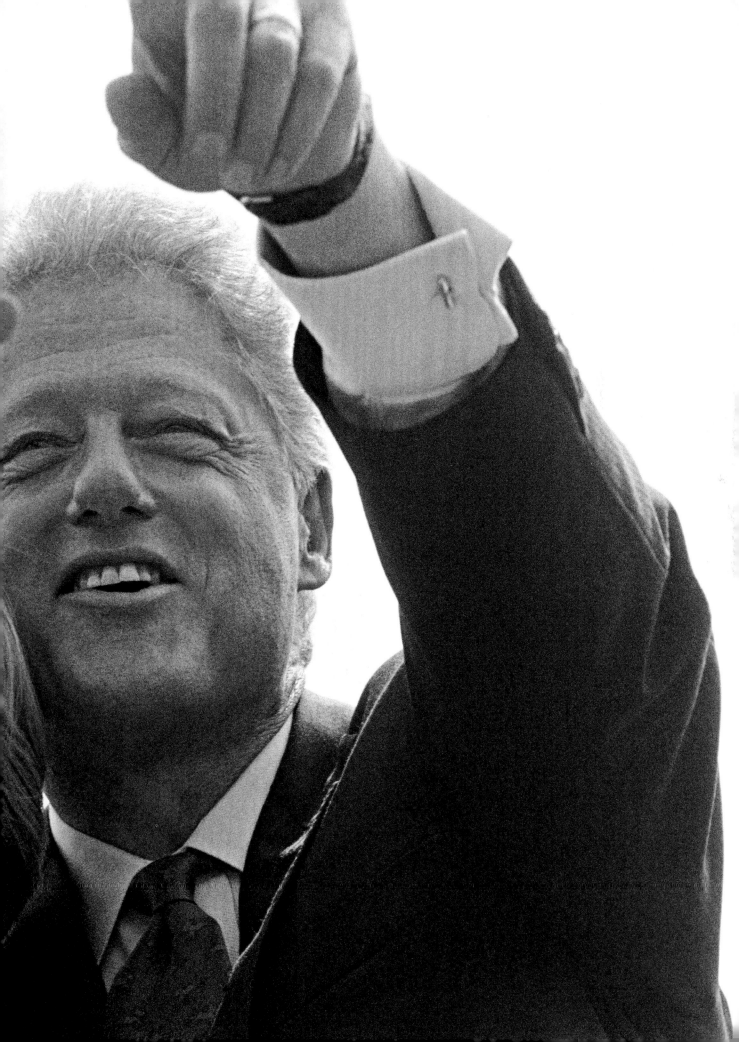

Getting ready
for President Clinton's
second inaugural,
Hillary gets her
first glimpse of daughter
Chelsea's short skirt.
— January 20, 1997

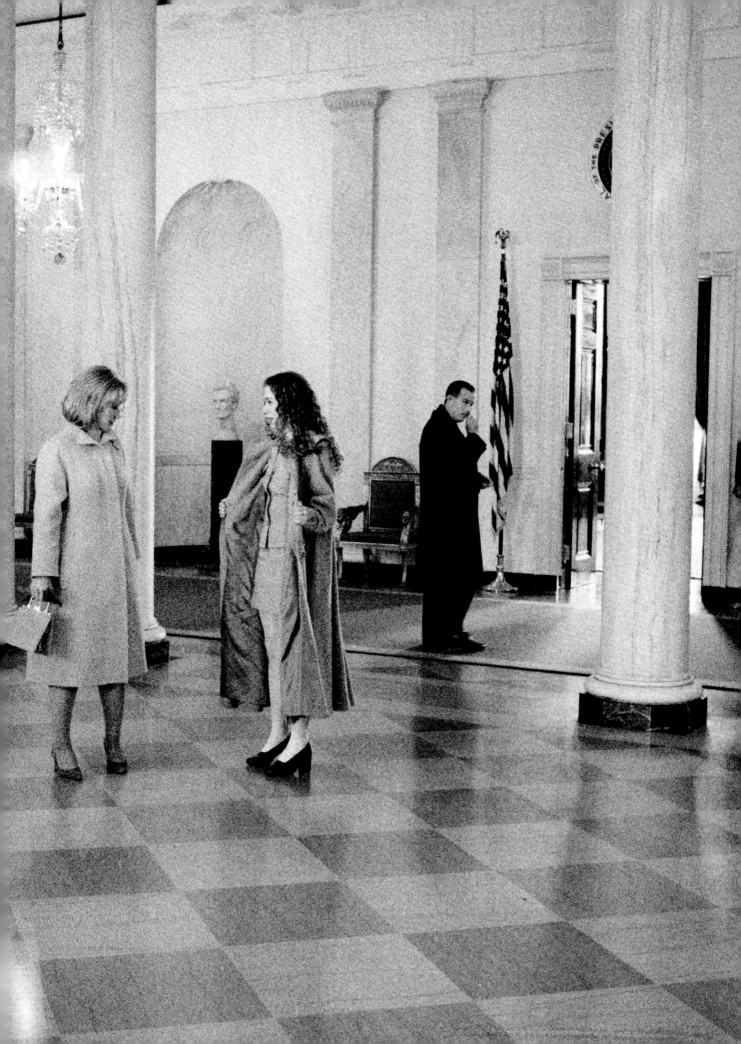

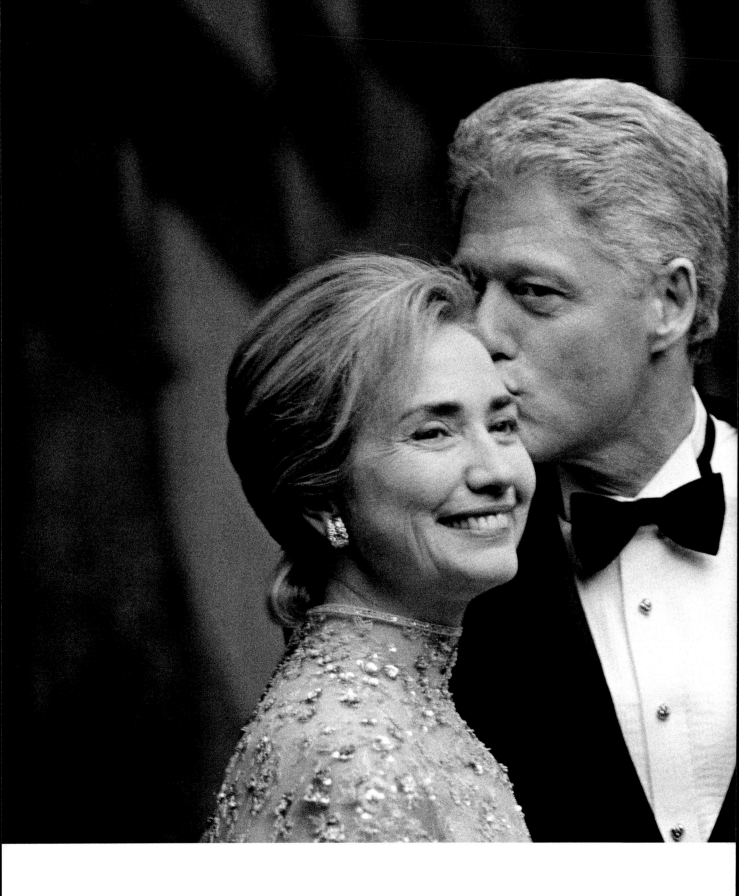

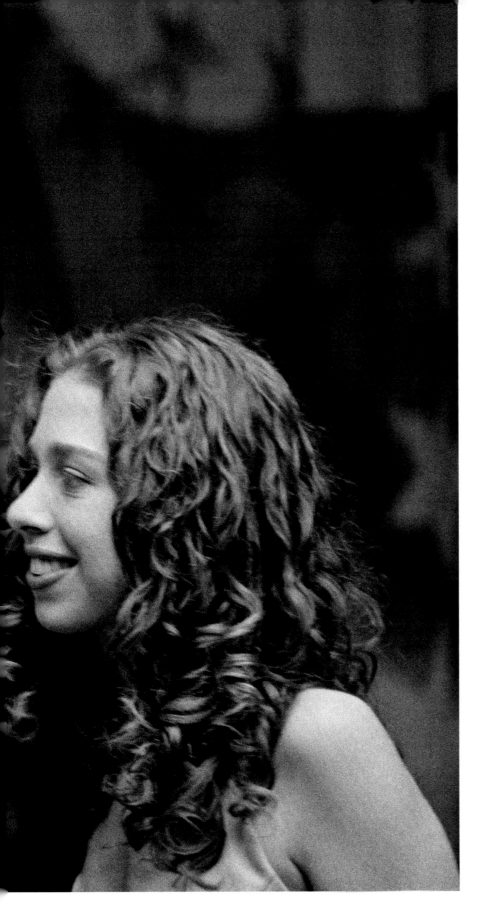

Left: Backstage at one of the
many inaugural balls, the Clintons
stop for a picture session with
photographer Gregory Heisler.
This photograph was taken while
Mr. Heisler was adjusting his lights.
— January 20, 1997

Following spread: When Hillary
saw this picture, she remembered
that she was singing
a ditty that she made up as she
waited in the garage of yet another
inaugural ball hotel.
— January 20, 1997

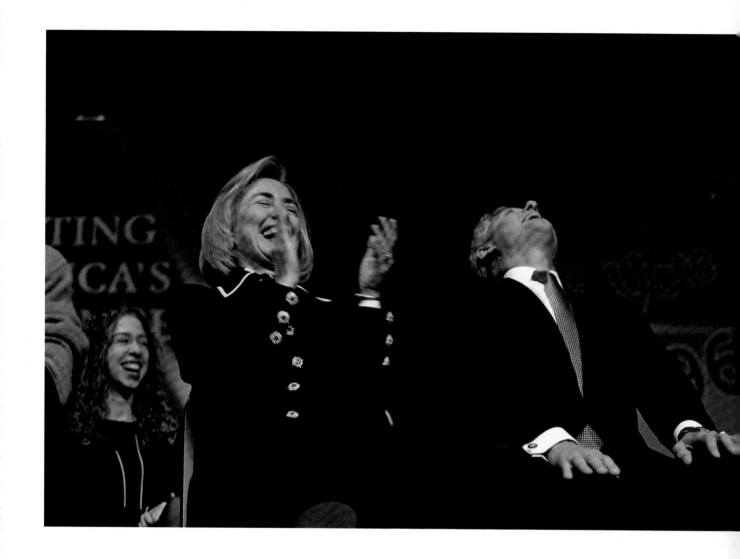

Above: At the last campaign stop of 1996 in Cedar Rapids, Iowa, the Clintons' spirits
are lifted by the music and dancing provided by the Iowa City High School Marching Band and
the All-City Flag and Drum Corps. — November 4, 1996

Opposite, top: The President and the First Lady enjoy the Kennedy Center Honors gala celebrating
Johnny Carson, Stephen Sondheim, and other performers. — December 5, 1993

Opposite, bottom: The First Family begins Inauguration Day by attending the inaugural prayer
service, held at the Metropolitan AME Church in Washington, DC, and laughs along
with the Gore family at a comment made by visiting clergyman Reverend Tony Campolo, a
longtime friend of the Clintons. — January 20, 1997

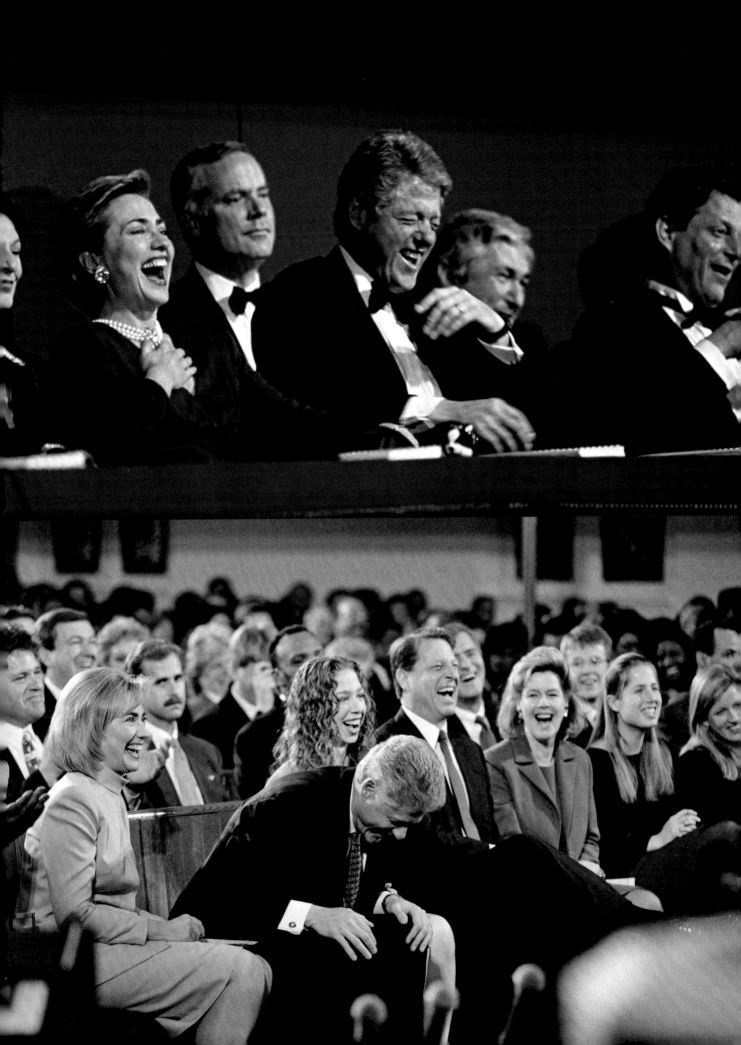

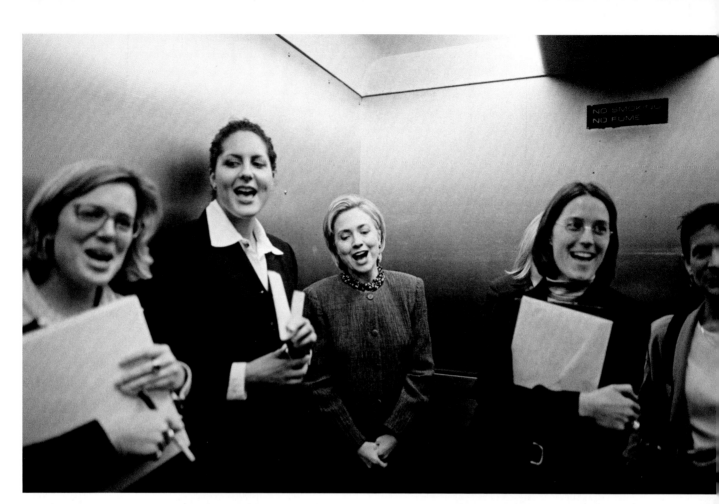

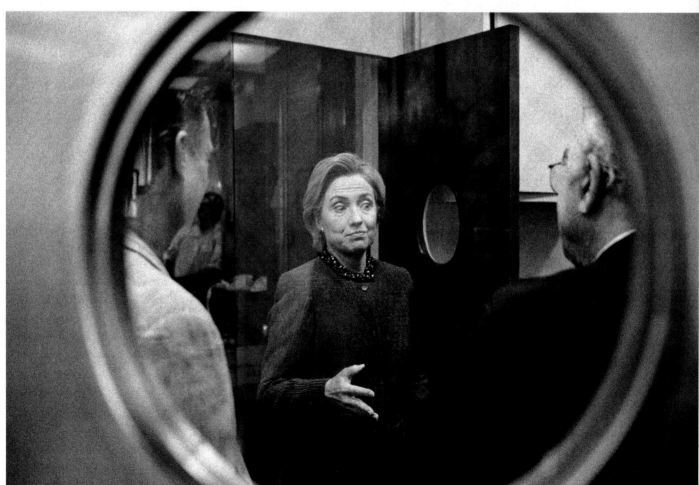

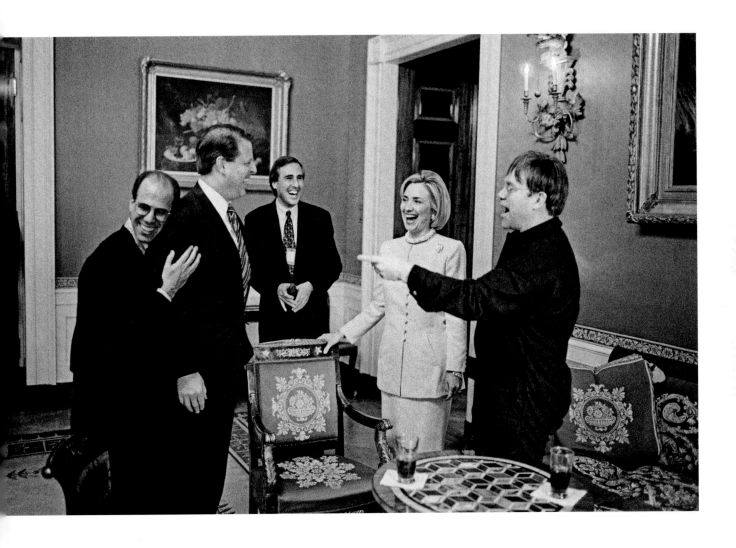

Opposite, top: Hillary, along with her traveling staff, sing "Happy Birthday" to *Time* correspondent Karen Tumulty (not pictured) in an elevator on the way to the launch of a children's Reach Out and Read program in New York. — December 1, 1998

Opposite, bottom: In the pantry of the State Dining Room, Hillary talks to staff about plans for upcoming guests to the White House. — October 29, 1997

Above: Hillary, Vice President Al Gore, and Andy Spahn, of the DreamWorks studio, get in on the laugh as singer Elton John teases DreamWorks chief Jeffrey Katzenberg (far left) in the Red Room the afternoon of the state dinner for British prime minister Tony Blair. — February 5, 1998

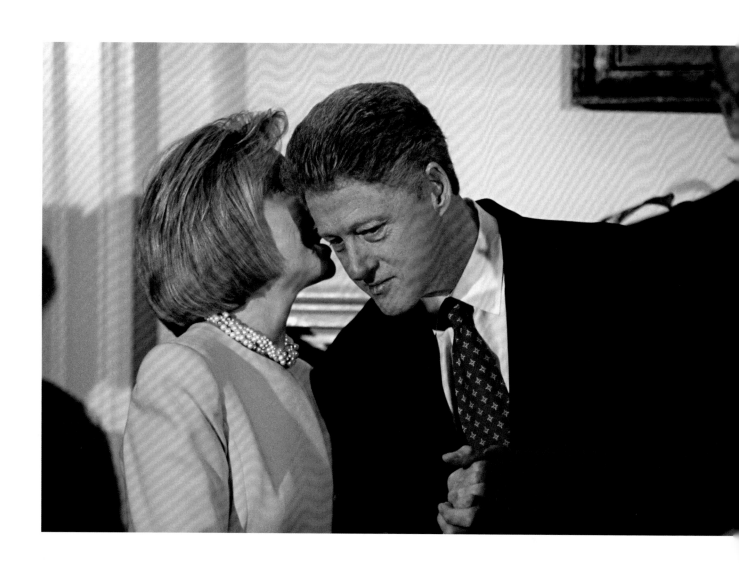

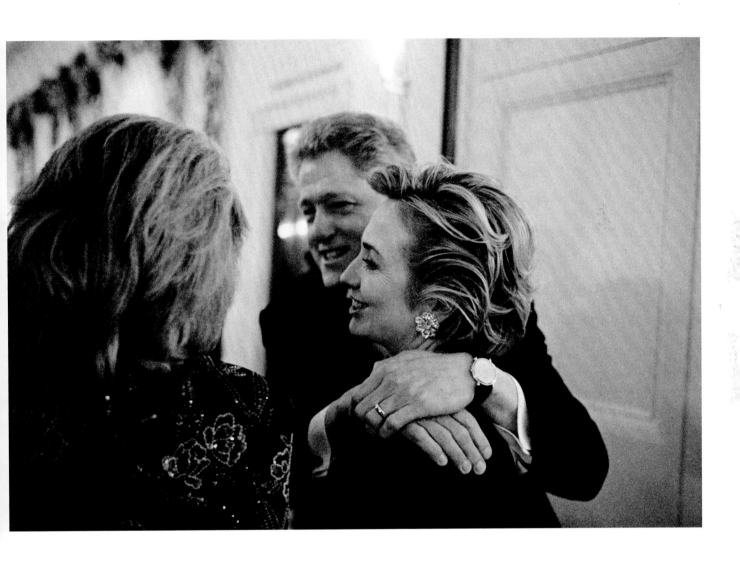

Opposite: In the Roosevelt Room, Hillary whispers to her husband before his remarks on the
After-School Child Care Initiative. At the end of his speech, President Clinton,
with Hillary by his side, responds to allegations that he had an inappropriate relationship
with Monica Lewinsky. — January 26, 1998

Above: The Clintons enjoy a respite from the expected impeachment vote the following
day, in a private moment with Eunice Shriver and her family on their way to a dinner in the
White House honoring the Special Olympics. — December 17, 1998

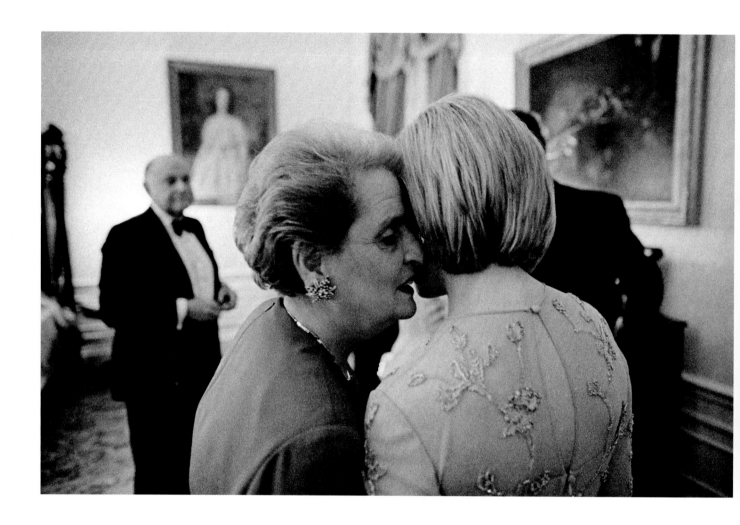

Above: Secretary of State Madeleine Albright has a quiet word with Hillary. Before most
White House state dinners, Albright briefed the First Lady on recent developments
between the United States and the guest of honor's country. The pressing foreign policy issue that
night concerned the conflict in the Balkans. — February 5, 1998

Opposite: After welcoming Prime Minister Tony Blair and his wife, Cherie Blair, to the
White House private quarters, the Clintons and the Blairs proceed down the
grand staircase. Hillary and Cherie Blair had more in common than their legal professions. They
both wore long champagne-beige evening dresses that night. — February 5, 1998

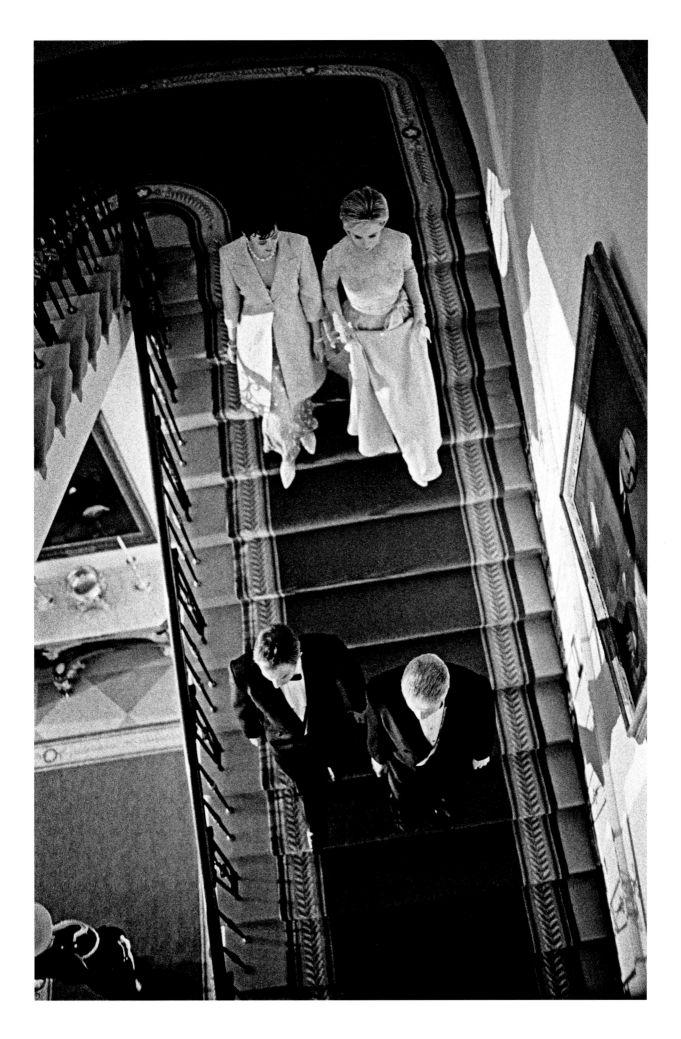

33

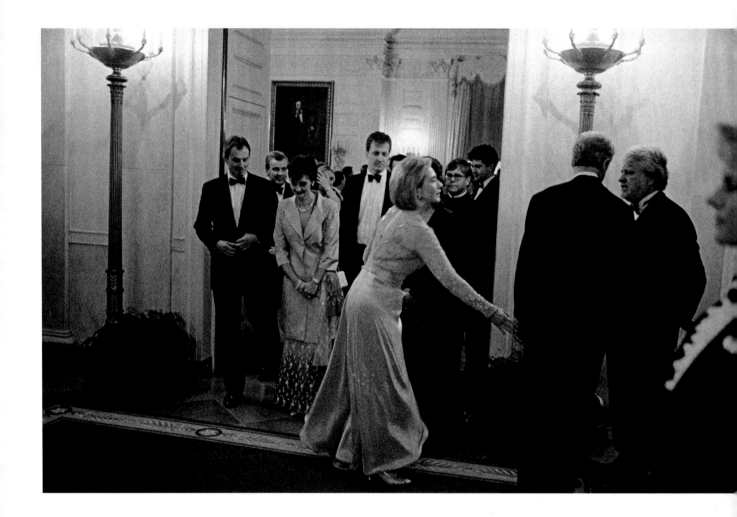

Above: Hillary interrupts a conversation between the president and longtime friend and Hollywood producer Harry Thomason to coax the president onto the dance floor. Many of the journalists attending the dinner that night had to leave early when news broke of a *New York Times* story about grand jury testimony of the president's secretary, Betty Currie, on the Lewinsky matter. — February 5, 1998

Opposite, top: The President and the First Lady dance following the entertainment provided by Elton John and Stevie Wonder, who sang a medley for Cherie Blair, including "My Cherie Amour." — February 5, 1998

Opposite, bottom: Hillary has a word with the president on the dance floor. — February 5, 1998

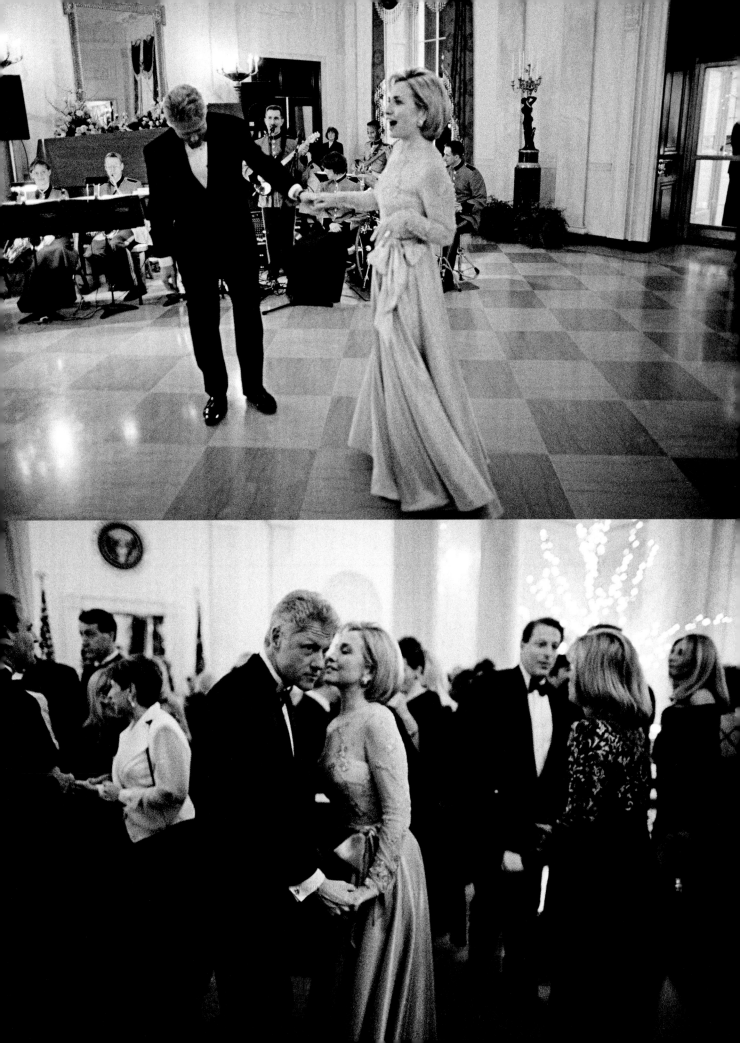

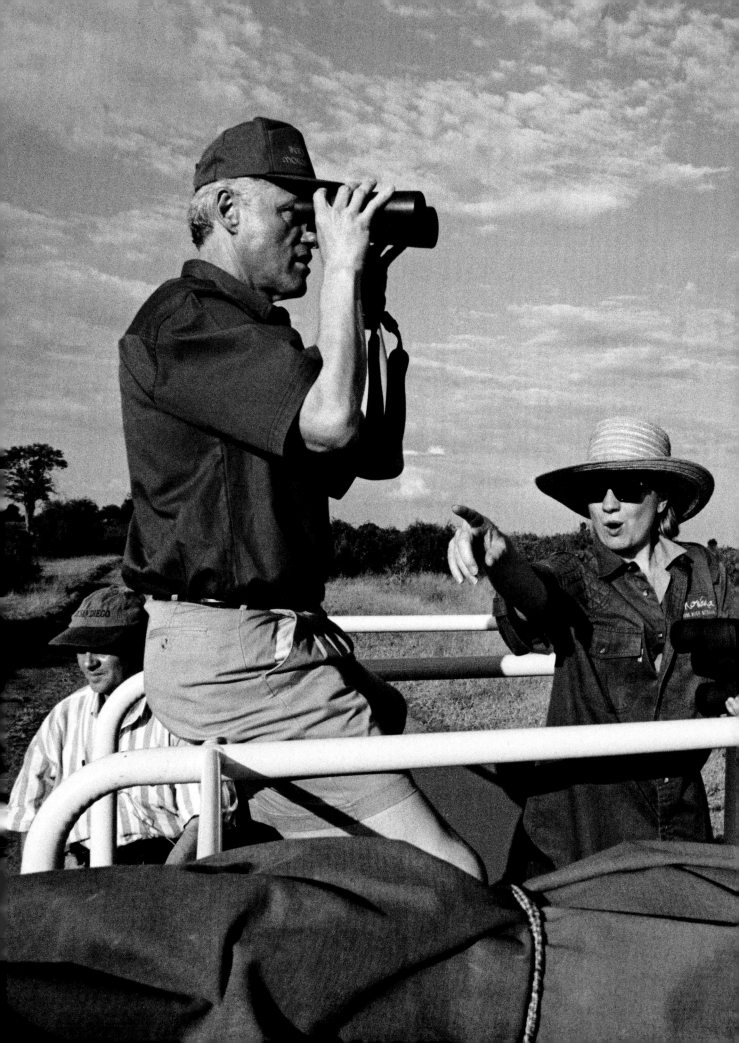

The President and
the First Lady take a safari
tour of the Chobe
National Park in Kasane,
Botswana, known to
have one of the highest
concentrations
of elephants in Africa.
— March 30, 1998

37

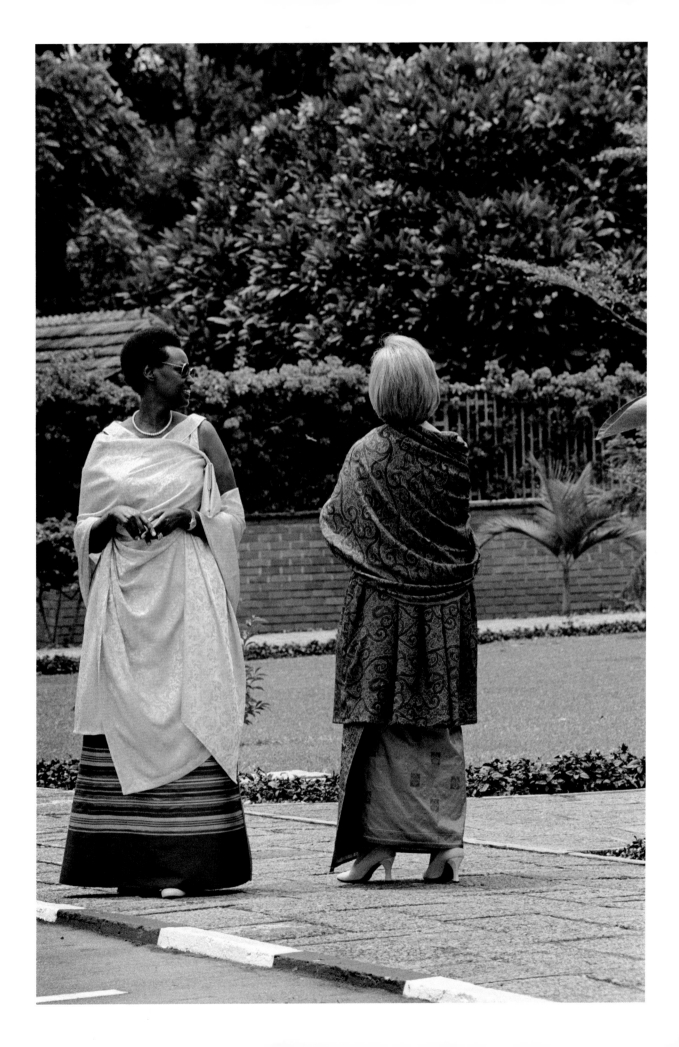

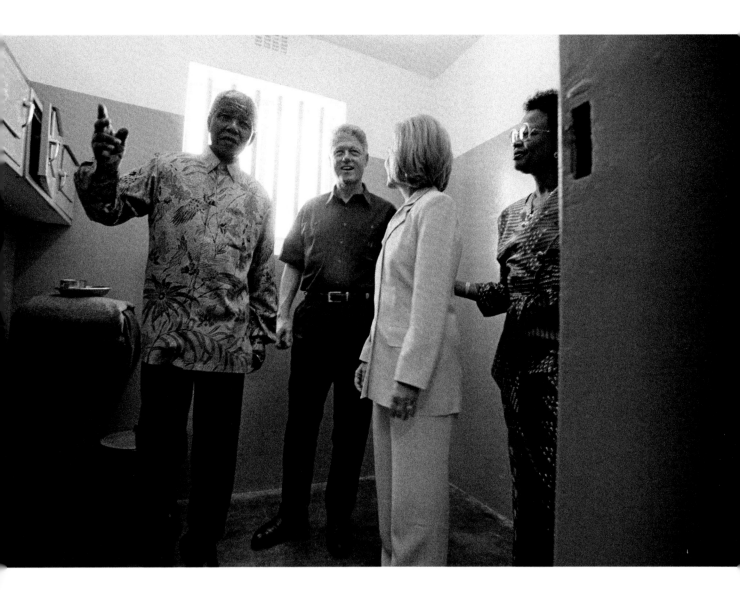

Opposite: Standing with Janet Museveni, wife of the president of Uganda, in Kampala, Uganda, Hillary admires the garden of the presidential palace. Hillary is wearing a native dress given to her by the Ugandan First Lady. — March 24, 1998

Above: Accompanied by President Nelson Mandela of South Africa and his companion, Graca Machel (they were married on July 18, 1998), the President and the First Lady visit the jail cell on Robben Island where Mandela was held as a political prisoner for eighteen years. Inside the jail cell, President Mandela told the Clintons, "This was my home." — March 27, 1998

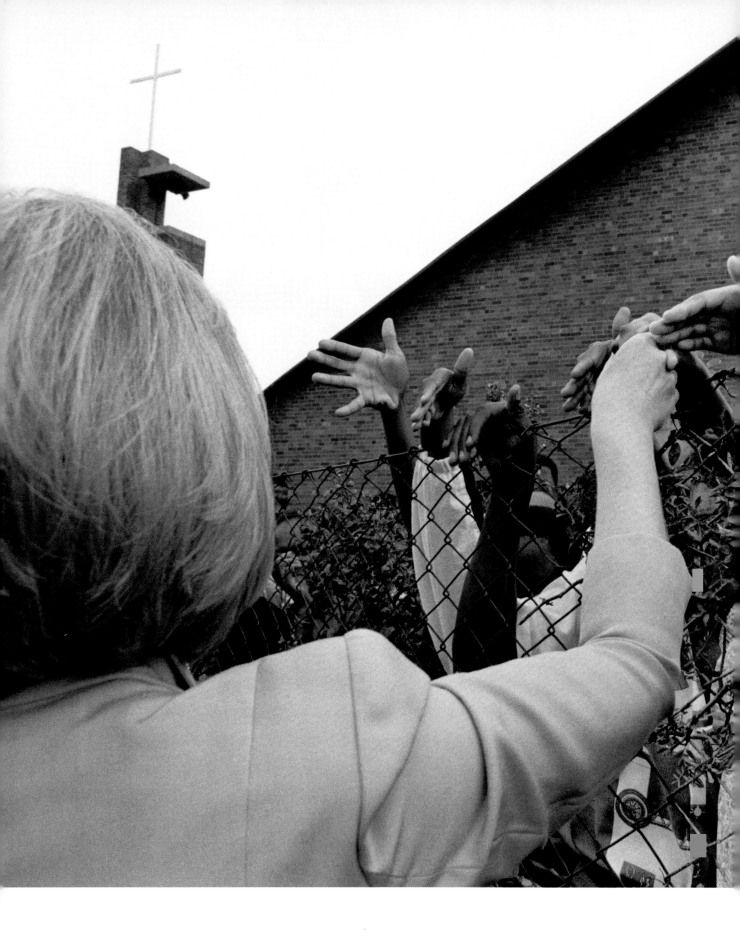

After services at the
Regina Mundi Catholic
Church in the Moroka
neighborhood of Rockville,
Soweto, citizens reach
to shake Hillary's hand.
— March 29, 1998

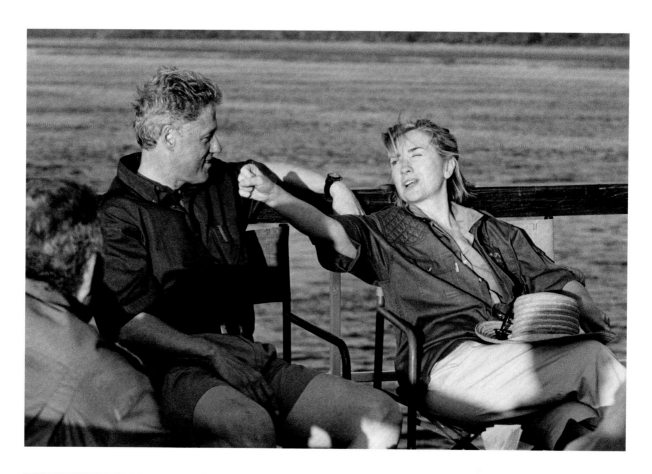

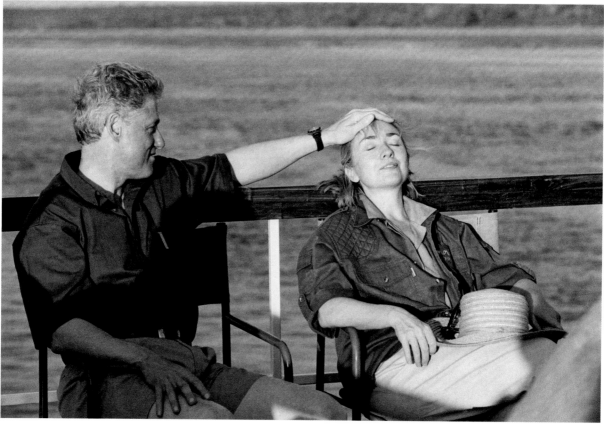

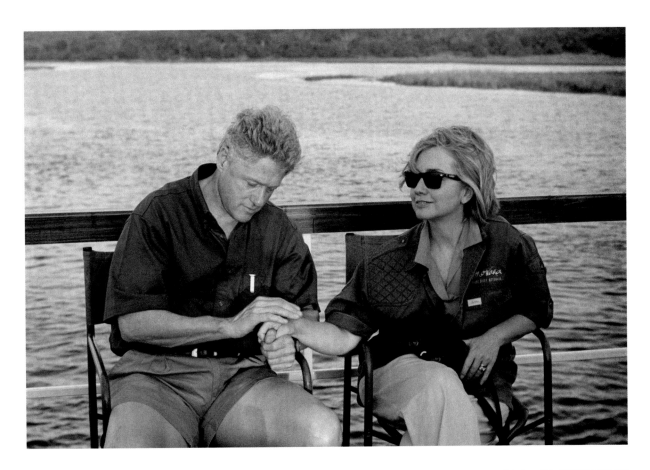

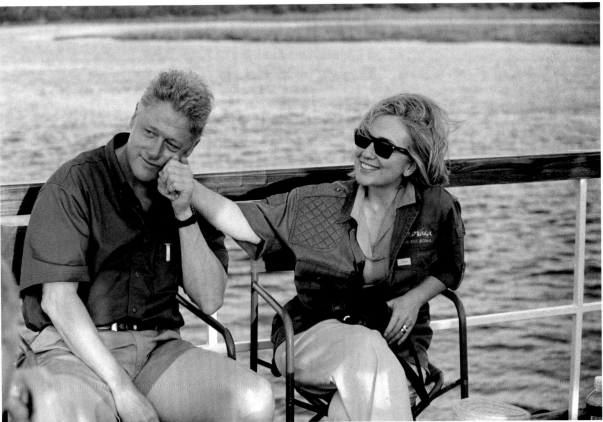

The President and the First Lady end their day at Chobe National Park, Botswana, with a sunset river cruise on the Chobe River, accompanied by gunboats and frogmen. — March 30, 1998

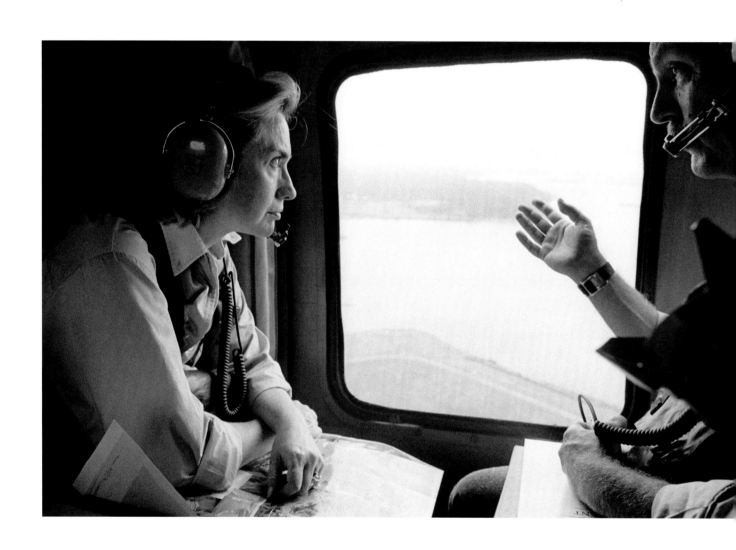

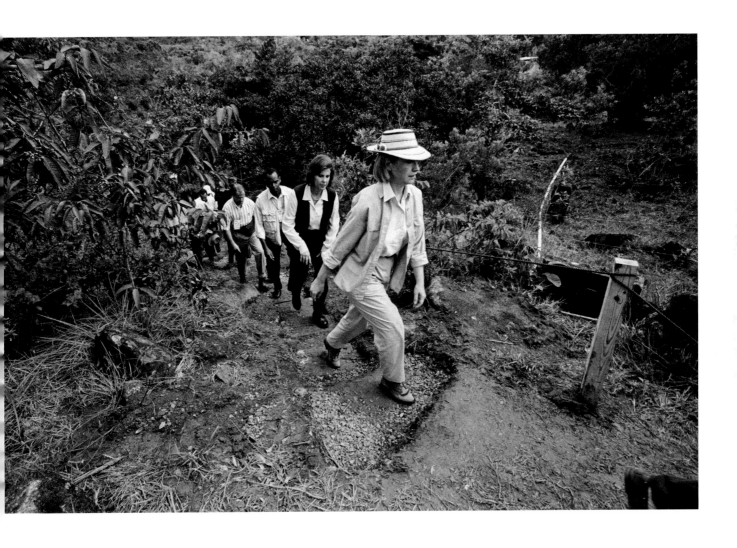

Opposite: In Panama for a three-day visit aimed at giving women a bigger role in the region's democracies, Hillary flies by helicopter to visit Chicá and receives an onboard briefing from Lars Klassen, mission director of USAID in Panama. — October 10, 1997

Above: During her visit to Chicá, Hillary walks along a trail on her way to see a women's cooperative garden. — October 10, 1997

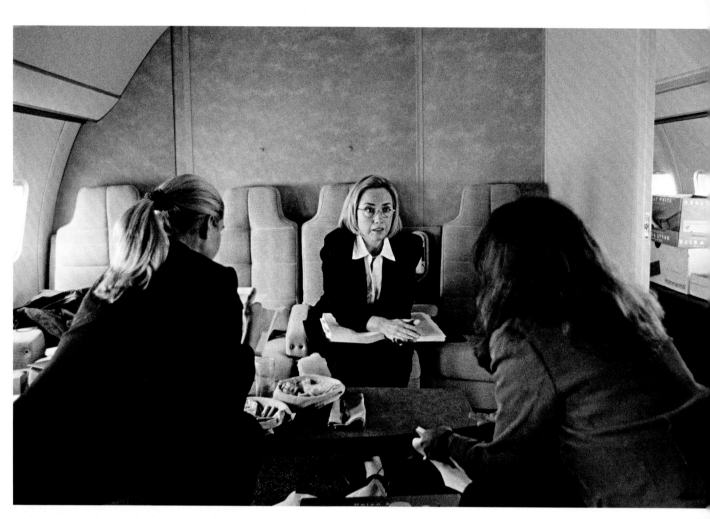

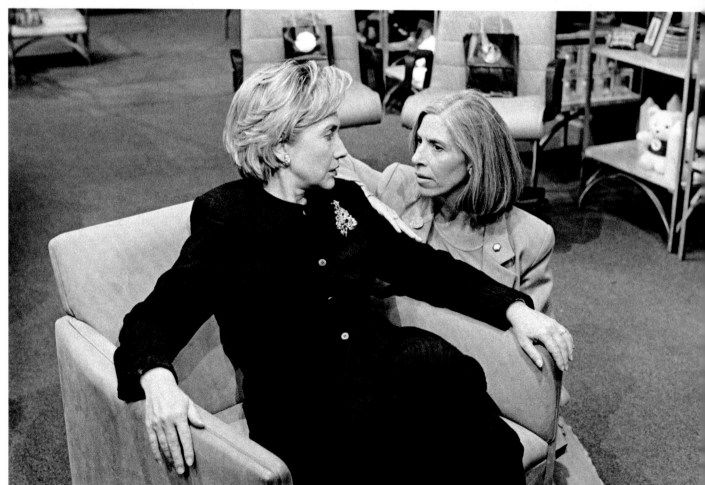

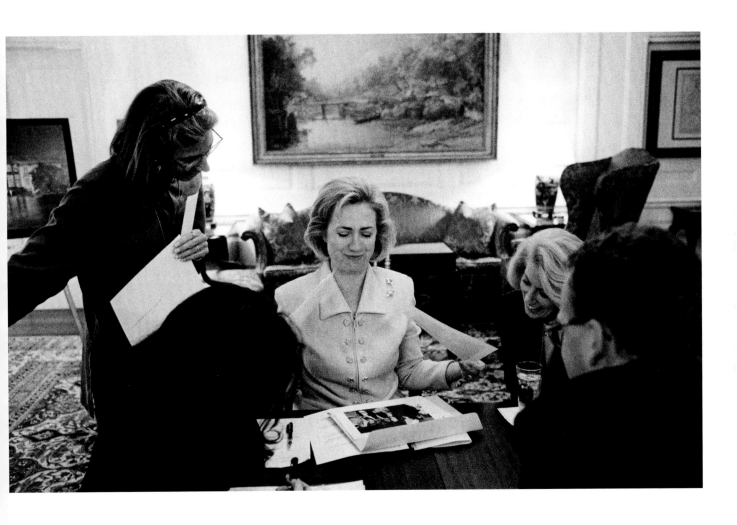

Opposite, top: Aboard the Air Force plane flying to Panama City, Hillary reviews the itinerary for the Panama trip with staffers Kelly Craighead, left, and Sarah Farnsworth, right. While in Panama, Hillary participated in the Seventh Conference of Wives of Heads of State and Government of the Americas and stressed that "a vibrant democracy depends on women's empowerment and full participation." — October 8, 1997

Opposite, bottom: Seated in a holding room in New York's Rockefeller Center, Hillary confers with her press secretary, Marsha Berry, before taping *The Rosie O'Donnell Show.* — December 2, 1998

Above: Hillary chuckles as she looks at photos during an afternoon staff meeting at the White House. — October 3, 1997

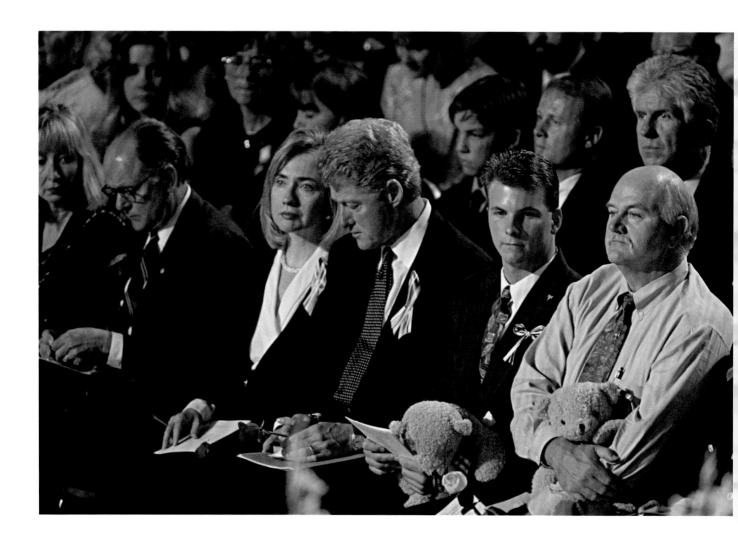

Above: Hillary and the president attend the memorial service for the victims of
the Oklahoma City bombing. — April 23, 1995

Opposite: Hillary autographs copies of her book *Dear Socks, Dear Buddy: Kids' Letters to the
First Pets* in the private dining room of the White House. — December 9, 1998

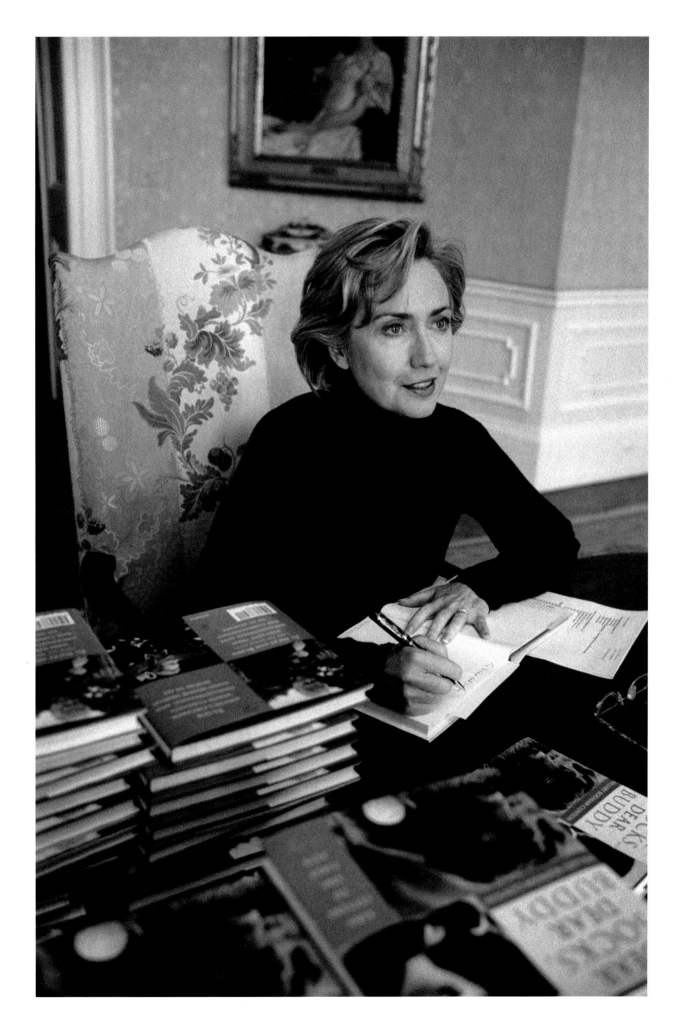

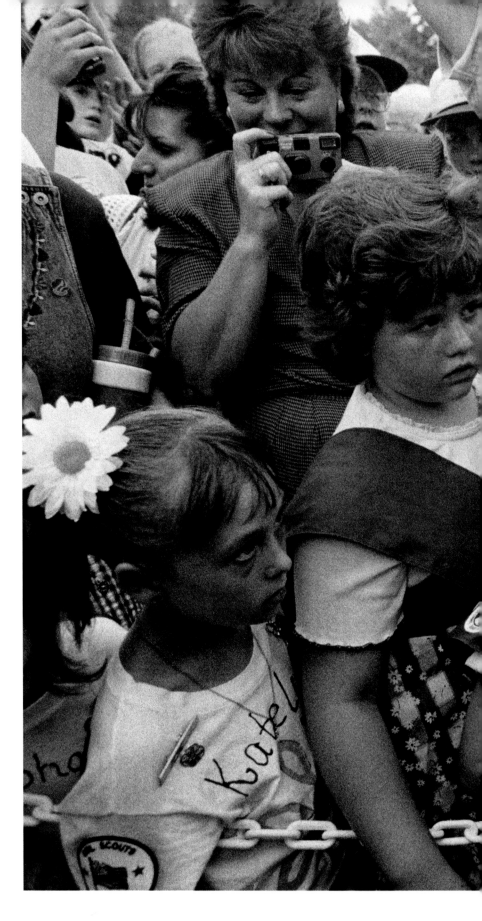

As part of her
Save America's Treasures
tour, Hillary visits
M'Clintock House
in Waterloo, New York,
and works the crowd.
— July 15, 1998

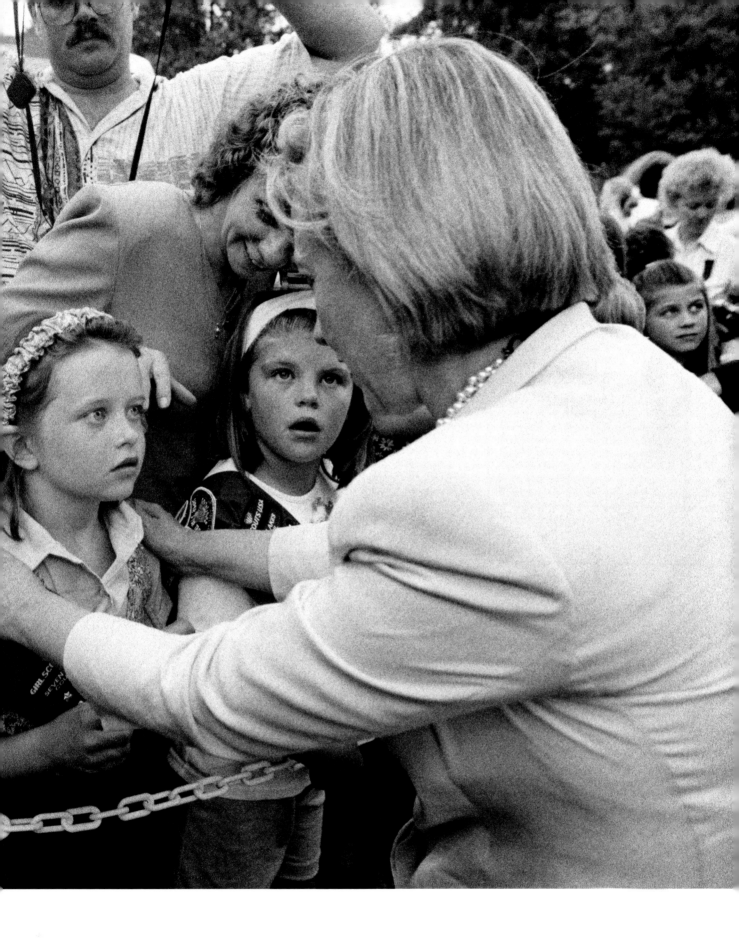

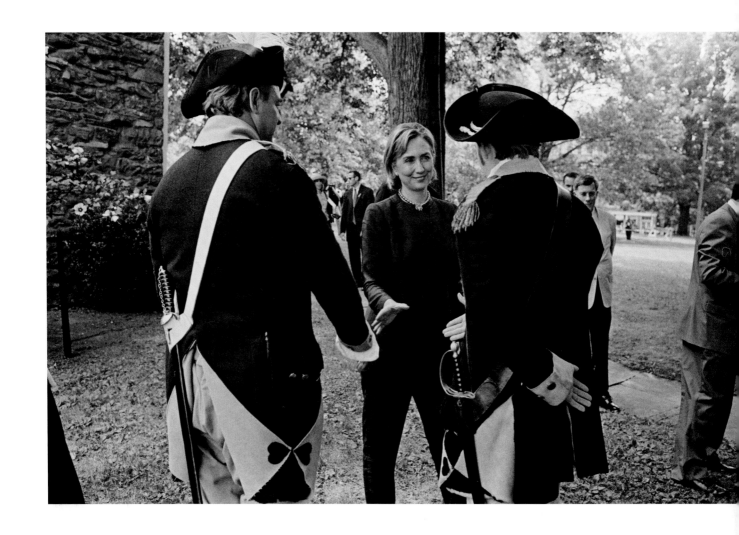

Above: As she continues her preservation tour, Hillary meets colonial soldiers at Washington's Headquarters State Historic Site in Newburgh, New York. — July 14, 1998

Opposite, top: Hillary visits the Center for Young Children at the University of Maryland. — October 3, 1997

Opposite, bottom: At a stop in Newburgh, New York, Hillary greets a woman who was a graduate of the Wellesley class of 1923. — July 14, 1998

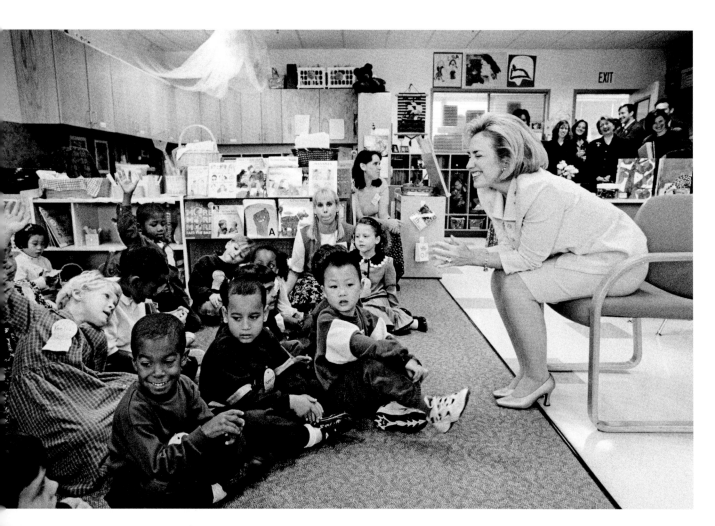

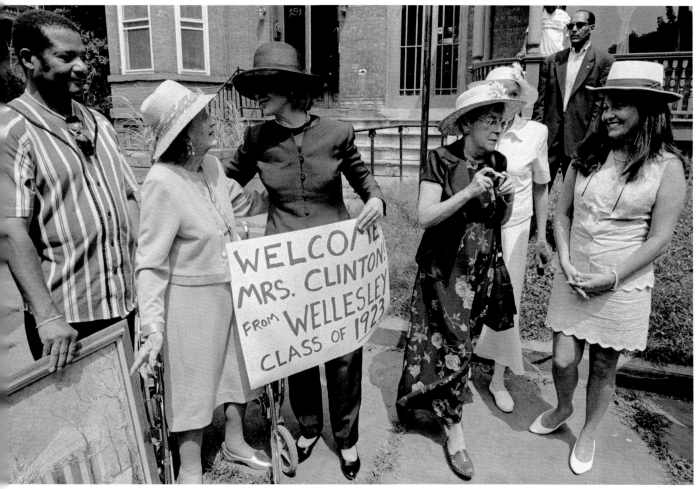

On the way back
to the White House from
her visit to the Center
for Young Children,
Hillary shares a laugh
with her chief of
staff, Melanne Verveer.
— October 3, 1997

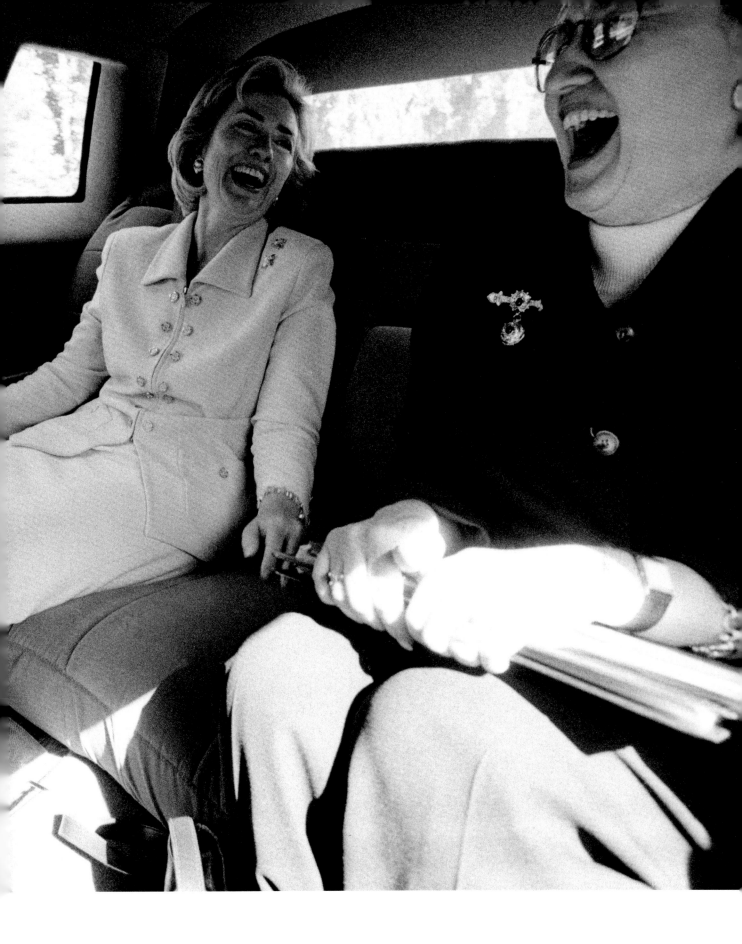

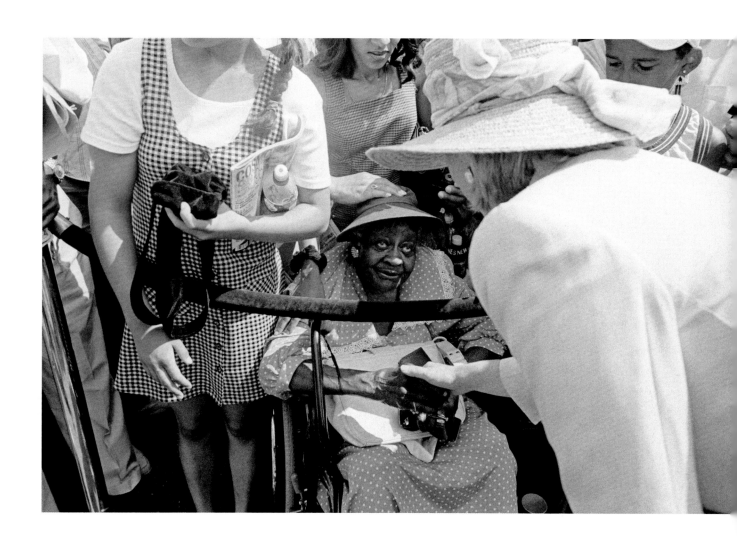

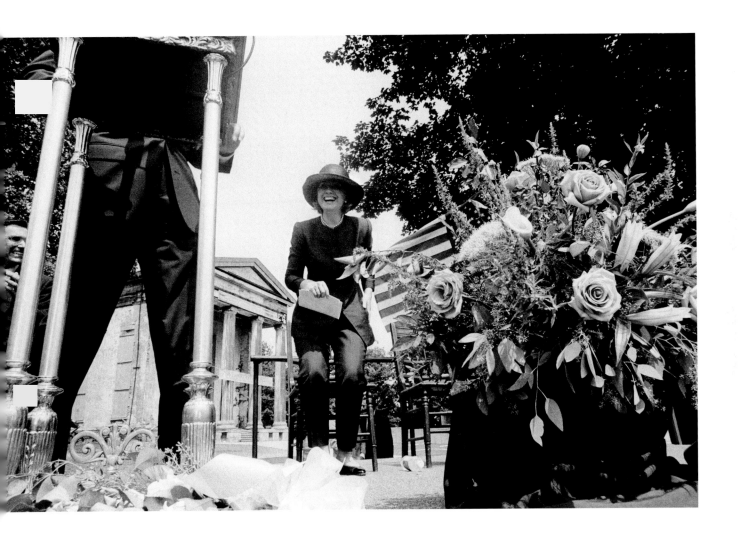

Opposite: Before a tour of the Harriet Tubman Home for the Aged in Auburn, New York,
Hillary greets the crowd. — July 14, 1998

Above: Hillary is introduced at an outdoor rally near the Dutch Reformed Church in Newburgh,
New York, another stop on her preservation tour. — July 13, 1998

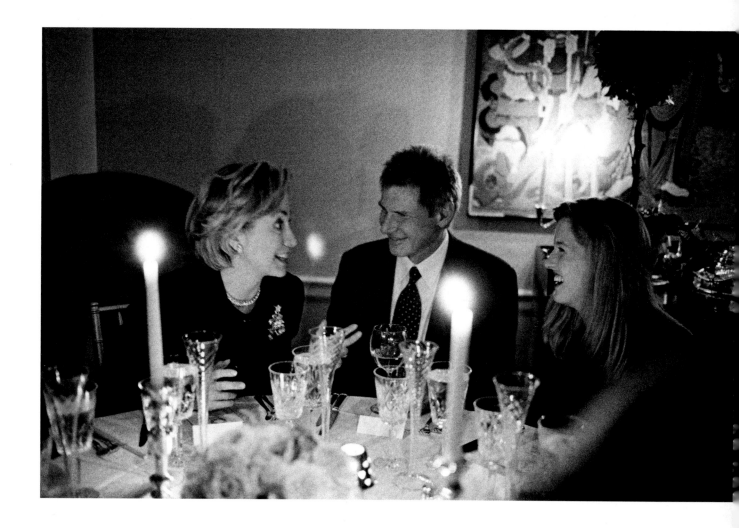

Above: Hillary chats with her tablemates, actor Harrison Ford and Karenna Gore Schiff, daughter of the vice president, at the home of Richard Holbrooke, special envoy to the Balkans, and his wife, author Kati Marton. — December 2, 1998

Opposite, top: After visiting the Bronx Zoo, where Hillary saw a holiday light show, she attends a movie screening of *Shakespeare in Love.* — December 3, 1998

Opposite, bottom: On Hillary's visit to Thomas Edison's famed laboratory and factory in West Orange, New Jersey, one of the sites on her Save America's Treasures tour, she shares a joke with General Electric CEO Jack Welch. — July 14, 1998

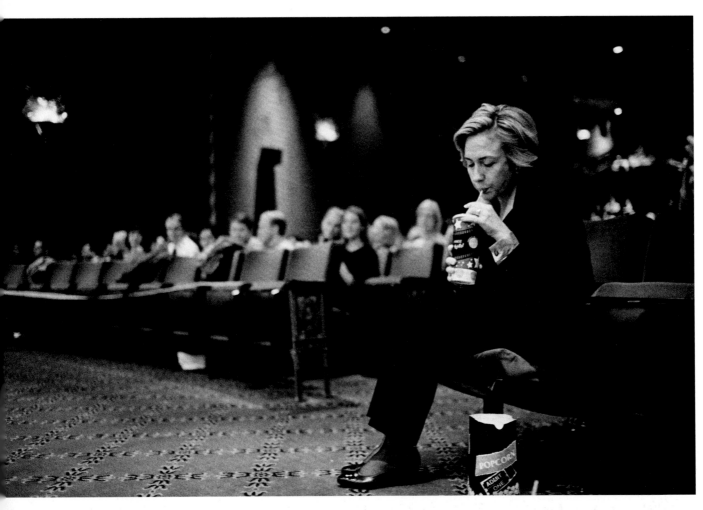

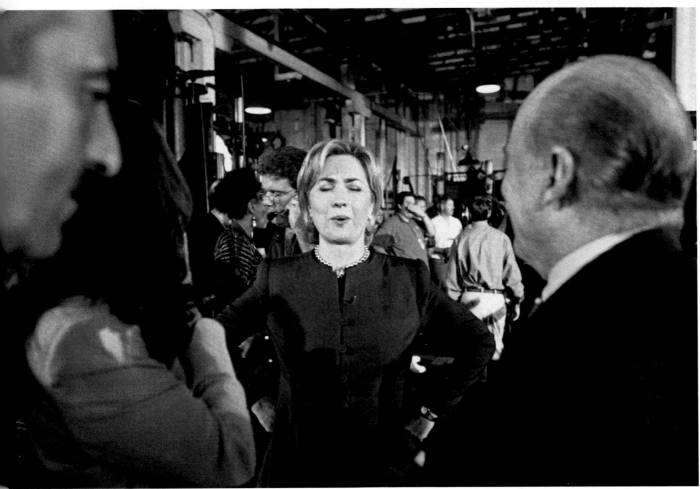

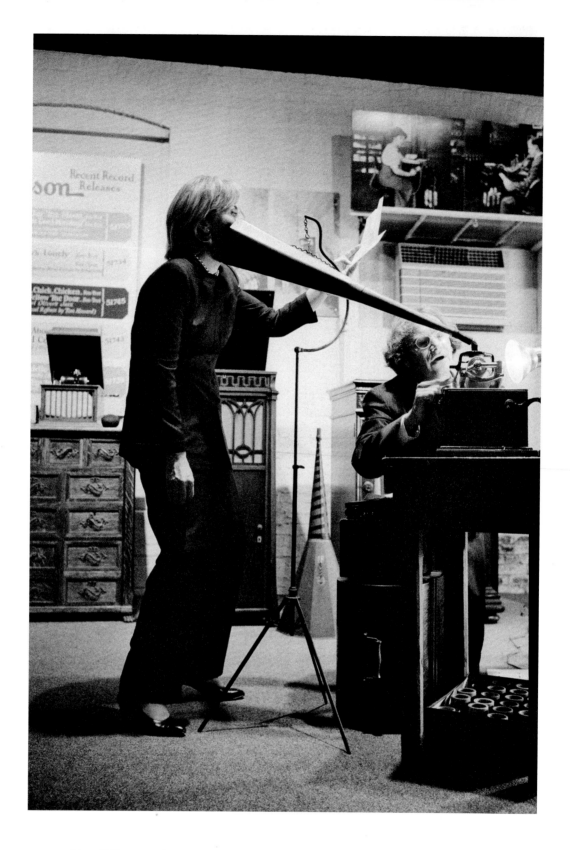

Above: Hillary records on an Edison wax cylinder record with the help of acoustic recording engineer Peter Dilg at the Edison Lab in West Orange, New Jersey. — July 14, 1998

Opposite, top: Hillary looks over the dining room at the William H. Seward House Historic Museum in Auburn, New York, one of the stops on the Save America's Treasures tour.
Seward (1801–72) was President Abraham Lincoln's secretary of state. — July 15, 1998

Opposite, bottom: Hillary visits the Louis Armstrong House Museum in Queens, New York, and designates it an official site of the Save America's Treasures program. — December 3, 1998

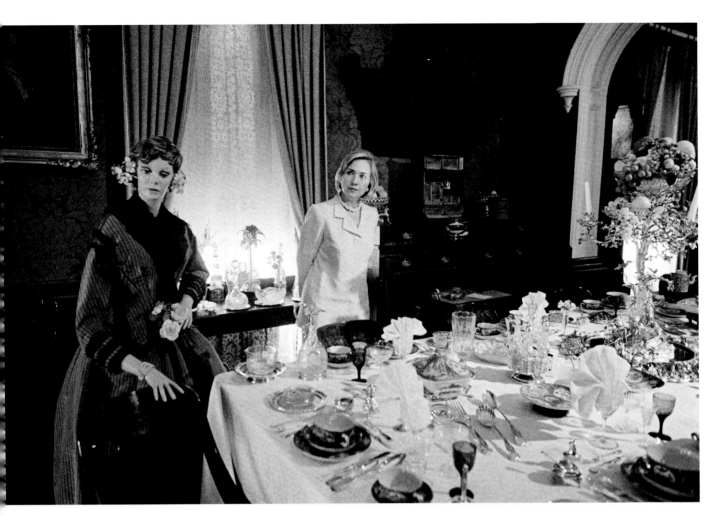

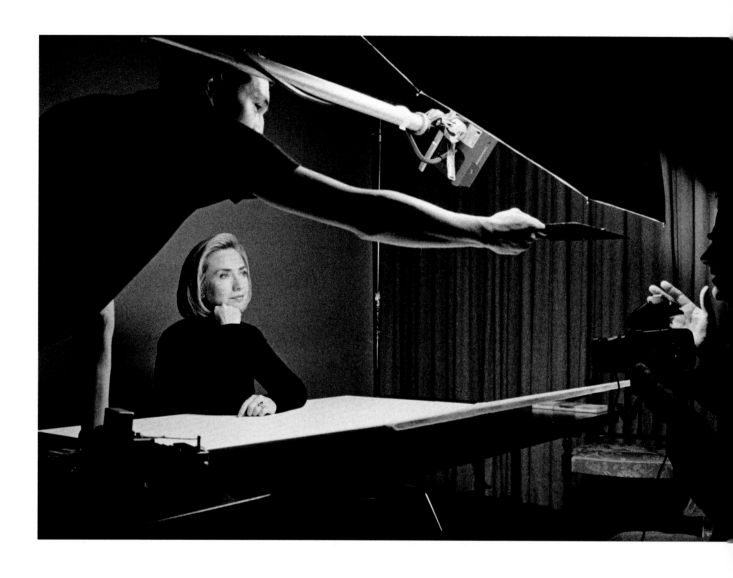

Above: Patrick Demarchelier, right, and his assistant, left, set the stage before shooting Hillary's portrait for a *Time* cover celebrating her fiftieth birthday. — October 20, 1997

Opposite: Diana took advantage of his set and lights to take this photograph. — October 20, 1997

Following spread: Hillary heads into New York City with her chief of staff, Melanne Verveer, after viewing the holiday lights at the Bronx Zoo. — December 3, 1998

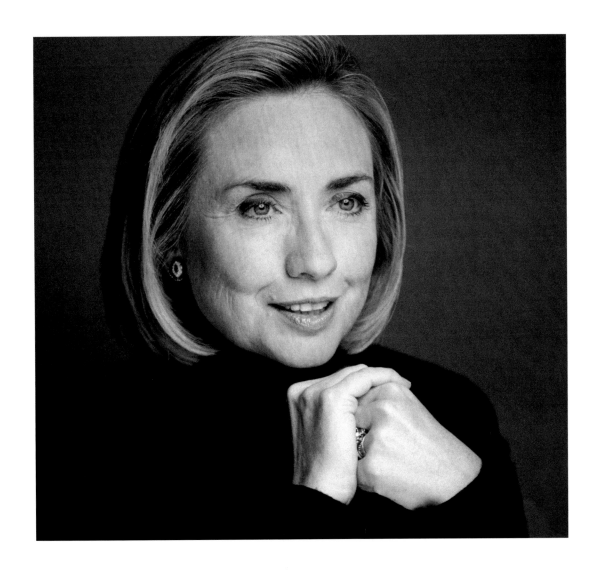

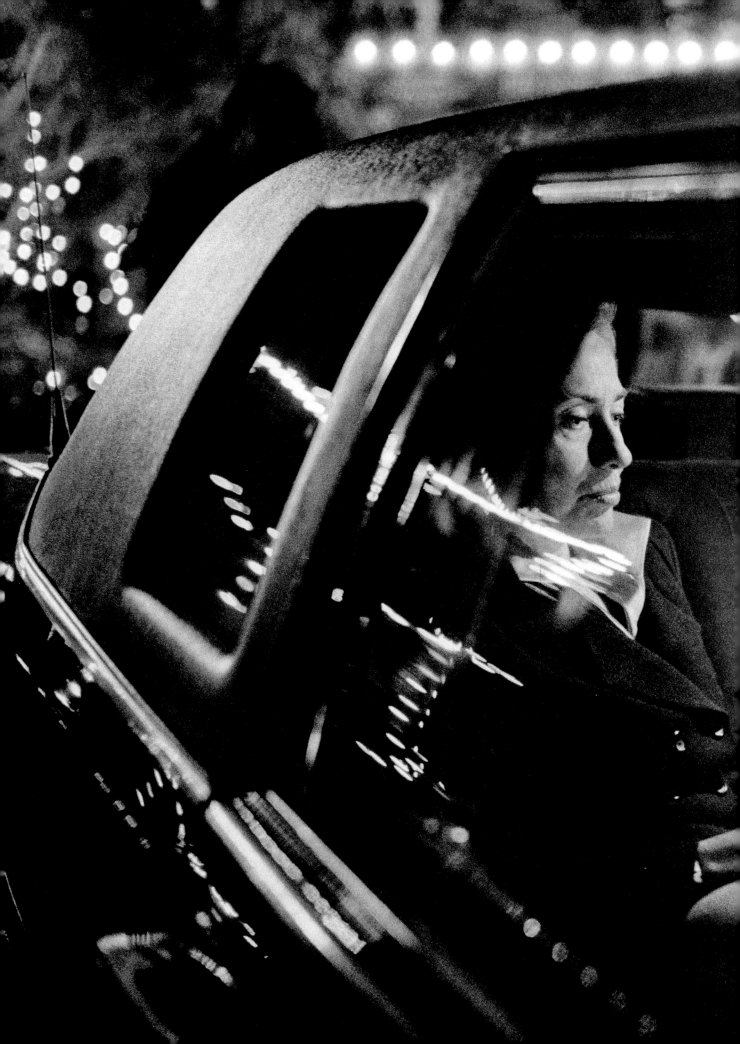

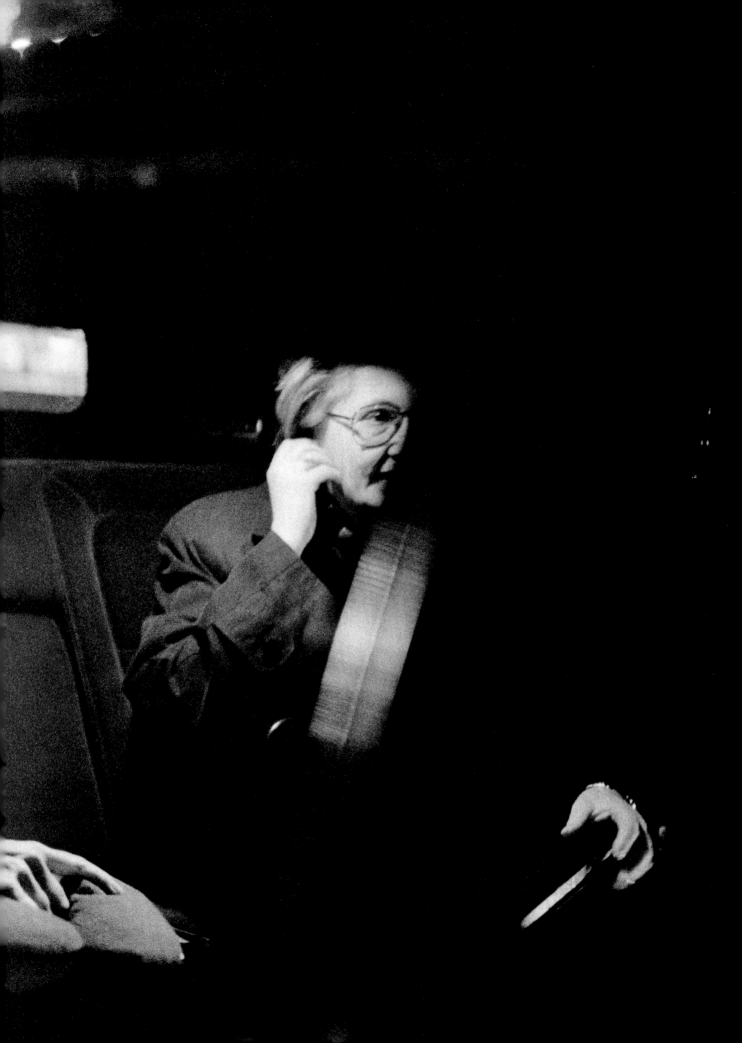

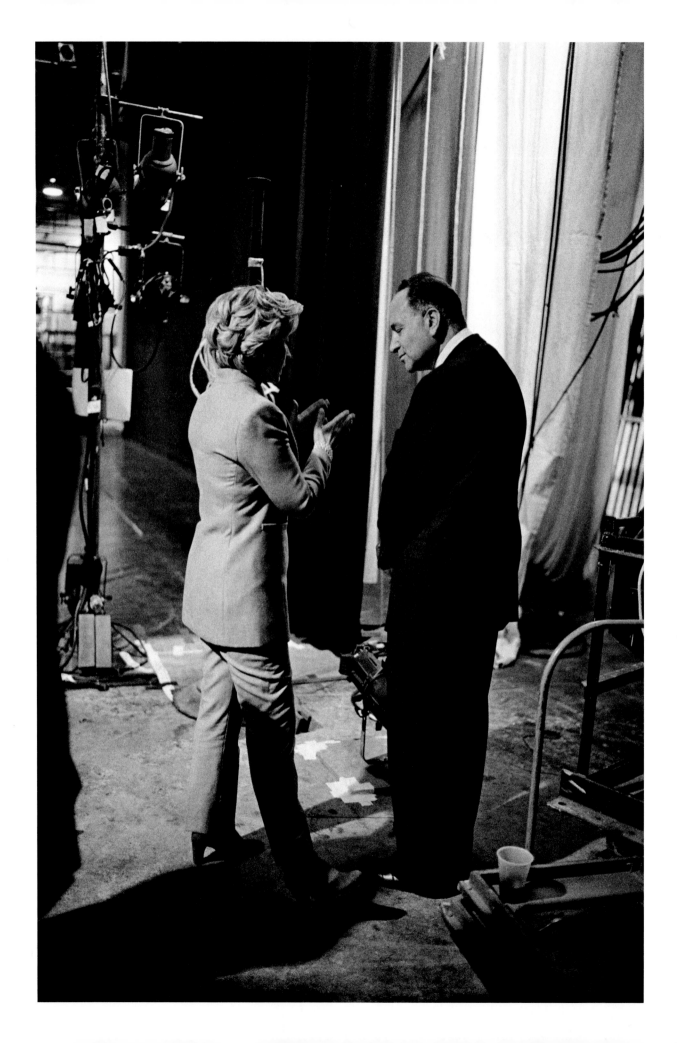

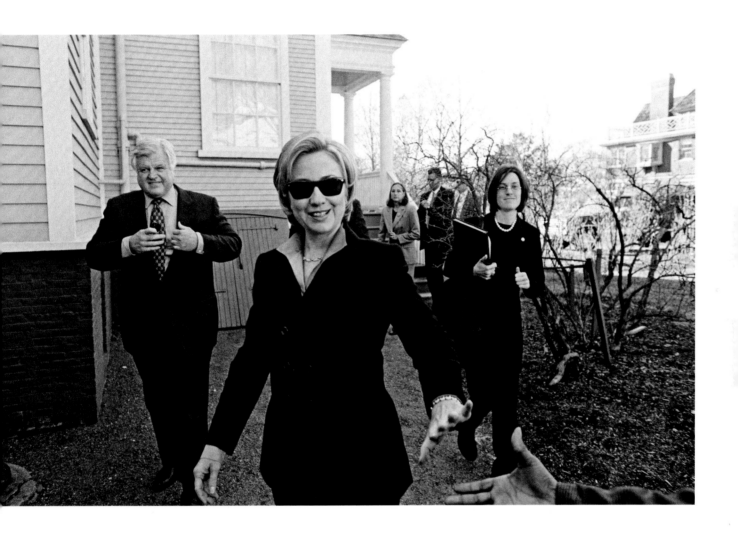

Opposite: As Hillary waits to announce new preservation efforts for the Louis Armstrong House
at the Colden Center for the Performing Arts in Queens, New York, she
gets into a conversation with then congressman Charles Schumer (D-NY). — December 3, 1998

Above: Hillary walks alongside the Longfellow House in Cambridge, Massachusetts, with
Senator Ted Kennedy (D-MA). — December 5, 1998

Hillary gets a tour of Fort
McHenry from National
Park Service superintendent
Kayci Cook and sees
Francis Scott Key's original
poem "The Defense of
Fort McHenry," which was
set to music and became
the national anthem,
"The Star-Spangled Banner."
— July 13, 1998

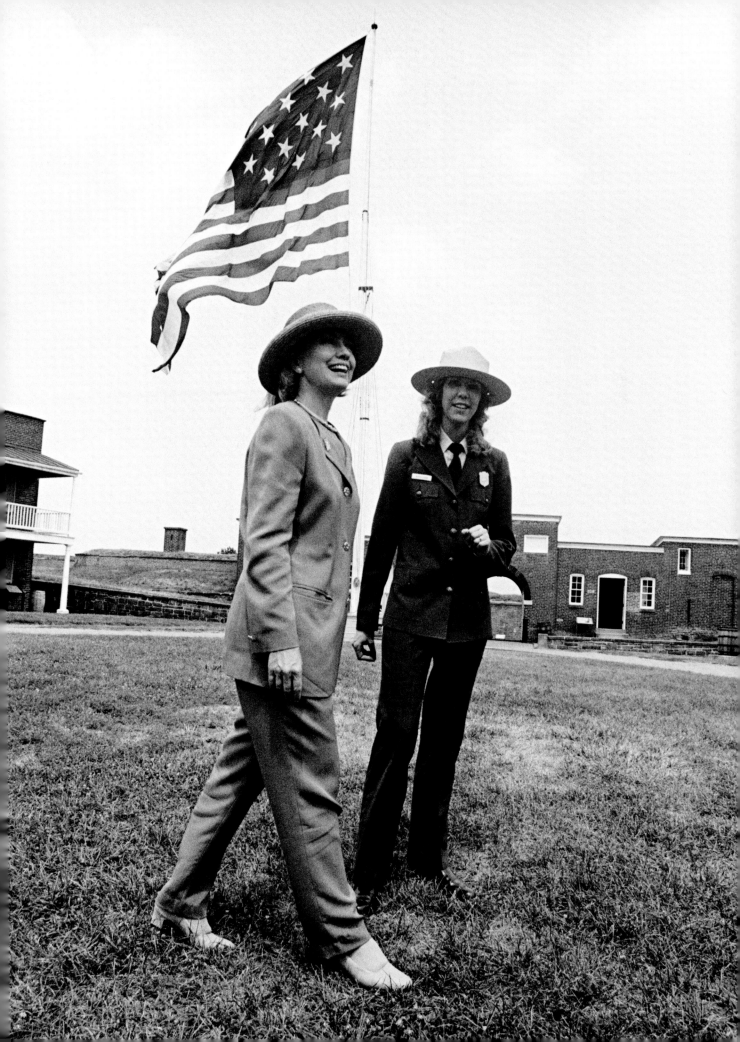

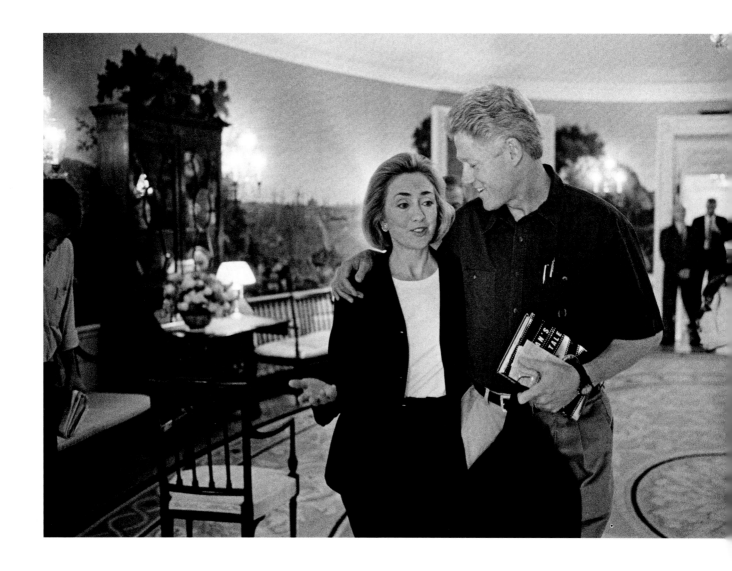

Above and opposite: Hillary walks with President Clinton toward the South Portico and bids
him good-bye as he goes out to catch a helicopter to Andrews Air Force Base,
where he will board Air Force One for Newark, New Jersey. She will fly to Panama later that day.
— October 8, 1997

Following spread: Relaxing after touring the main terminal of the new Gaza International Airport,
Chairman Yasser Arafat of the Palestinian Authority and his wife, Suha, sit down with the
Clintons for a chat. — December 14, 1998

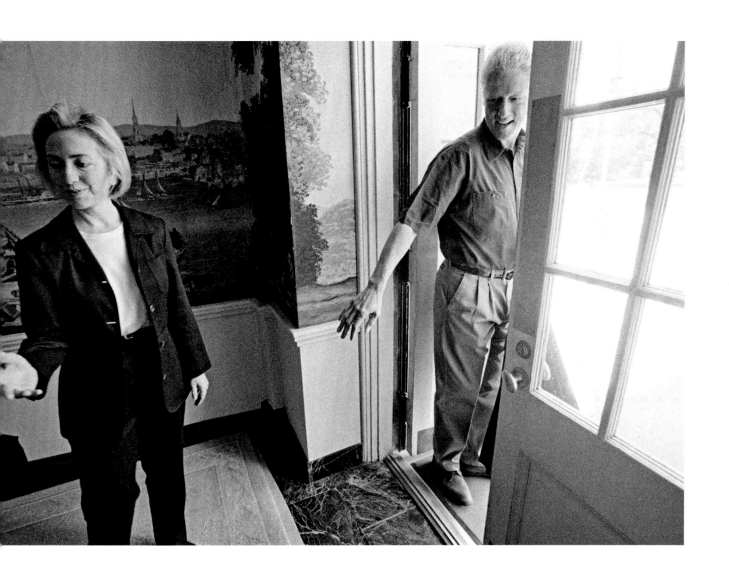

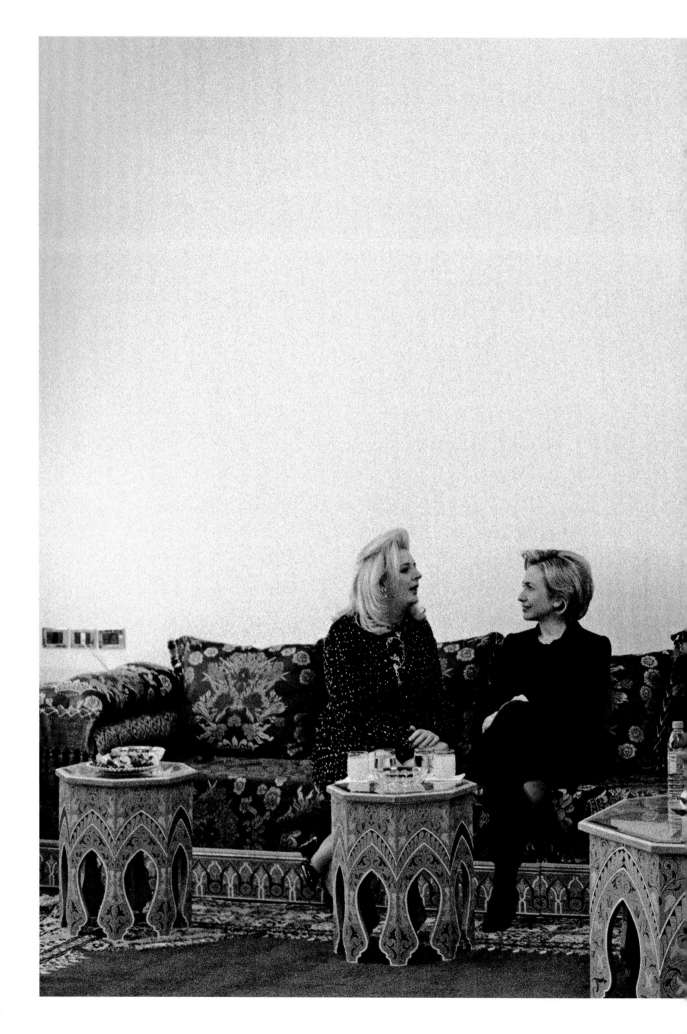

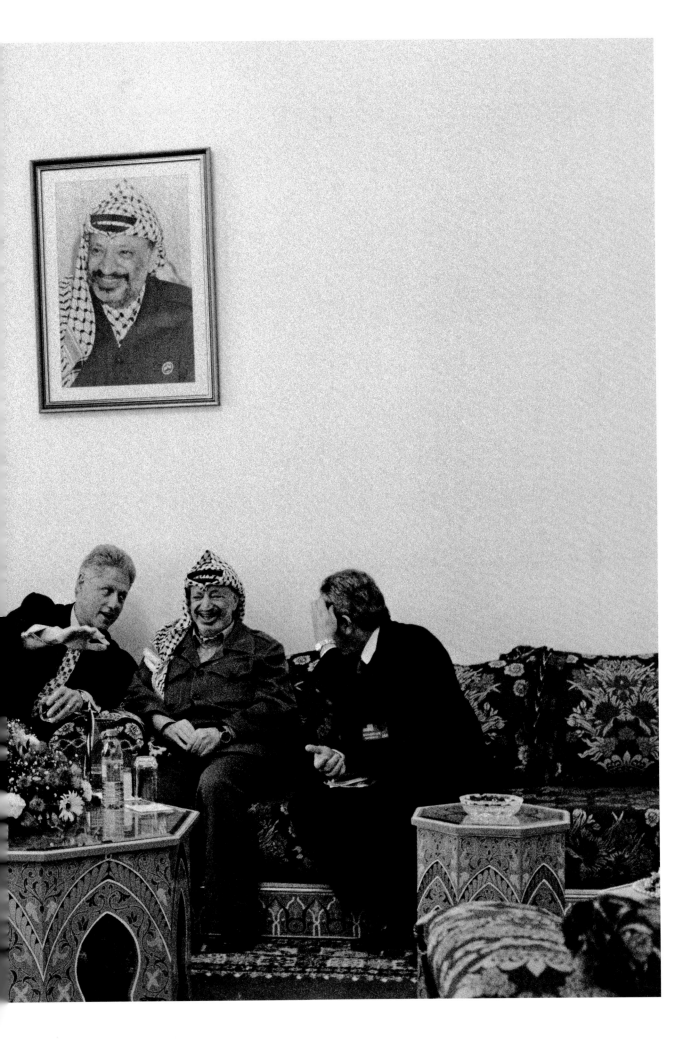

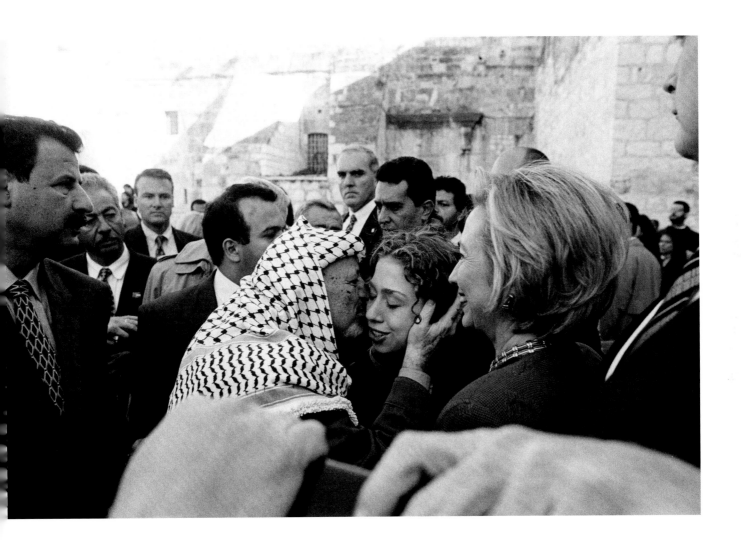

Opposite: Prime Minister Benjamin Netanyahu of Israel and his wife, Sara, walk with Hillary in the Jerusalem International Convention Center. — December 13, 1998

Above: After visiting the Church of the Nativity in Bethlehem, Chairman Arafat bids Chelsea good-bye. On Manger Square, the Arafats and the Clintons joined local religious leaders and a children's choir to sing carols. — December 14, 1998

Following spread: In Israel, the Clintons and the Netanyahus ride a cable car up to the ancient mountaintop fortress of Masada. — December 15, 1998

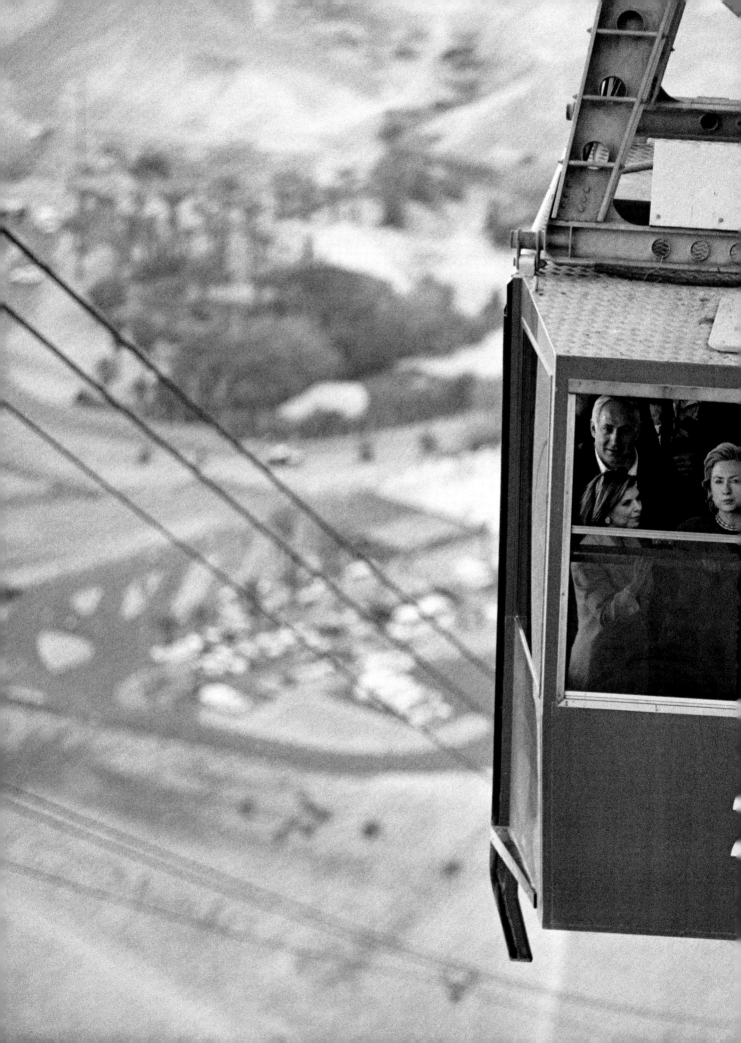

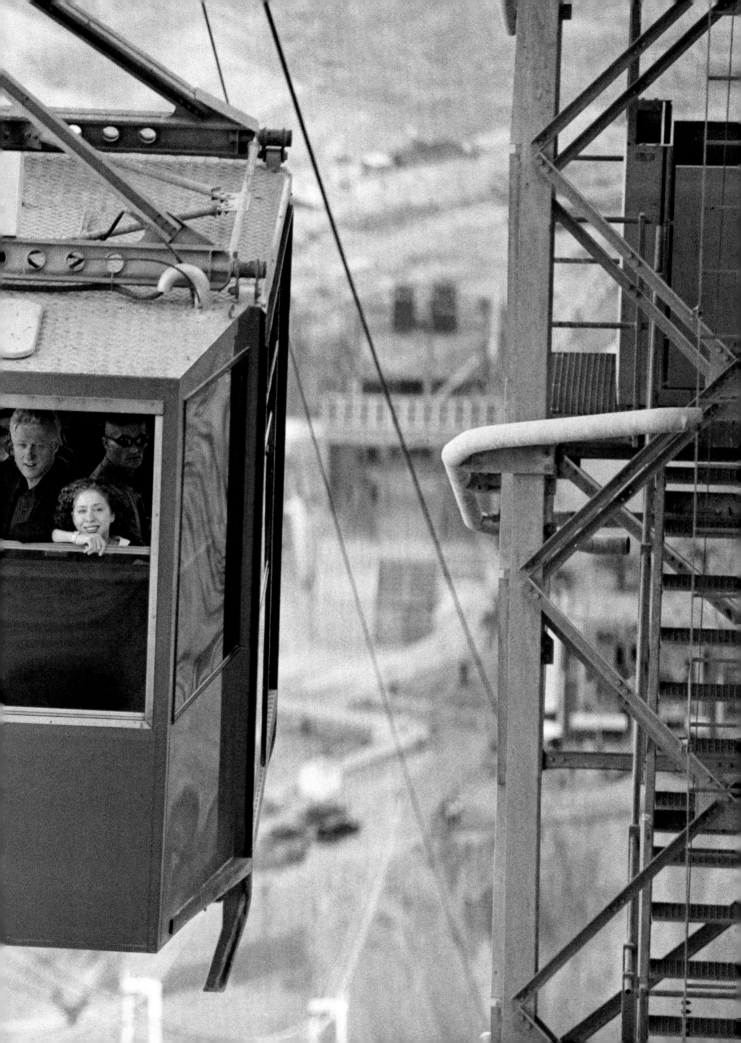

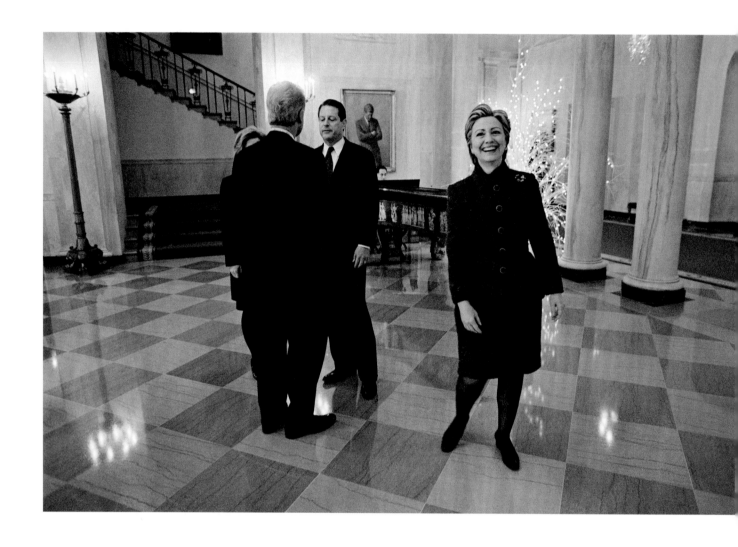

Above and opposite: The Clintons and the Gores await the arrival of President-elect George W. Bush and his wife, Laura. As piano music plays in the background on the State Floor, Hillary asks George Hannie, a member of the White House staff, for a farewell dance. — January 20, 2001

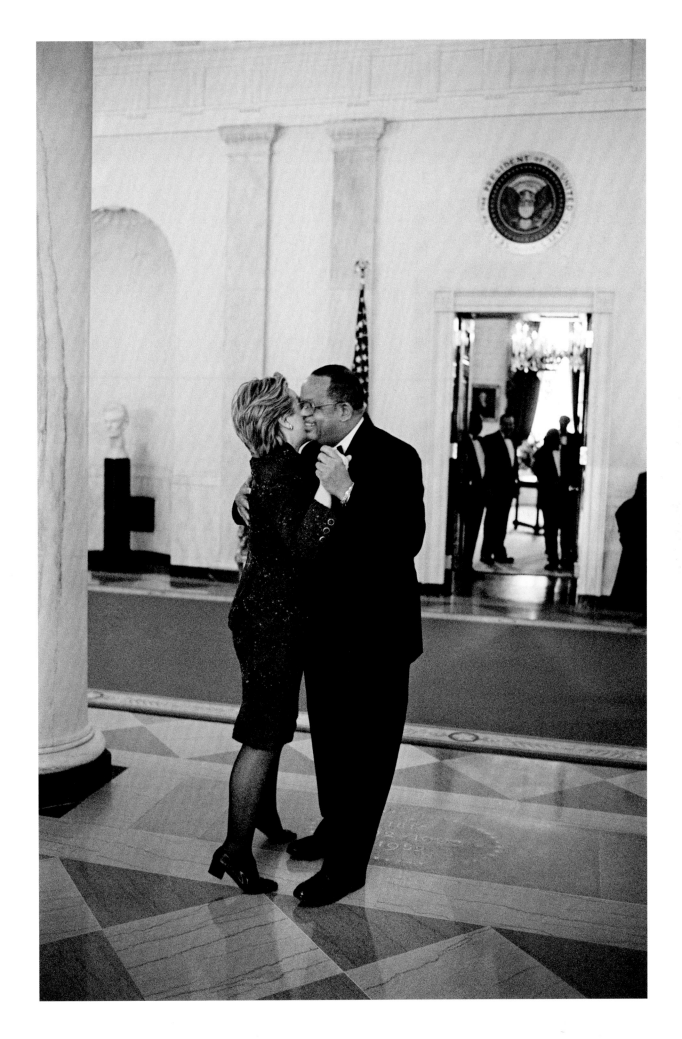

The President and
the First Lady share
a private moment,
one of their last in
the Oval Office.
— January 11, 2001

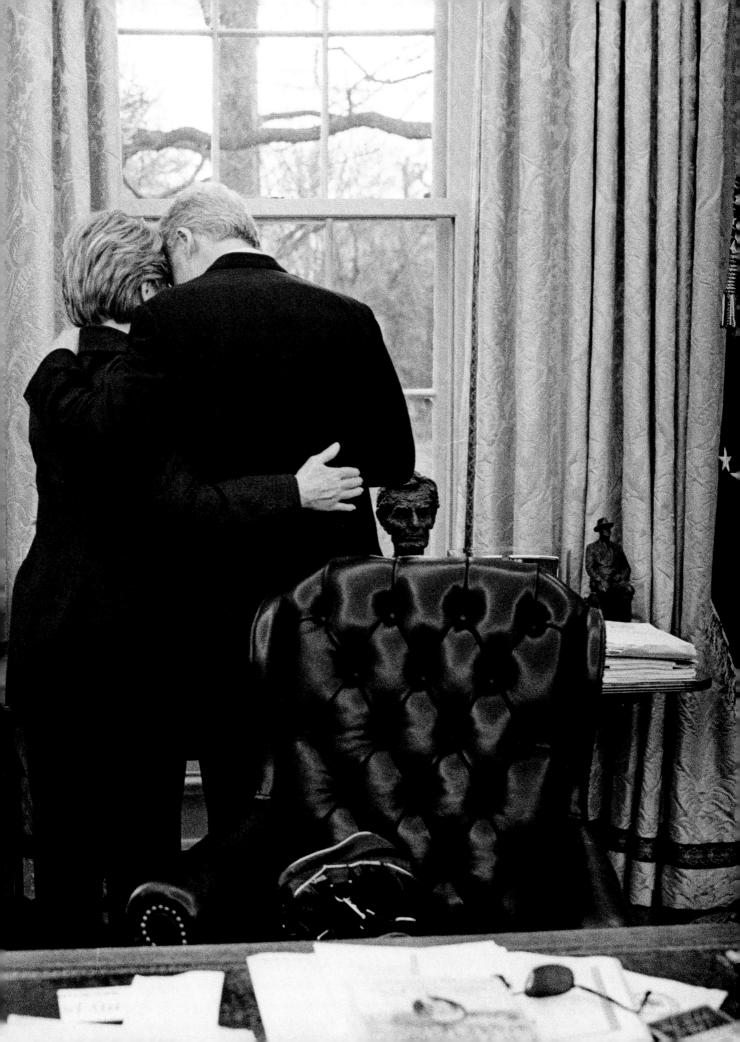

After the inauguration
of George W. Bush,
the Clintons flew to
New York City, where,
as the new senator
from New York,
Hillary addresses a
crowded airplane
hangar of well-wishers
as the president and
Chelsea look on.
— January 20, 2001

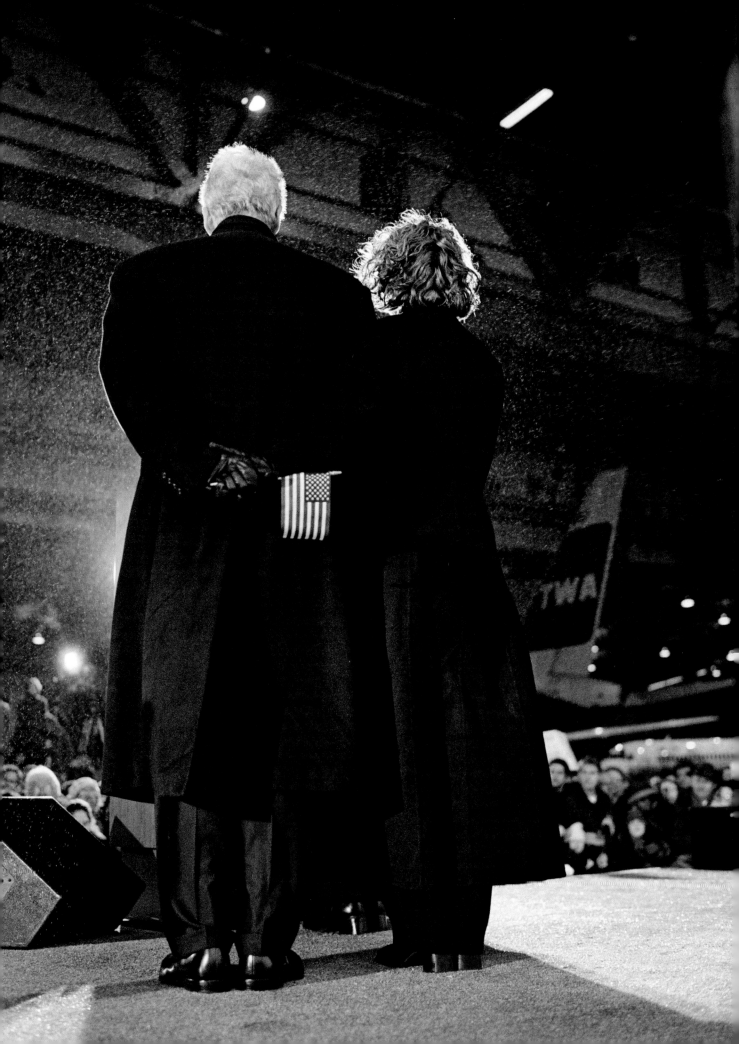

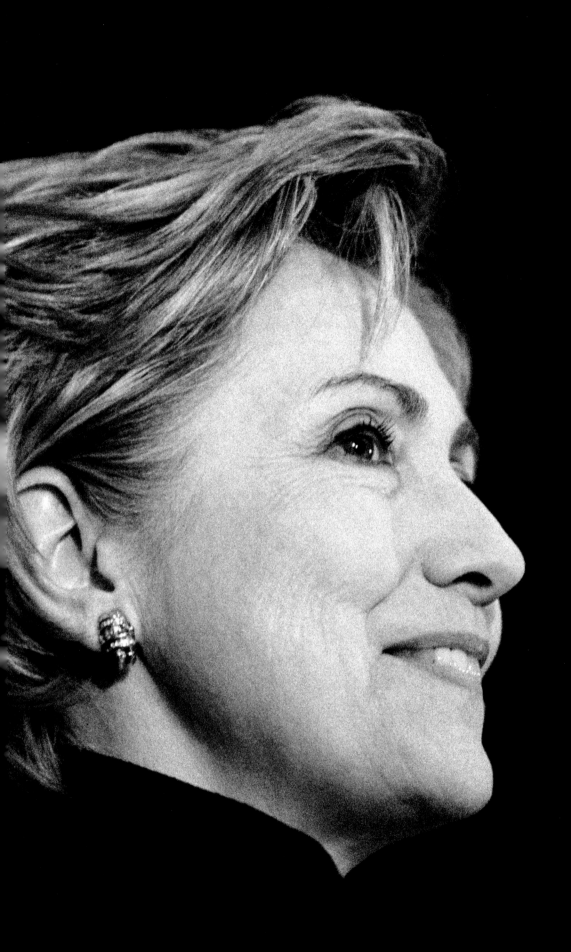

SENATOR 2001 – 2009

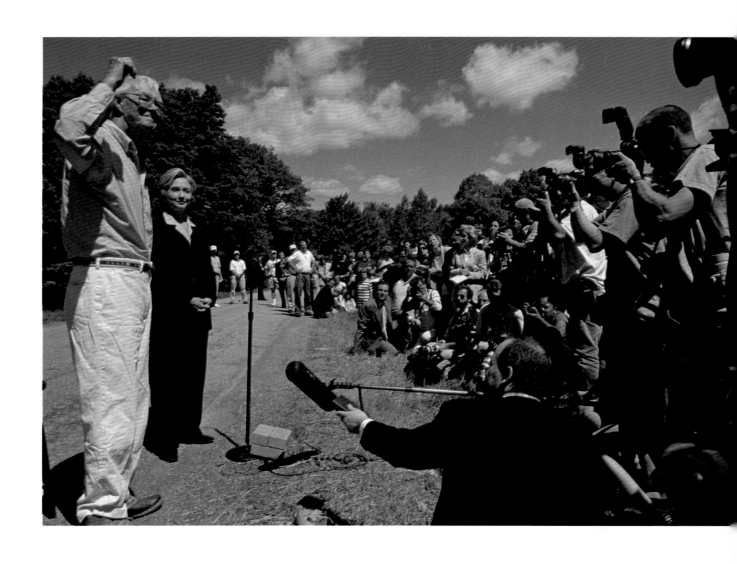

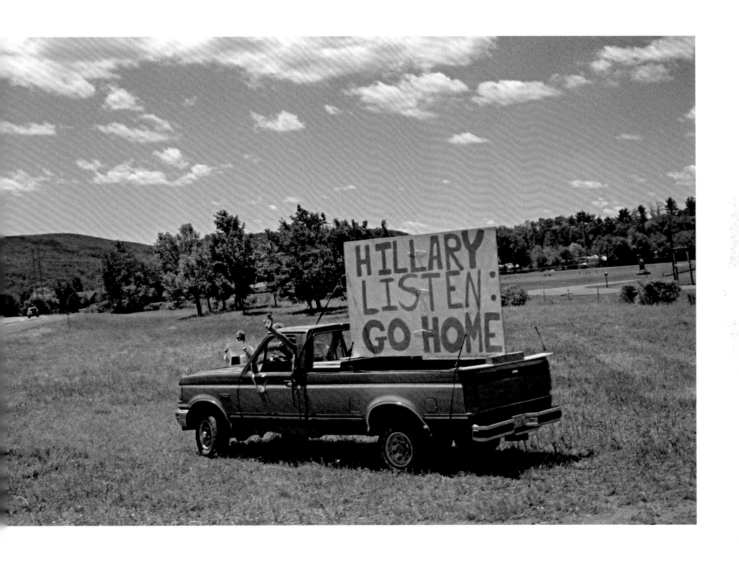

Previous spread: Hillary speaks at the Not-For-Profit Leadership Summit in
Rye Brook, New York. — May 15, 2006

Opposite and above: Hillary launches a summer-long listening tour at a news conference
with retiring Senator Daniel Patrick Moynihan (D-NY) on his farm near Oneonta,
New York. In a nearby field, a protester shows his displeasure. — July 7, 1999

Following spread: Hillary takes questions from reporters at the launch of her Senate candidacy
listening tour at Senator Moynihan's farm in Pindars Corners, New York. — July 7, 1999

Pages 90–91: On a campaign swing through upstate New York, Hillary has breakfast
and talks about education and economic development with locals
at the Village House Restaurant in Albion, New York. — February 8, 2000

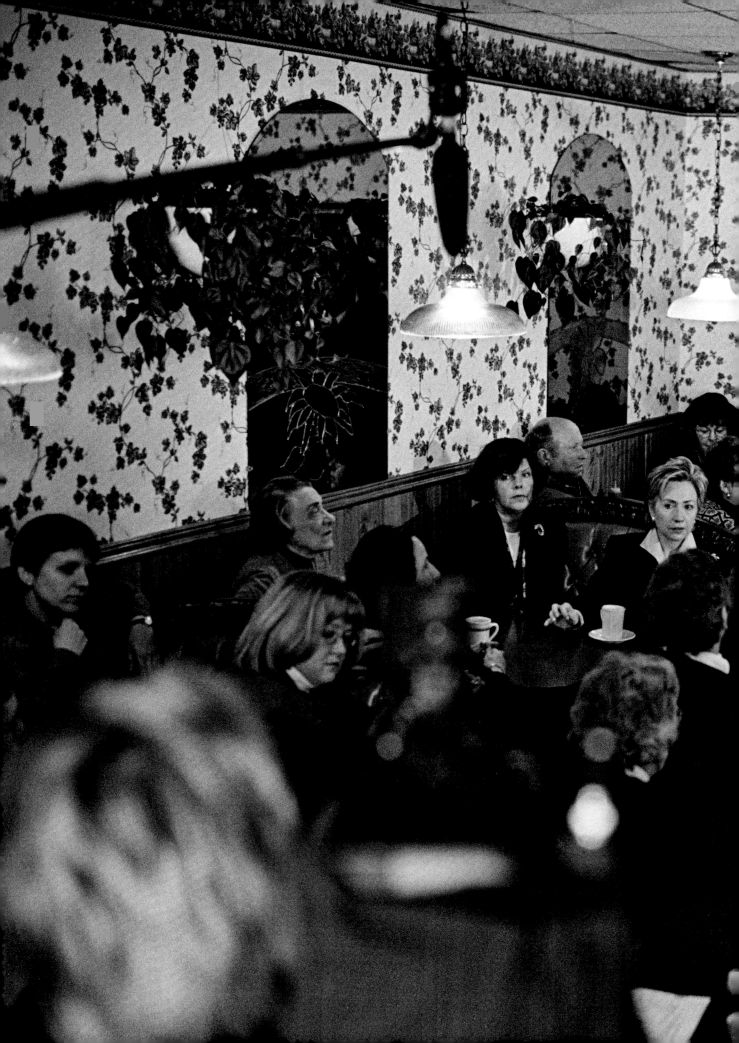

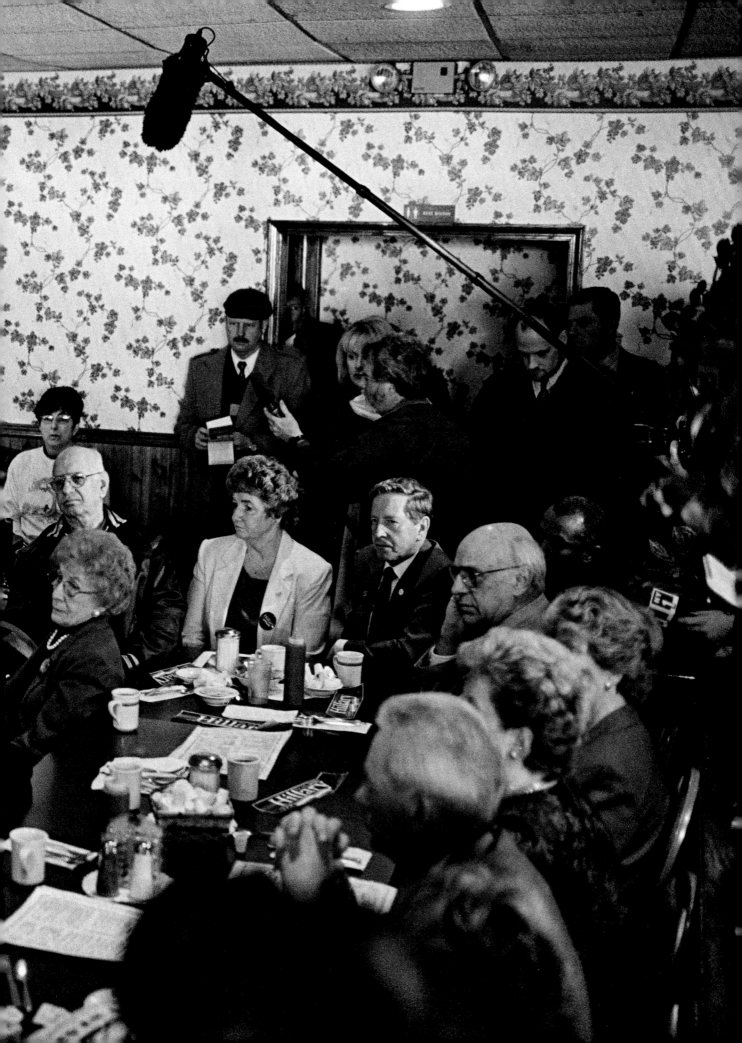

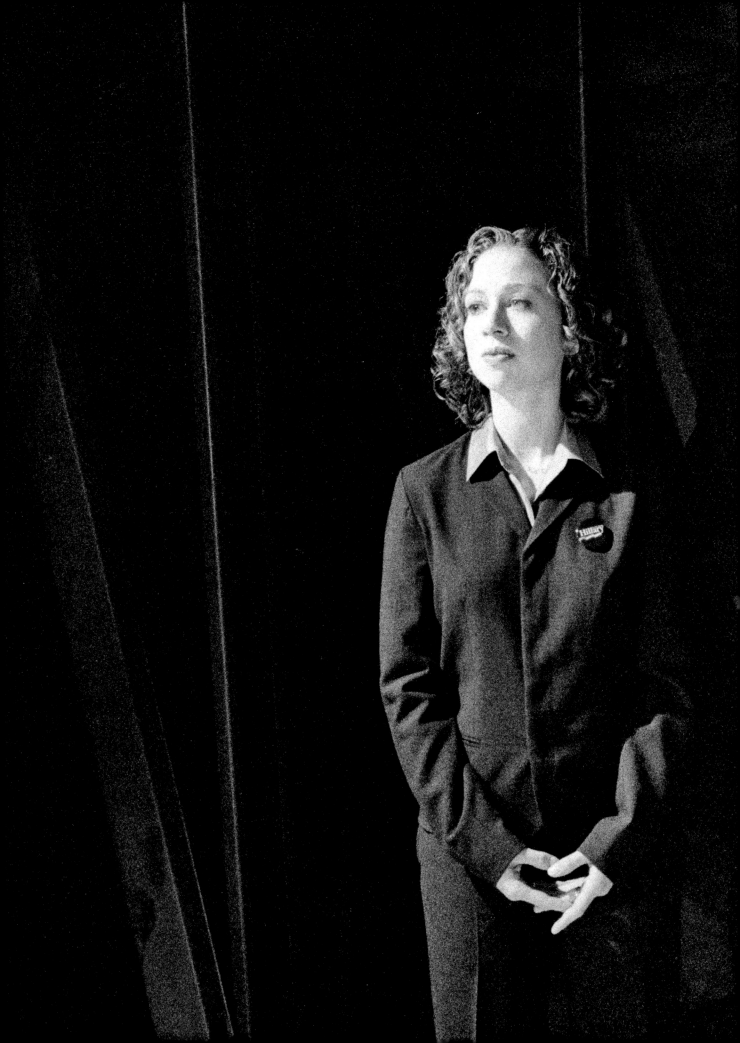

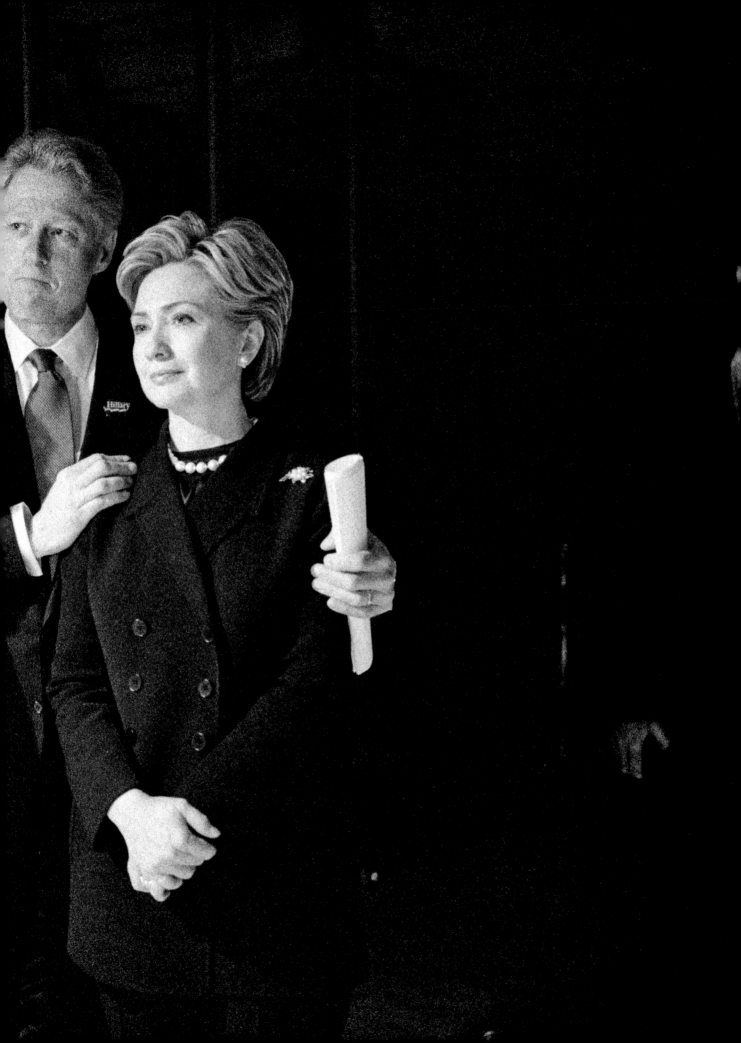

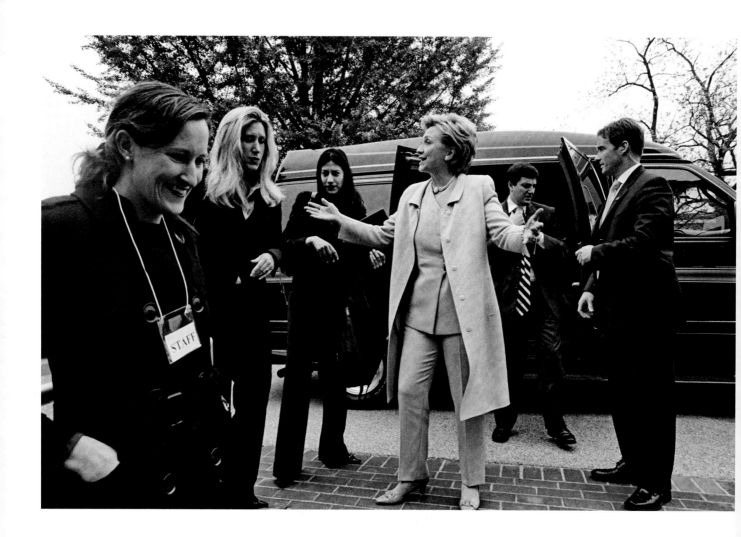

Previous spread: The Clintons stand backstage at the State University of New York
at Purchase watching a biographical film introducing Hillary on the day that she formally
announces her candidacy. — February 6, 2000

Above: Hillary arrives at the C. W. Post campus of Long Island University, where she
will give the commencement address. — May 14, 2006

Opposite: At the Democratic State Convention in Buffalo, New York, the Clintons dip-hug after
Hillary accepts her party's unanimous nomination for a second term. — May 31, 2006

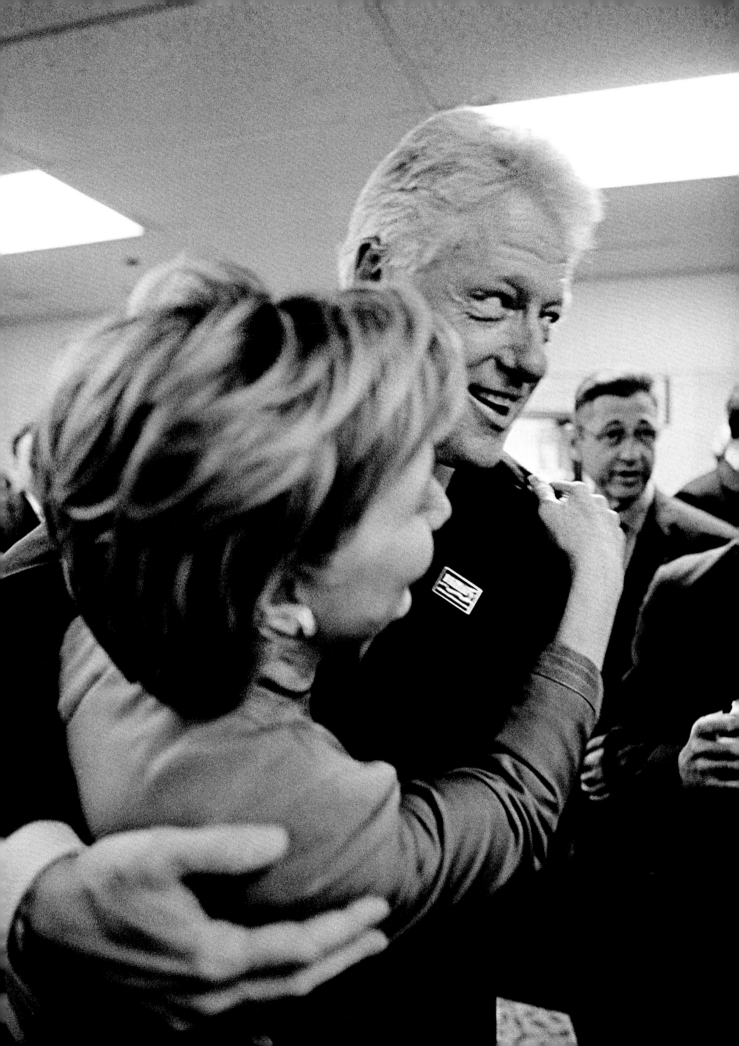

Above: Hillary prepares to give a statement on Capitol Hill. — July 19, 2001

Opposite: Hillary confers with Bill while reviewing her acceptance speech at the Democratic State Convention in Buffalo, New York. — May 31, 2006

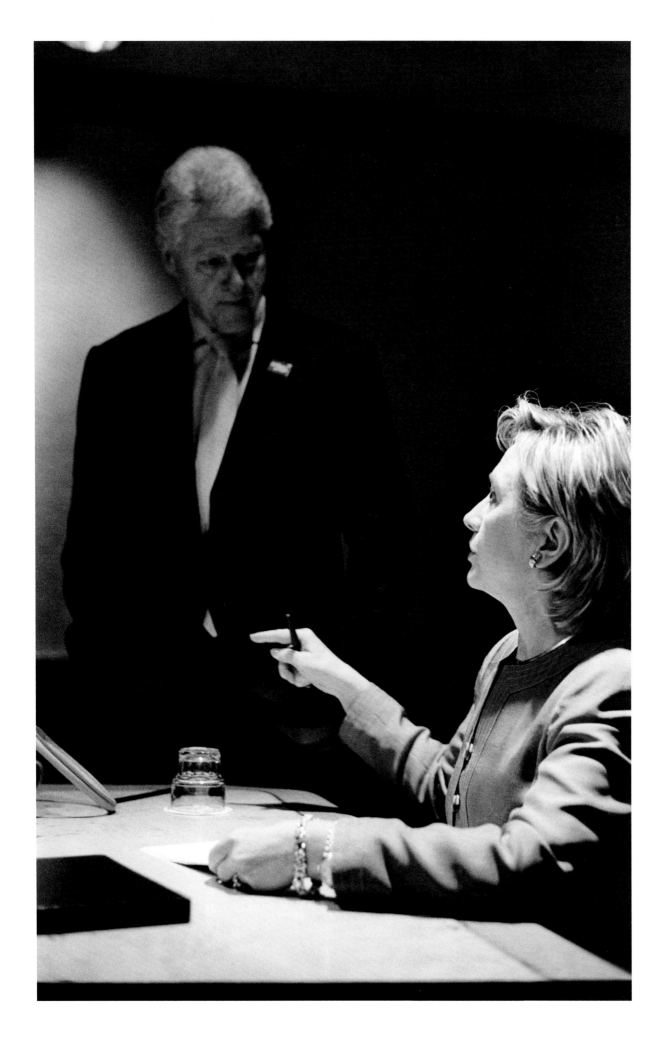

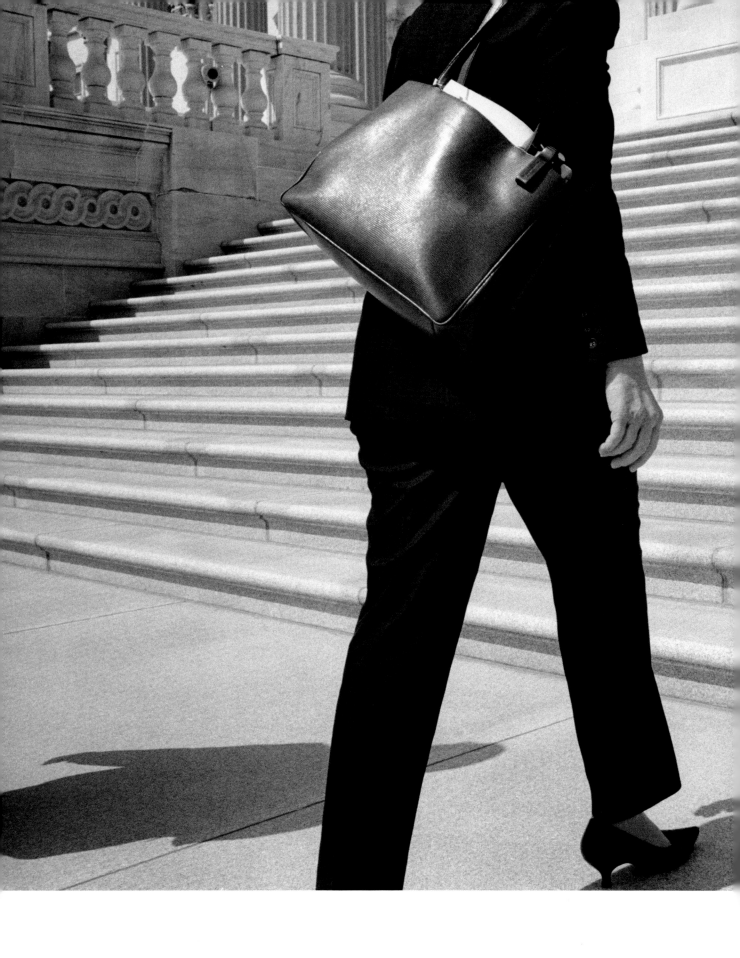

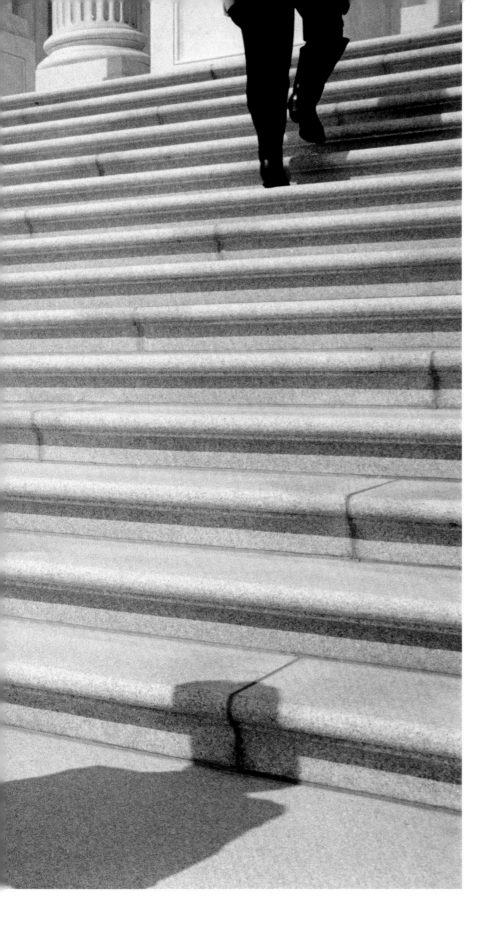

Hillary walks up the
steps of the US Capitol to
meet with Senate leaders.
— May 16, 2006

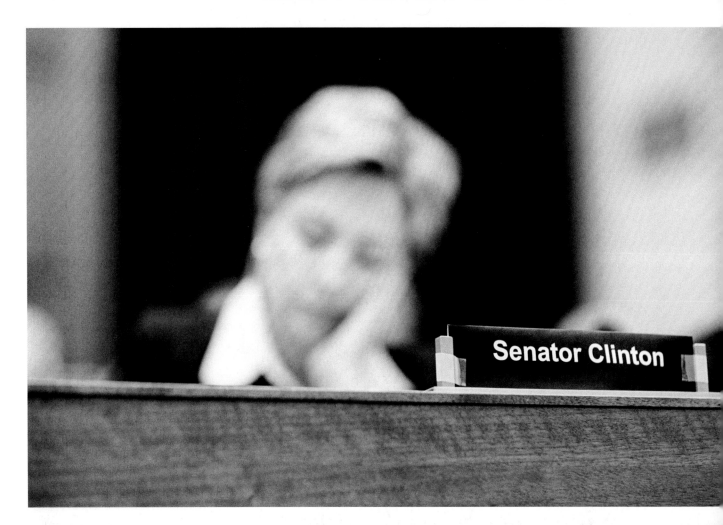
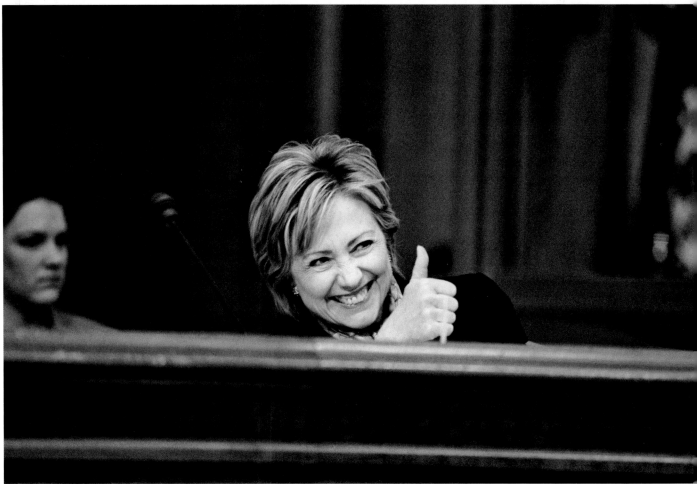

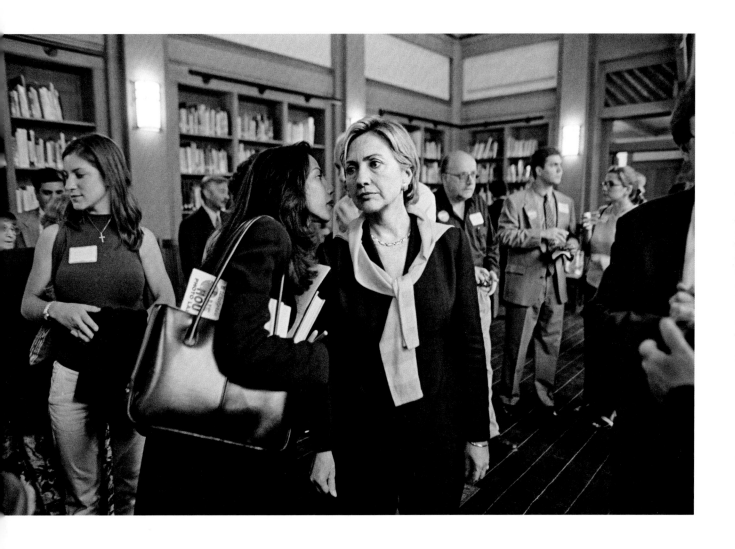

Opposite, top: Hillary attends a House-Senate conference on education in the
Rayburn House Office Building. — July 19, 2001

Opposite, bottom: Hillary gives a thumbs-up during an Armed Services
Committee meeting. — May 16, 2006

Above: Assistant Huma Abedin delivers a message to Hillary while she is attending
a fund-raiser at a library in Jamestown, New York. — July 28, 2001

Following spread: Hillary, on her cell phone, waits in the President's Room of the
US Capitol for a meeting with fellow senators. — July 19, 2001

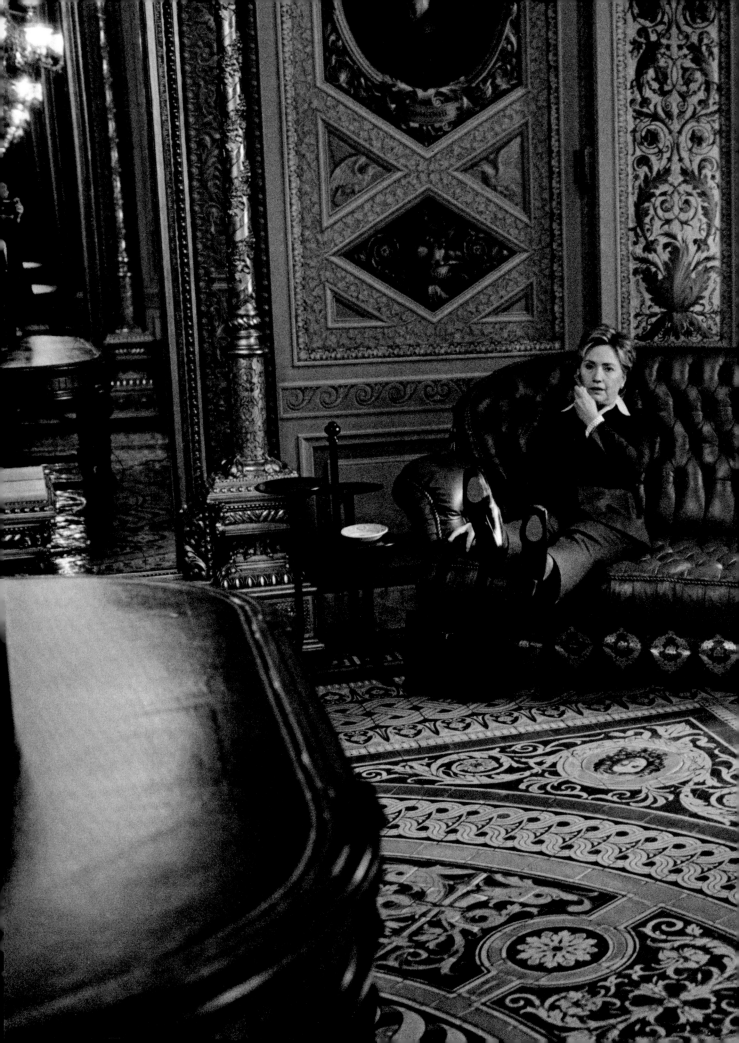

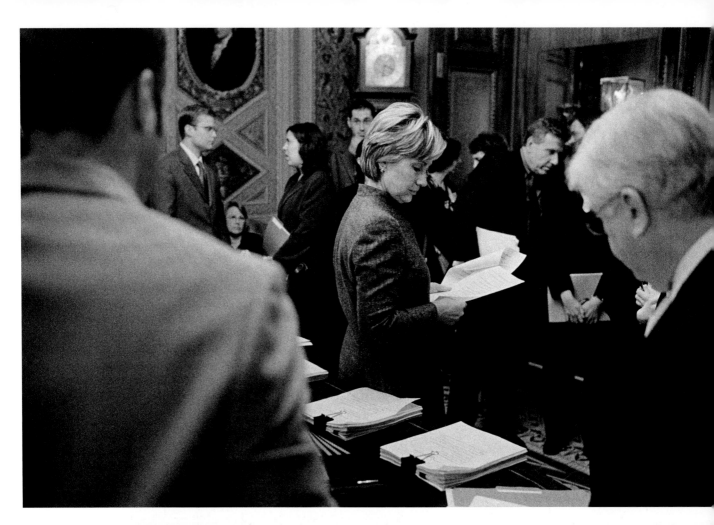
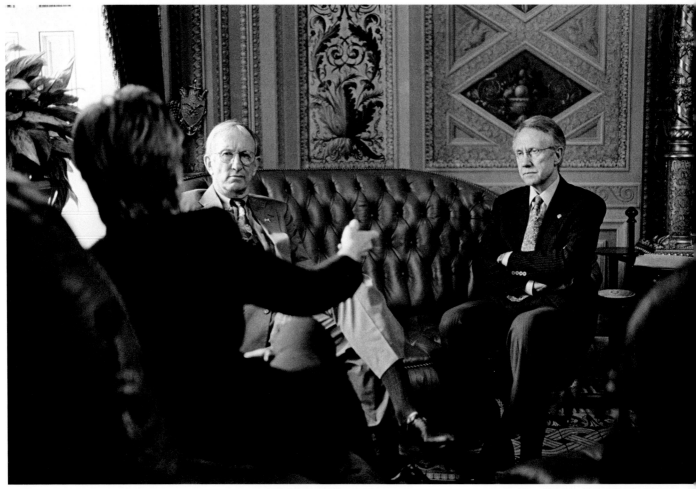

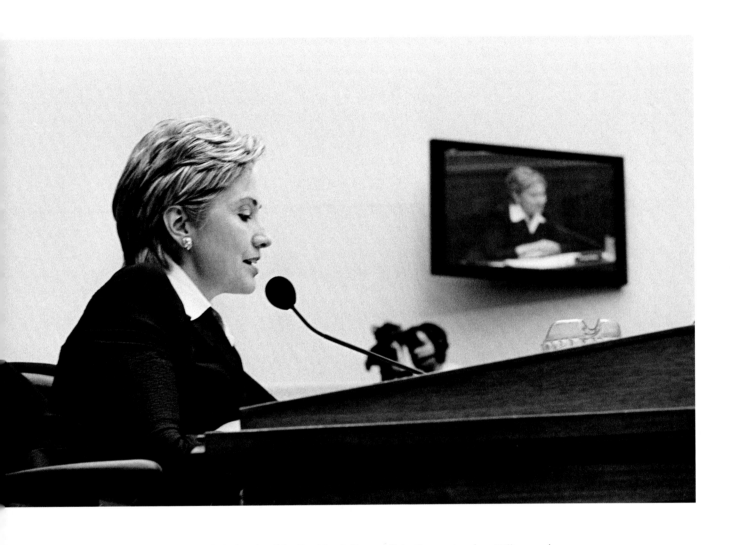

Opposite, top: Amid the bustle of the President's Room off the Senate chamber, Hillary marks up a bill with other members of the Armed Services Committee. — May 17, 2006

Opposite, bottom: Hillary discusses committee work with Senators James M. Jeffords (I-VT), left, and Harry Reid (D-NV), right, fellow members of the Environment and Public Works Committee. — July 19, 2001

Above: Hillary speaks at a House-Senate conference committee on education legislation in the Rayburn House Office Building. — July 19, 2001

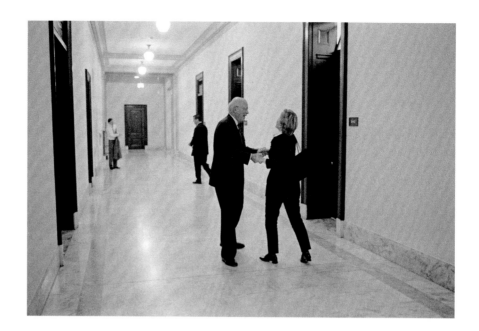

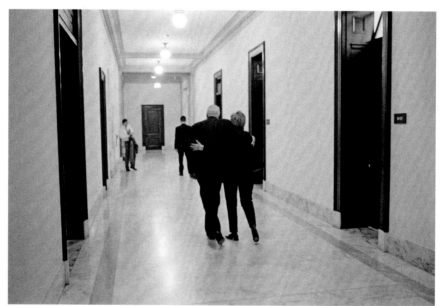

Right: On her way to vote on an appropriations bill, Hillary runs into Senator Patrick Leahy (D-VT). They walk down the hall together before squeezing into the elevator en route to the vote. — July 19, 2001

Far right: Hillary stops to pose for pictures and talk with members of the South Bronx Job Corps on a staircase in the Russell Senate Office Building. — July 19, 2001

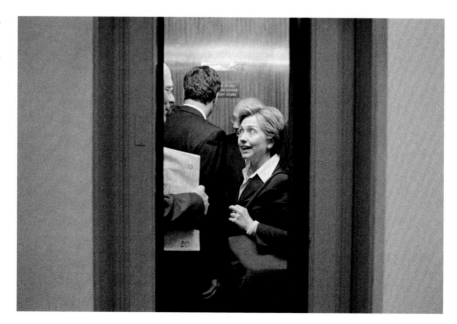

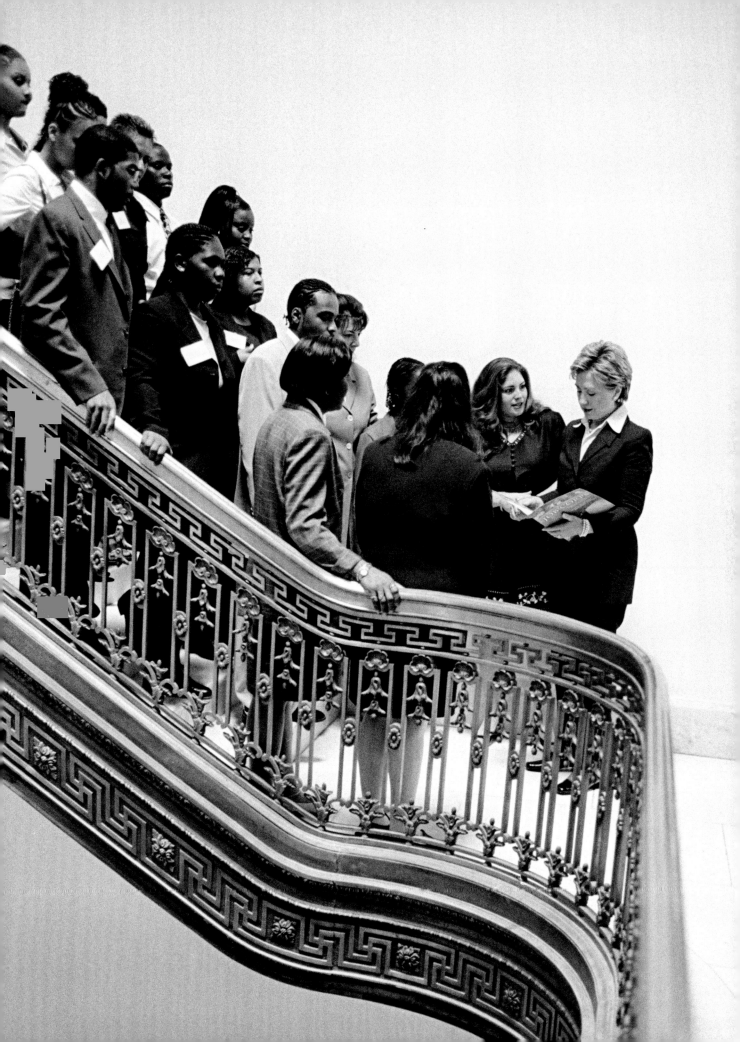

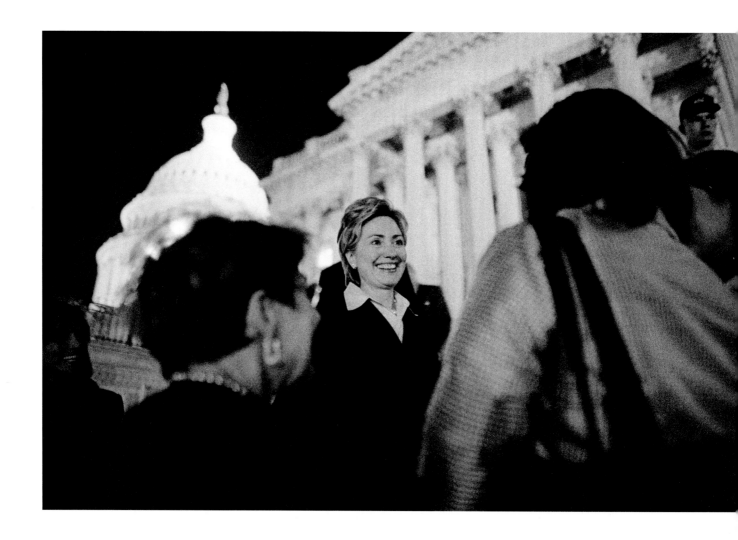

Above: After a long day, Hillary leaves the Senate at 11:00 p.m. and greets a
few fans as she walks to her car. — July 19, 2001

Opposite: Hillary discusses new legislation expanding the Children's Health Insurance Program
at a press availability at a museum in Horseheads, New York. — July 28, 2001

Following spread: In her office in the Russell Senate Office Building, Hillary has an early morning
meeting with staff members, including, from left to right,
Gabrielle Tenzer, Jim Kennedy, Karen Dunn, and Christina Ho. — July 19, 2001

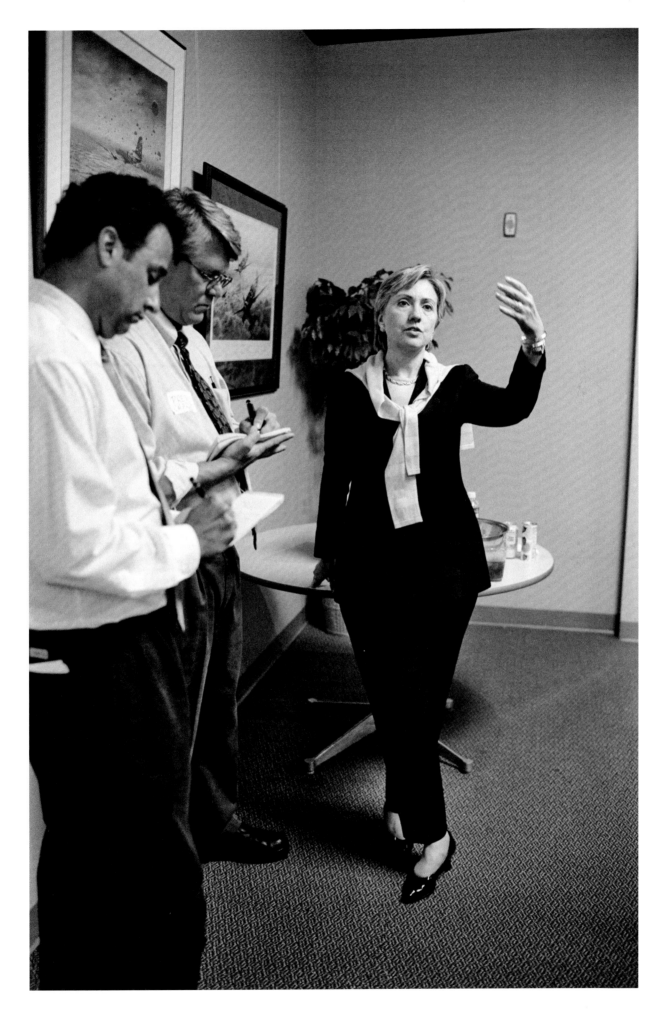

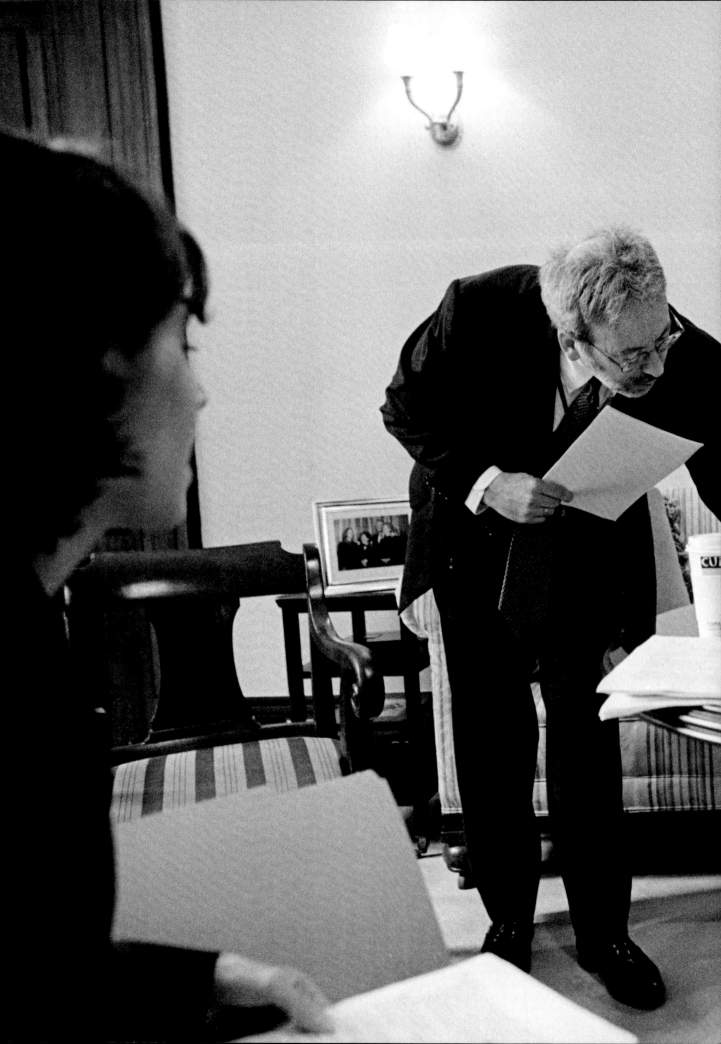

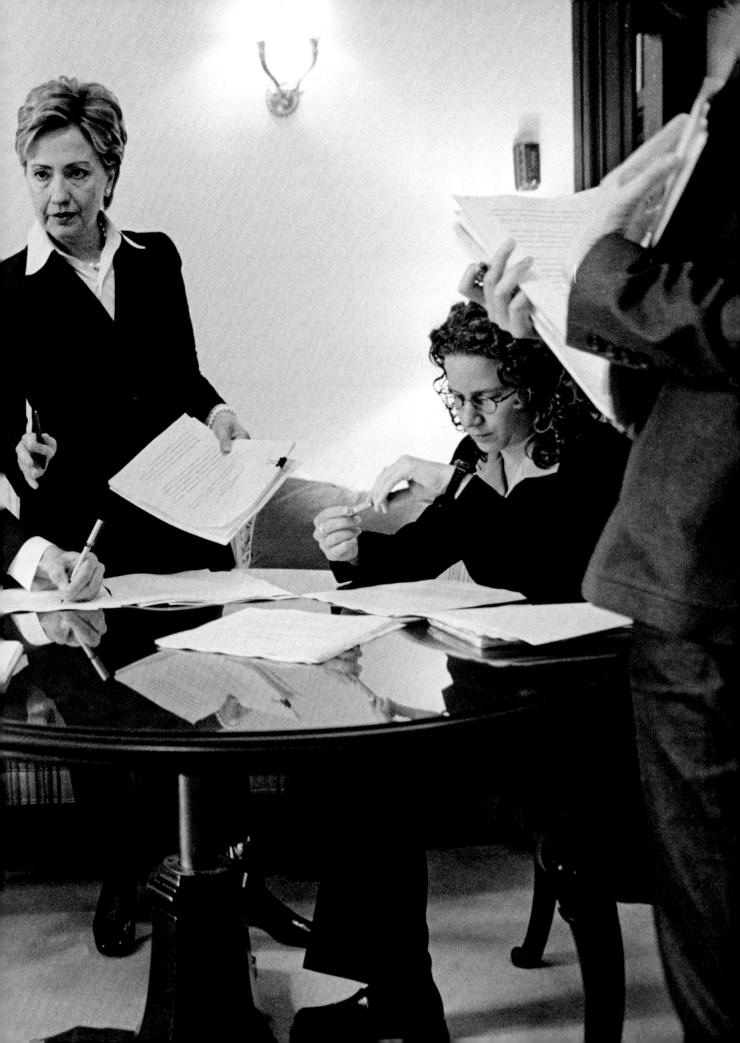

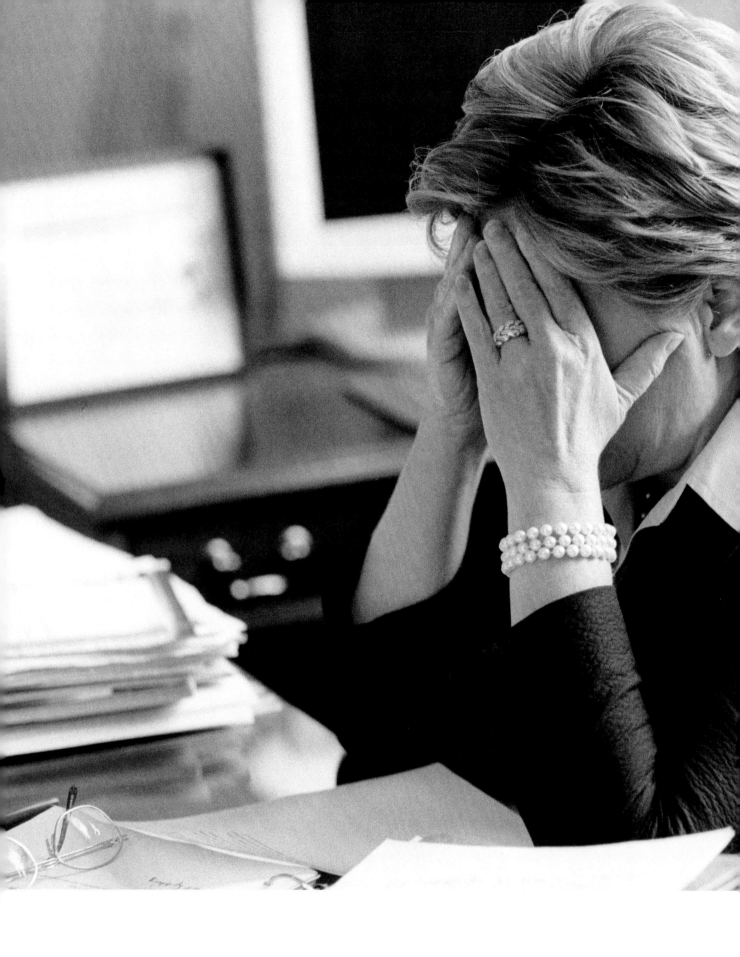

Left: Hillary works
late at her Senate office desk.
— July 19, 2001

Following spread: Late in the
evening, Hillary packs
up her papers to go home.
— July 19, 2001

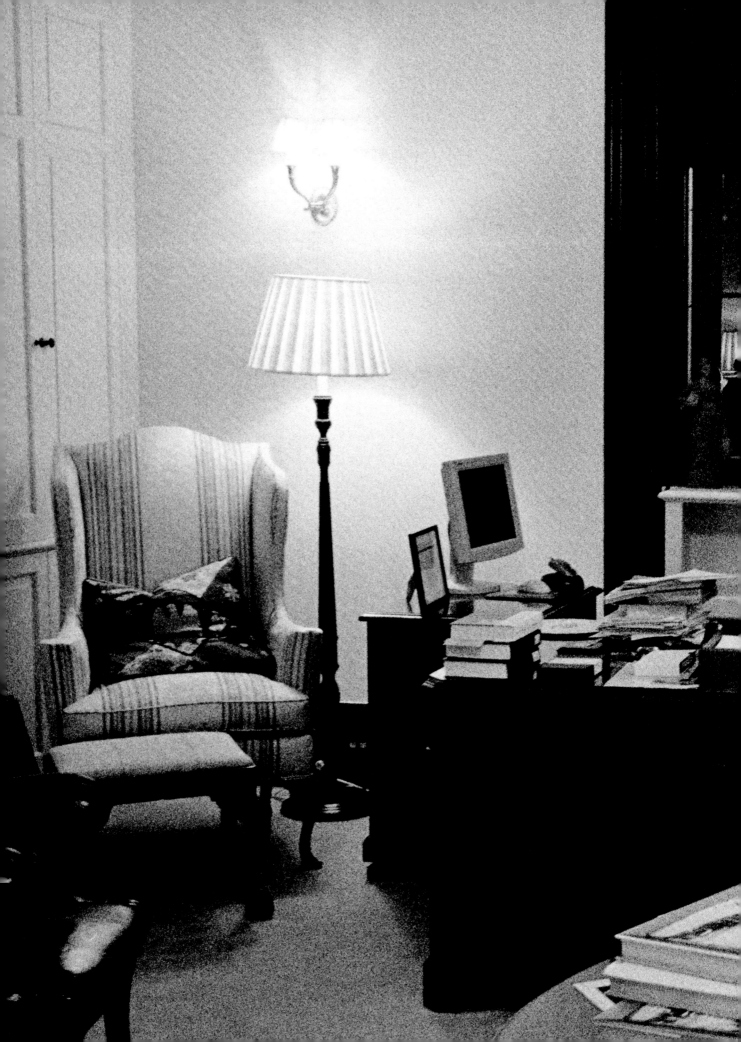

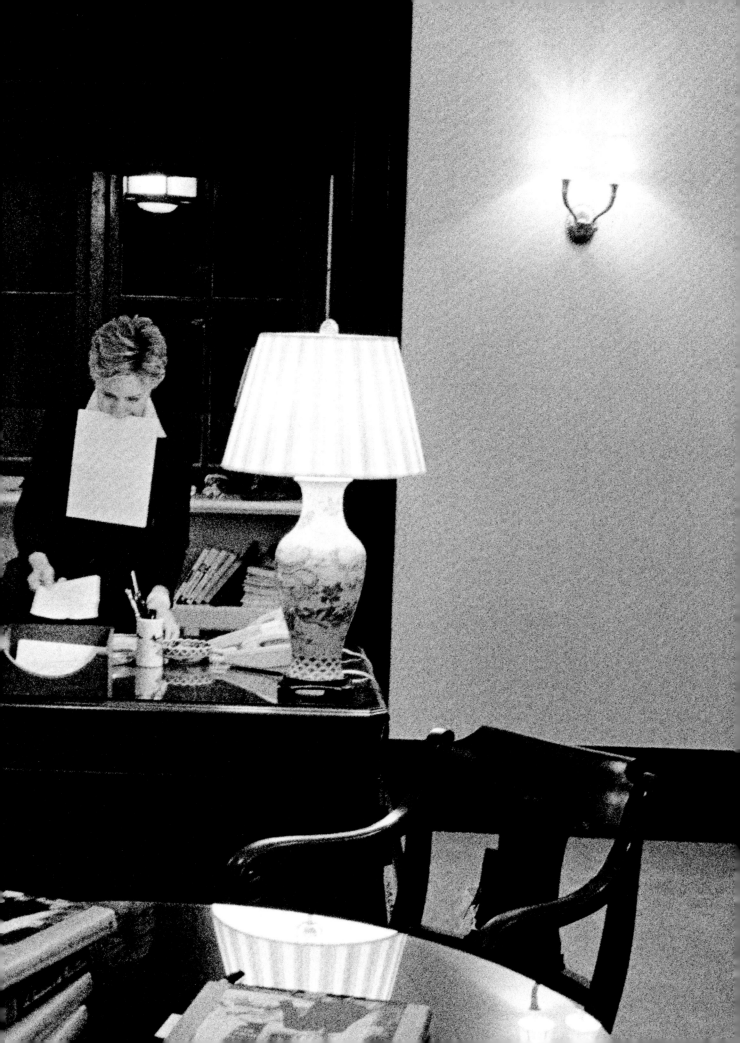

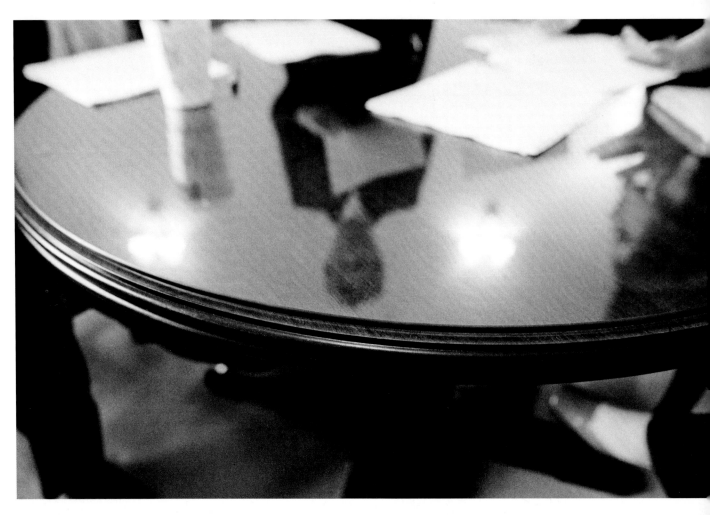

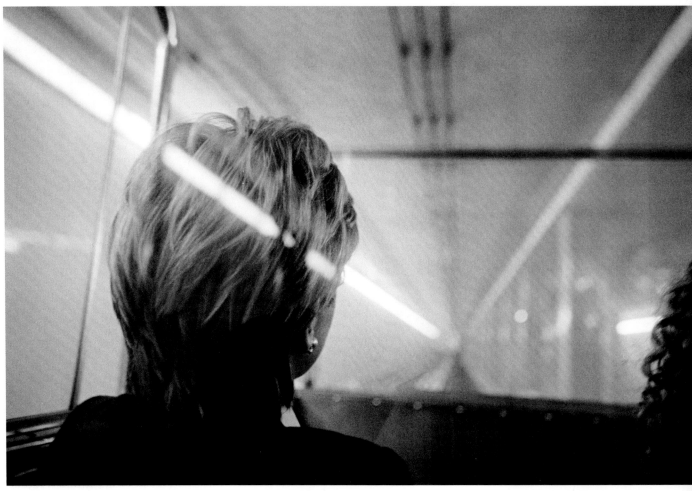

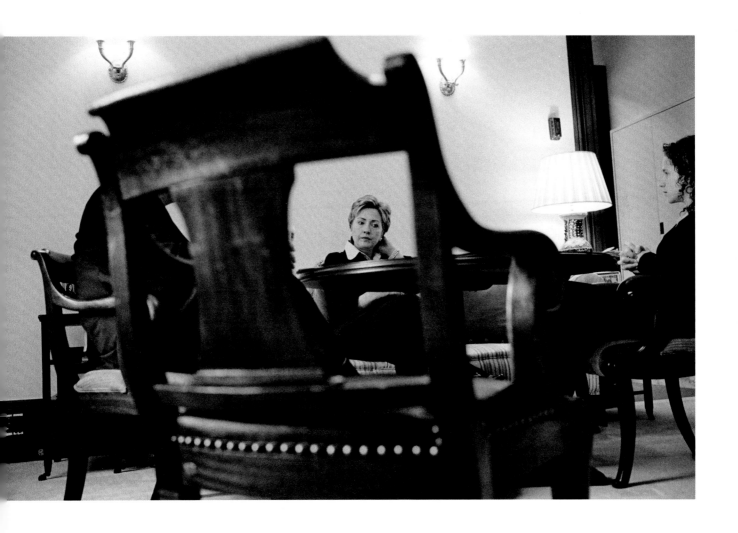

Opposite, top: Hillary is reflected in her office table. — July 19, 2001

Opposite, bottom: Hillary rides the Senate subway back to her office. — July 19, 2001

Above: Hillary chats with aides during a morning meeting in the
Russell Senate Office Building. — July 19, 2001

Hillary and her deputy communications director, Sarah Gegenheimer, walk between the Capitol and the Russell Senate Office Building. — May 16, 2006

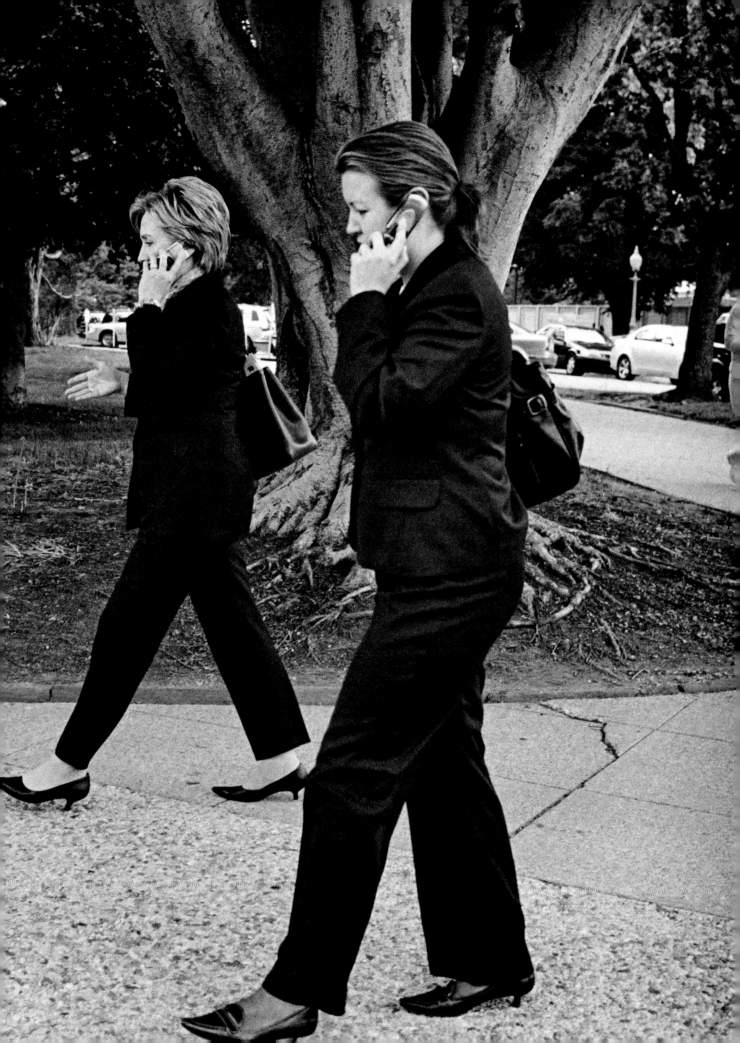

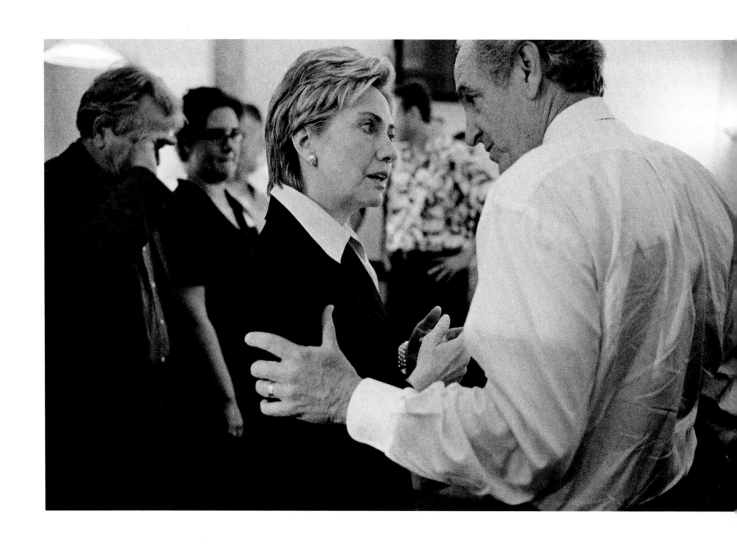

Above and opposite: Senator Tom Harkin (D-IA) chats with Hillary at a dinner
for 21st Century Democrats. At the dinner, Hillary talks
across the table with Richard E. Myers, then minority leader of Iowa's
House of Representatives. — July 19, 2001

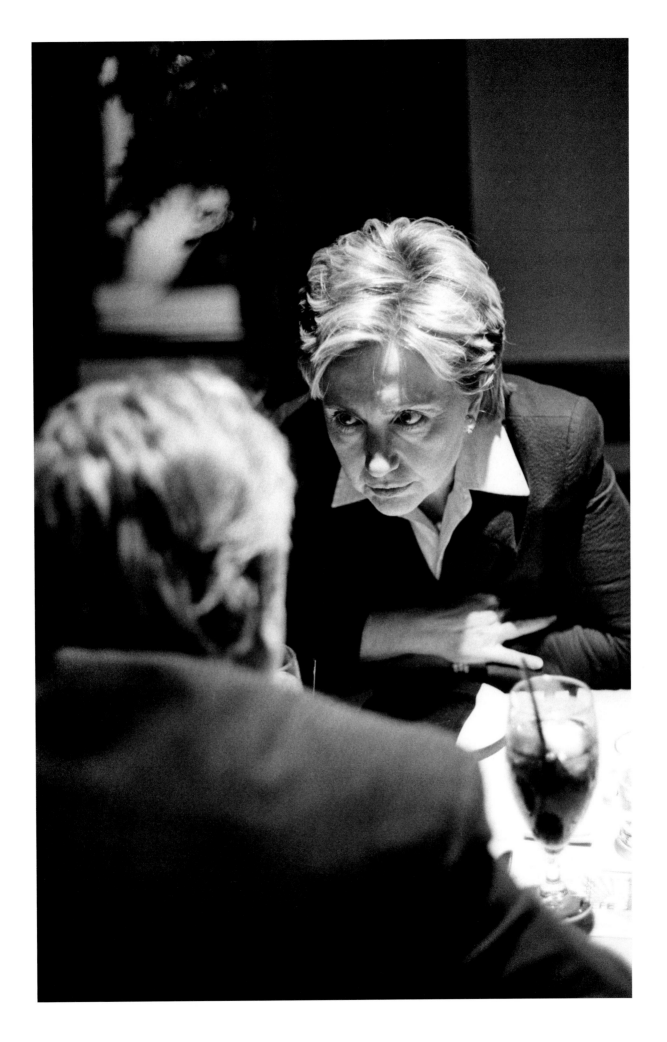

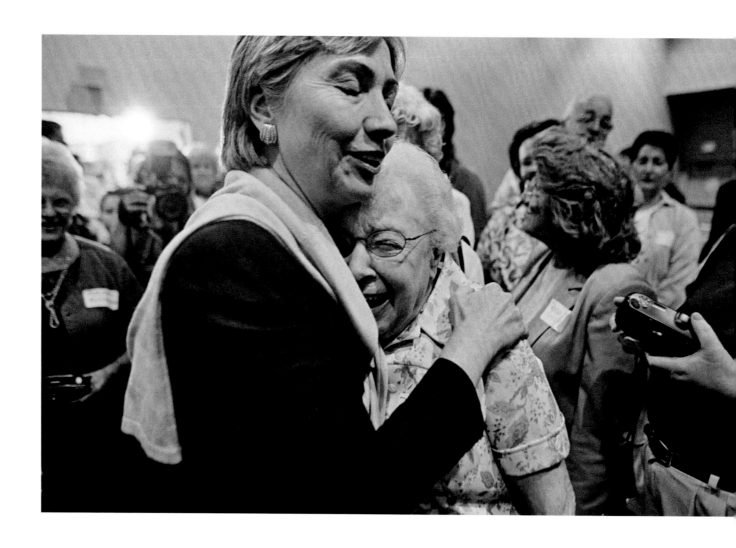

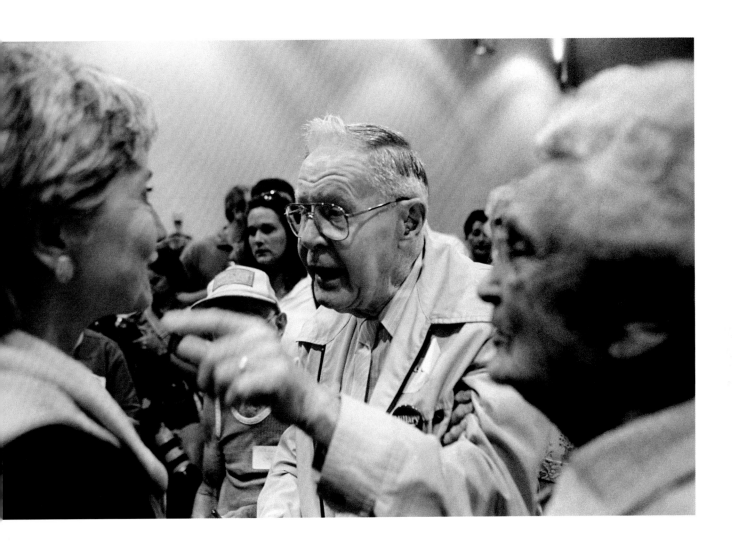

Opposite and above: After she speaks at a community forum in Horseheads, New York,
Hillary consoles and is confronted by constituents. — July 28, 2001

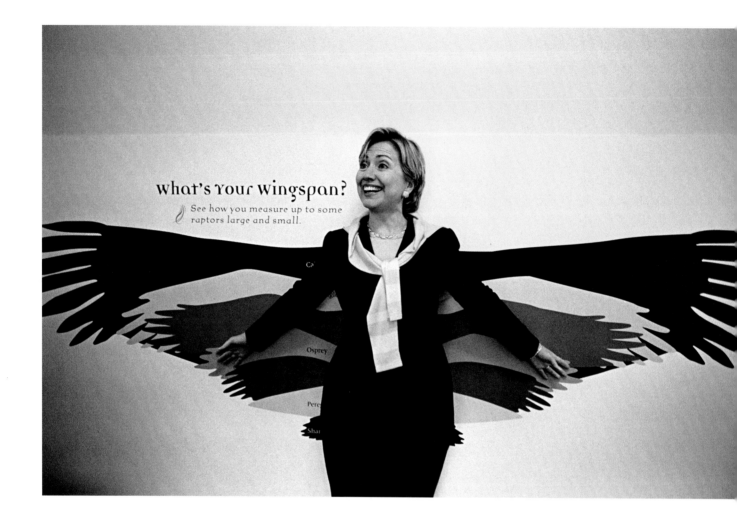

Above: Hillary checks her "wingspan" against a chart at the Roger Tory Peterson Institute of Natural History in Jamestown, New York. — July 28, 2001

Opposite: In Buffalo, New York, Hillary and Sister Mary Johnice, a Felician Franciscan nun and founder and director of the Response to Love Center, prepare to kick off a project to computerize health-care records for the poor. — June 2, 2006

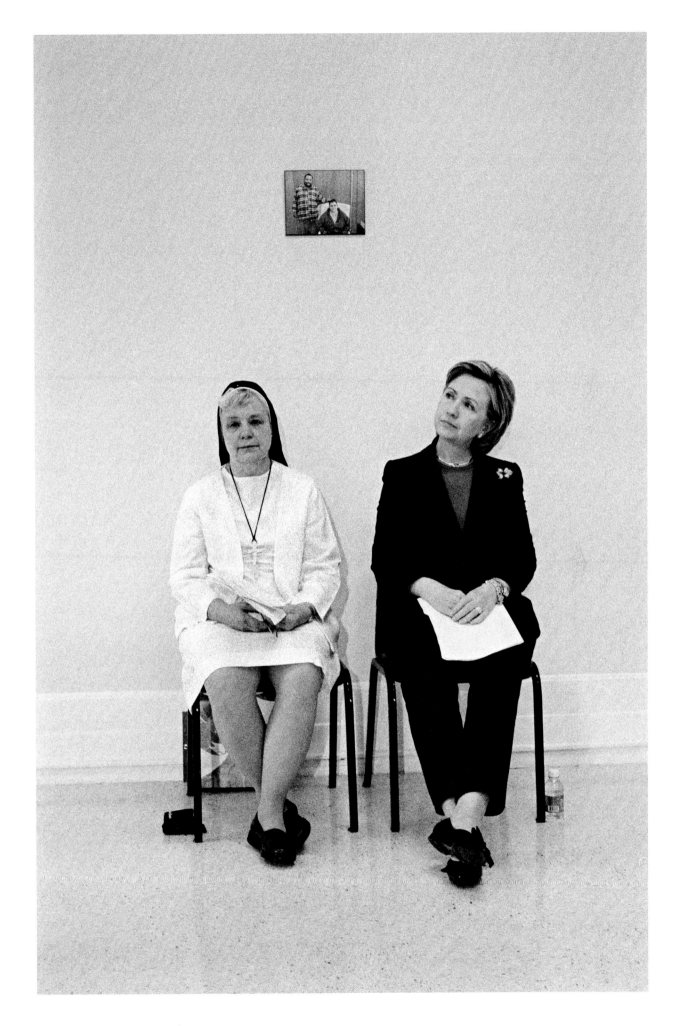

At 9:30 p.m., after a round of appearances in upstate New York, Hillary finds herself on a chilly airplane flying home, near the end of another typically long day. — July 28, 2001

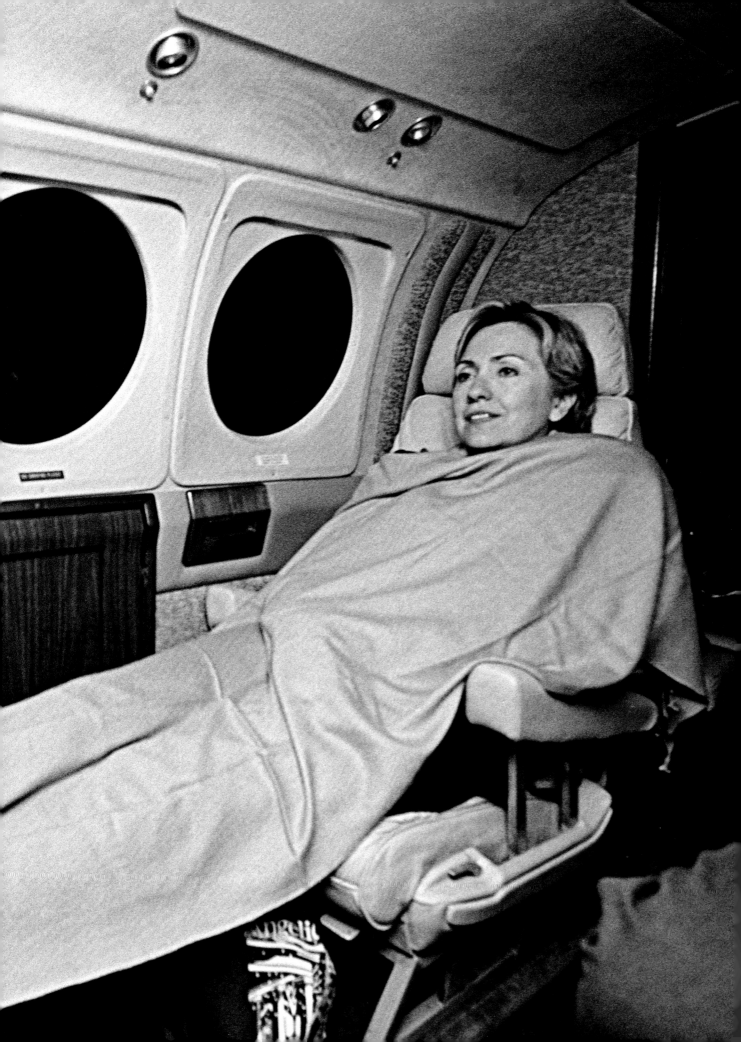

Opposite: At the end
of a fifteen-hour day spent
meeting constituents
around New York, Hillary
lands at Westchester
County Airport and
waits for a car to take
her home to Chappaqua.
— July 28, 2001

Following spread: Back
in the capital, Hillary
returns to her northwest
Washington home.
— July 19, 2001

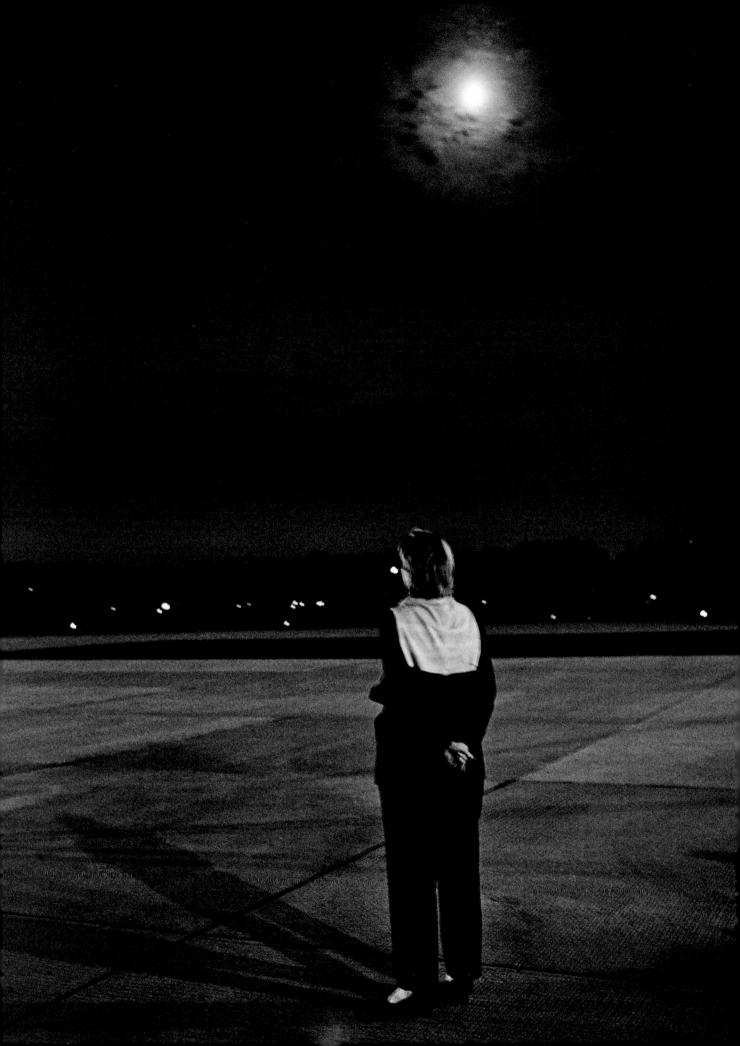

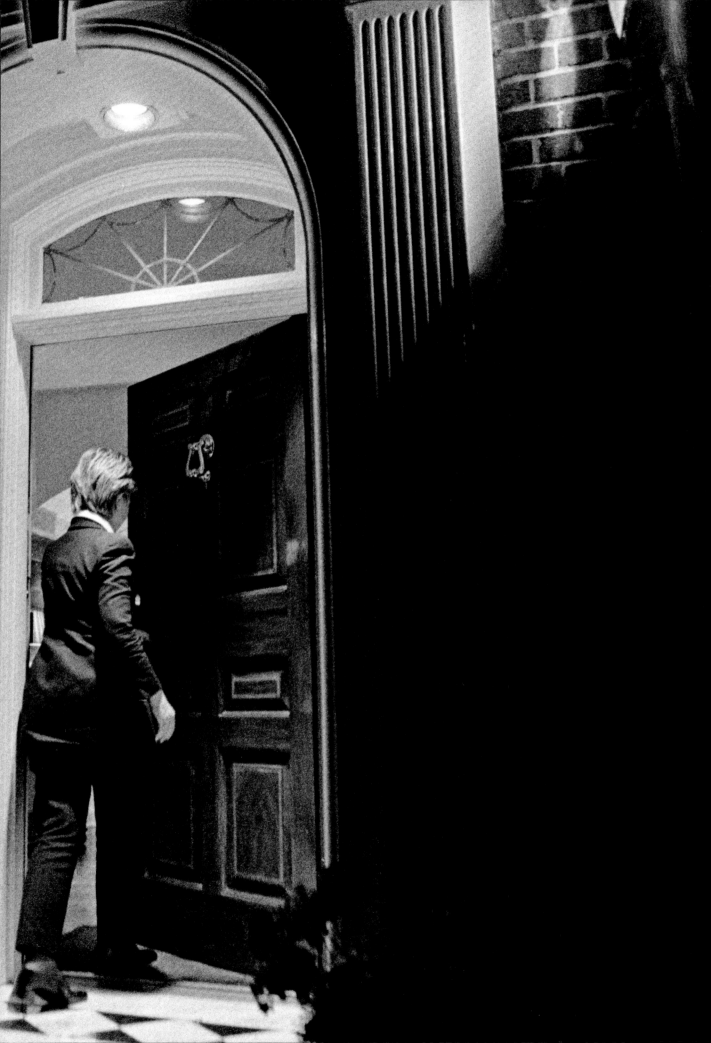

PRESIDENTIAL CAMPAIGN 2008

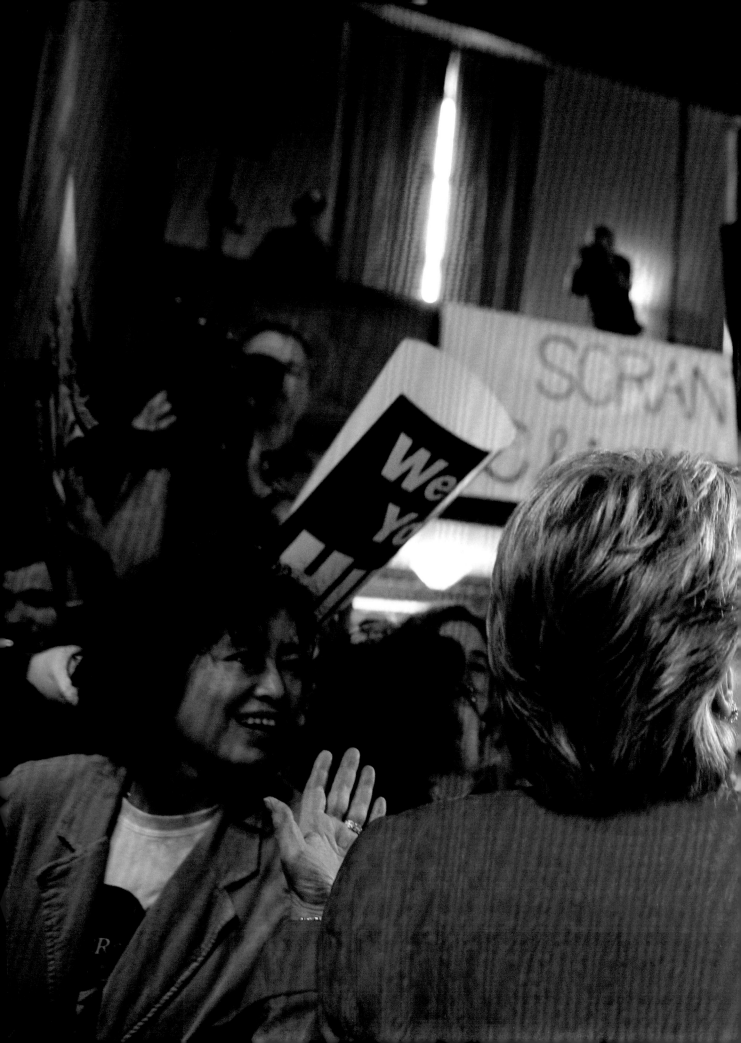

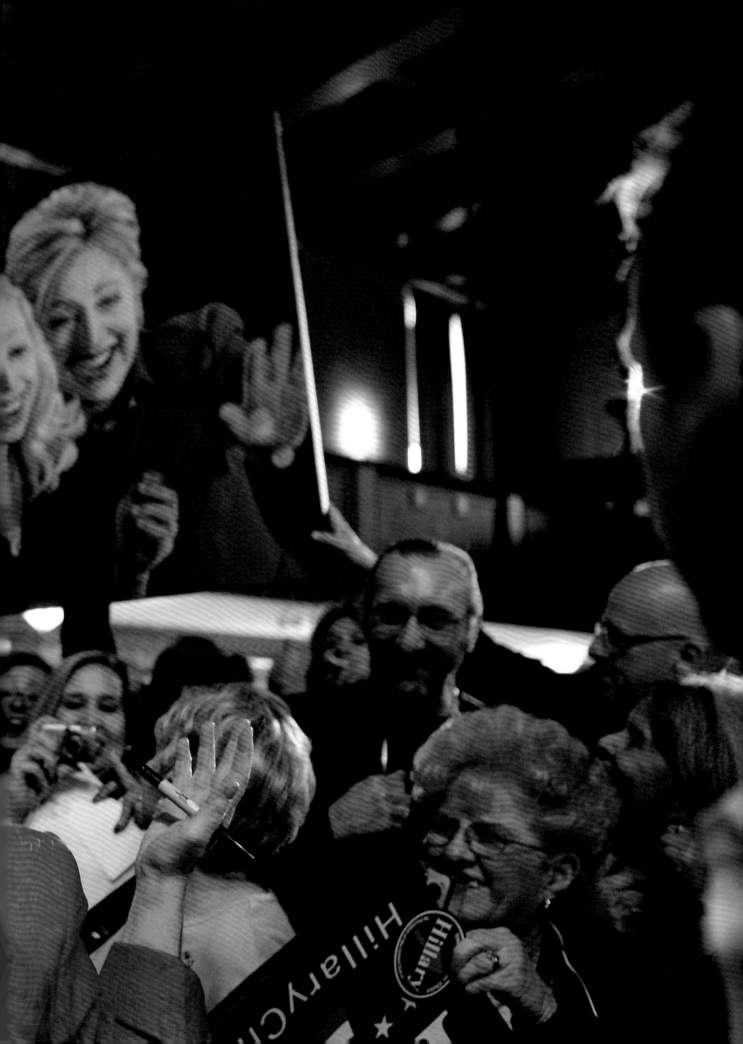

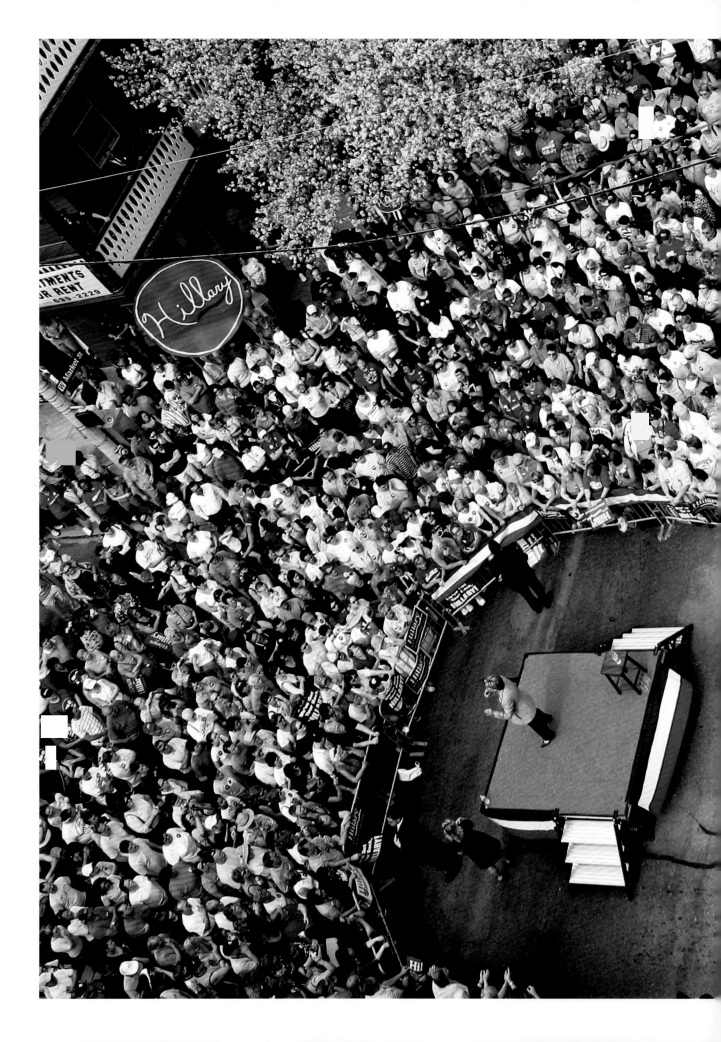

Pages 132–133:
Hillary draws more than
two thousand supporters at a
standing-room-only fund-
raiser at the Orpheum Theatre
in San Francisco.
— February 1, 2008

Previous spread: In
Scranton, Pennsylvania,
Hillary is surprised
to see a poster of a photo
of her and Chelsea taken
moments before.
— April 21, 2008

Left: After Governor Ed
Rendell and actor/director
Rob Reiner introduce
her, Hillary speaks at a rally
in York, Pennsylvania,
just three days before the
Pennsylvania primary.
— April 19, 2008

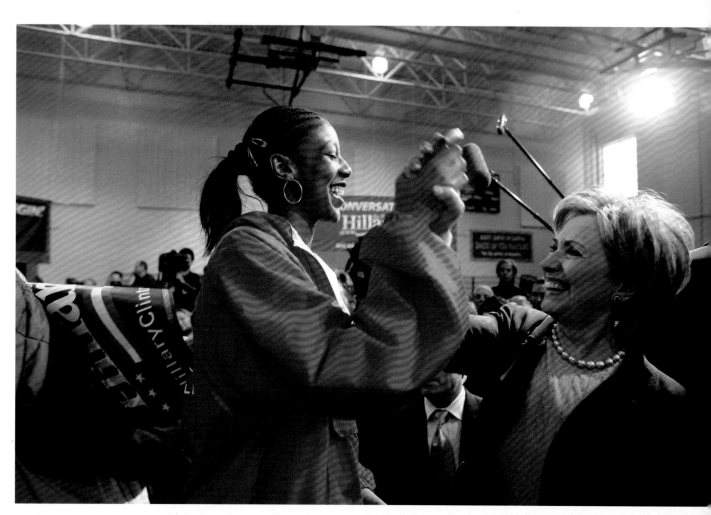

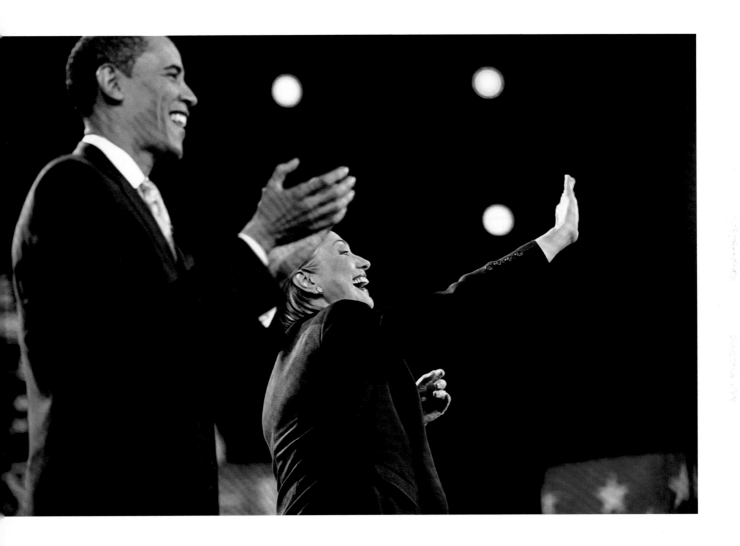

Opposite, top: Hillary launches a three-day tour of Iowa days after announcing she has formed an exploratory committee to run for president. — January 27, 2007

Opposite, bottom: Hillary thanks supporters at the party in Philadelphia following her Pennsylvania primary win. — April 22, 2008

Above: An audience of 2,400 in Los Angeles hears Hillary and Barack Obama in their first one-on-one debate of the race. — January 31, 2008

Above: Hillary greets a future voter after a roundtable discussion at the Yale Child Study Center in New Haven, Connecticut. — February 4, 2008

Opposite, top: More than five thousand supporters come to hear Hillary at the Solutions for America rally at California State University, Los Angeles. — February 2, 2008

Opposite, bottom: Hillary enters a Super Bowl party at a bar and grill in St. Paul, Minnesota, where she watches the New York Giants win the game. — February 3, 2008

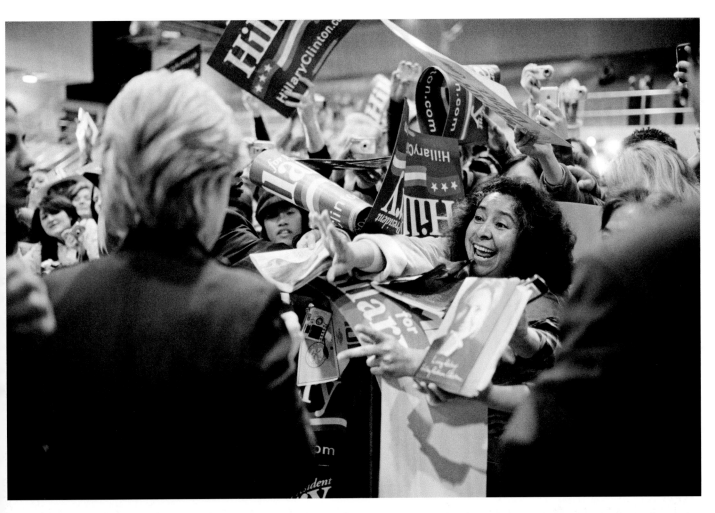

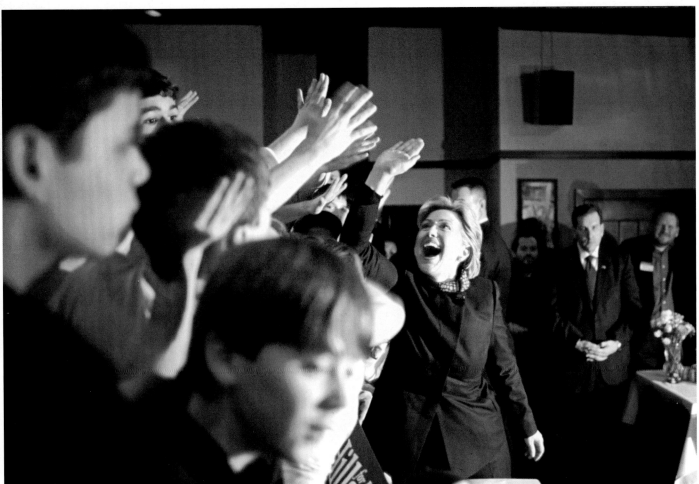

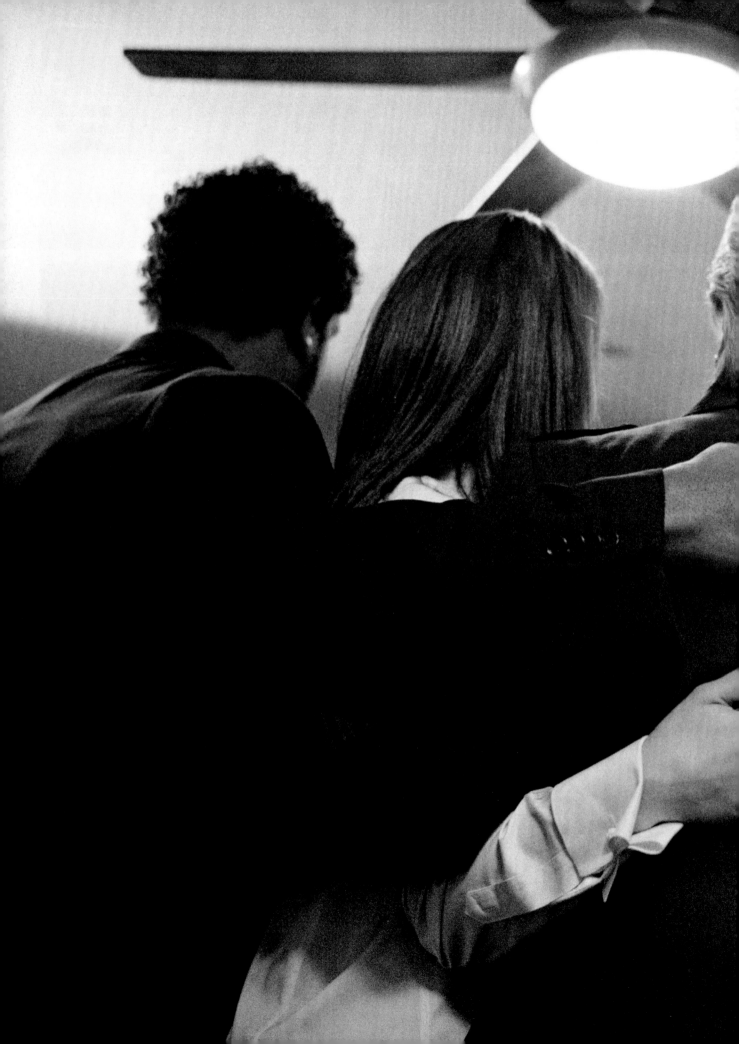

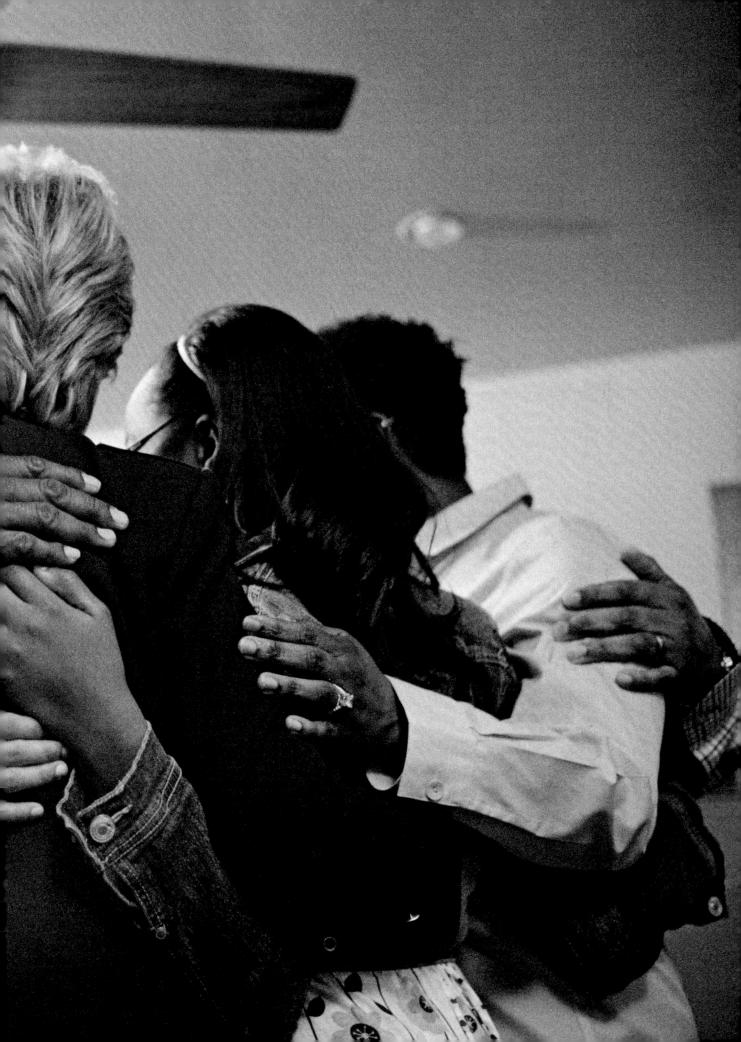

Previous spread: Hillary poses for pictures at a get-together at a private home in Inglewood, California.
— February 2, 2008

Opposite: Hillary gathers her thoughts moments before her introduction at Nueva Esperanza Academy Charter High School in Philadelphia.
— April 18, 2008

Following spread: After an event in Harrisburg, Pennsylvania, Hillary prepares for television interviews.
— April 21, 2009

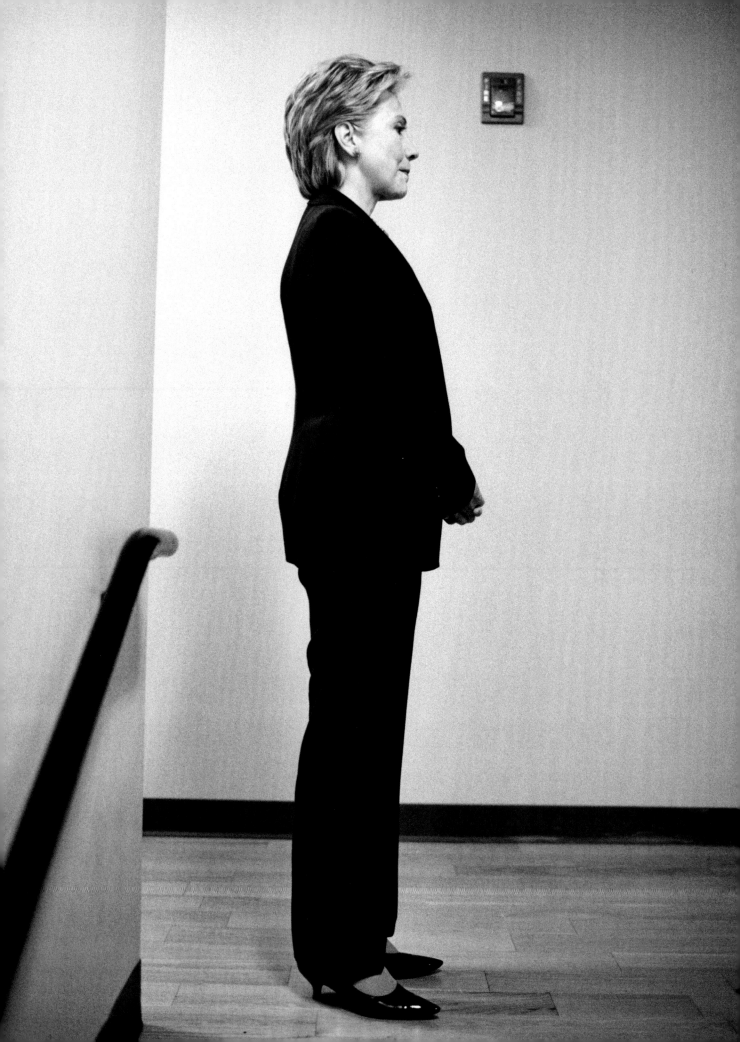

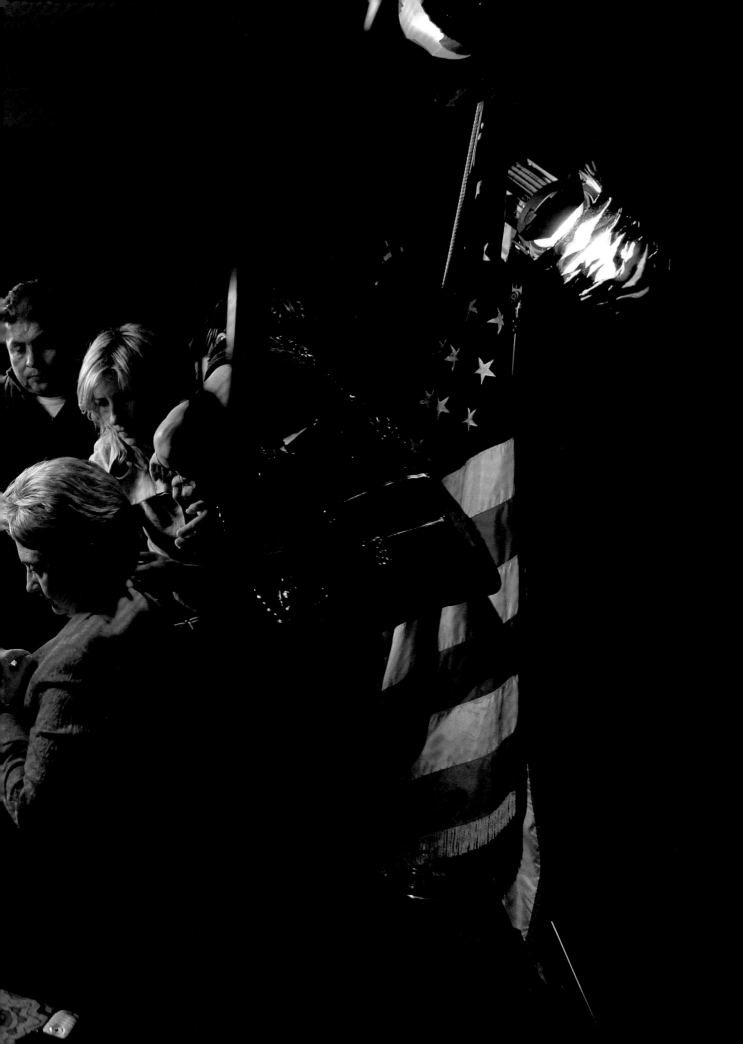

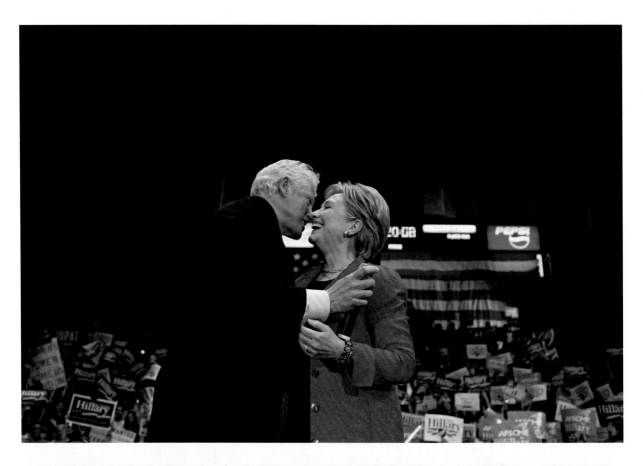

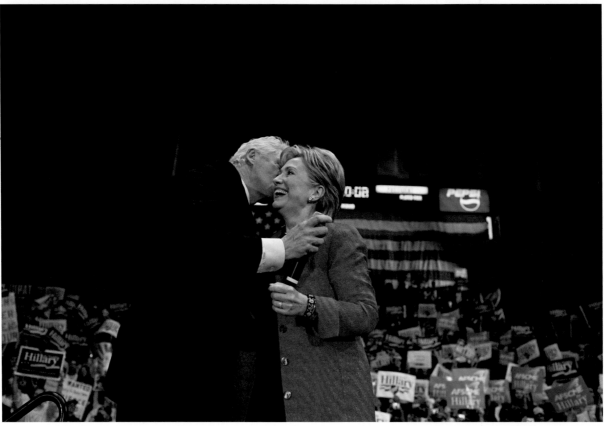

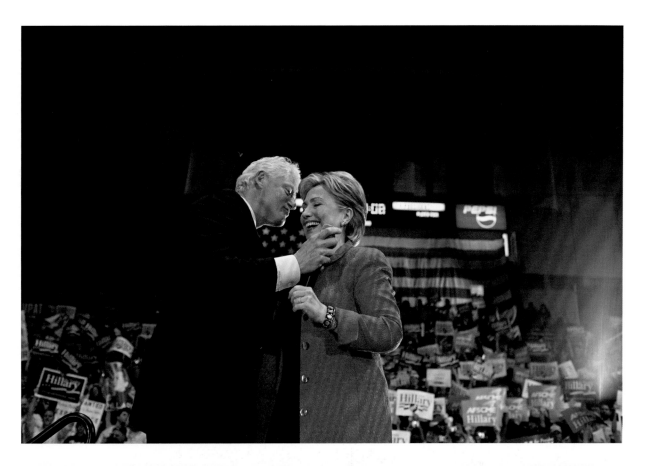

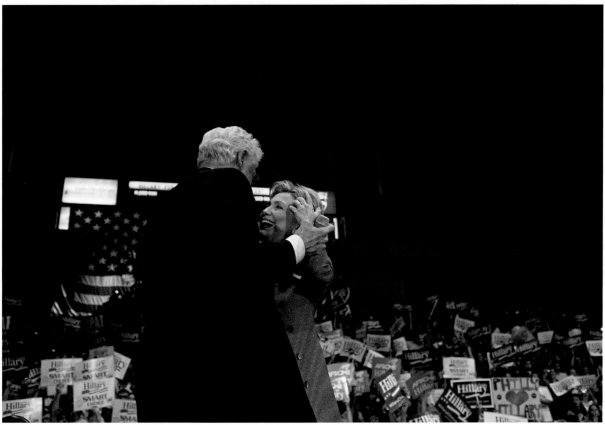

As six weeks of intense campaigning before the Pennsylvania primary draw to a close, cheerleader-in-chief President Clinton introduces Hillary at a rally at the University of Pennsylvania in Philadelphia. — April 21, 2008

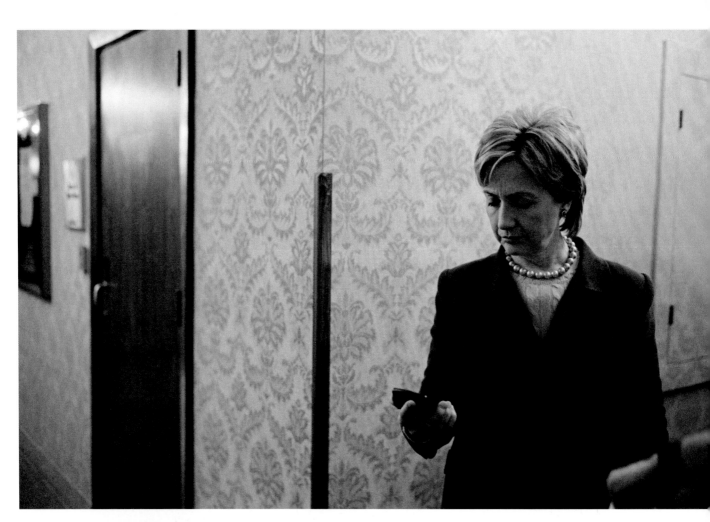

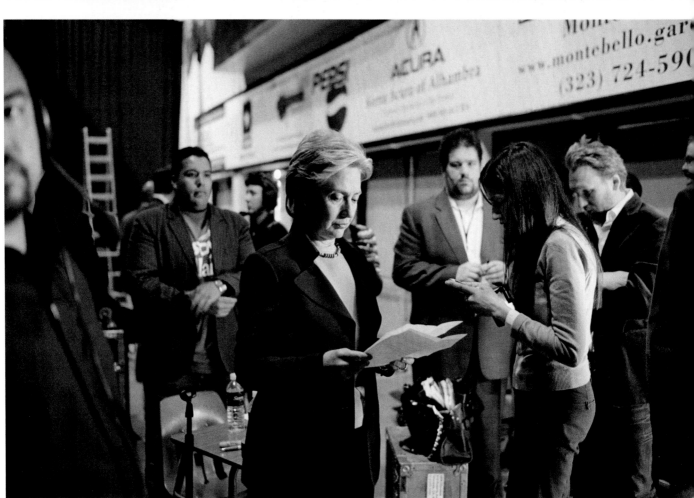

Opposite, top: Hillary checks her messages just before meeting with labor leaders at the Fort Des Moines Hotel on a three-day trip to Iowa. — January 27, 2007

Opposite, bottom: A final moment of preparation as Hillary waits in the wings at a celebrity-studded rally at California State University, Los Angeles. — February 2, 2008

Above: Hillary enters a press conference following a town hall meeting at the University of Pittsburgh's Greensburg campus. — March 25, 2008

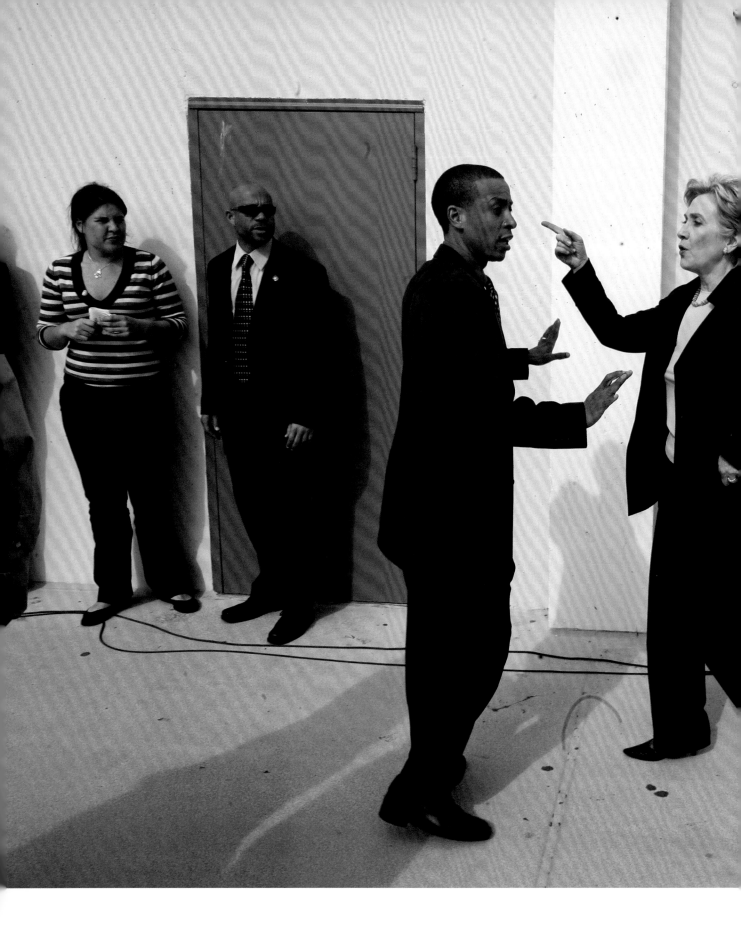

Left: Hillary looks
for the entrance to a rally
at California State
University, Los Angeles.
— February 2, 2008

Following spread: Hillary
arrives with staff and security
at a labor-union hall in
greater St. Louis, Missouri.
— February 3, 2008

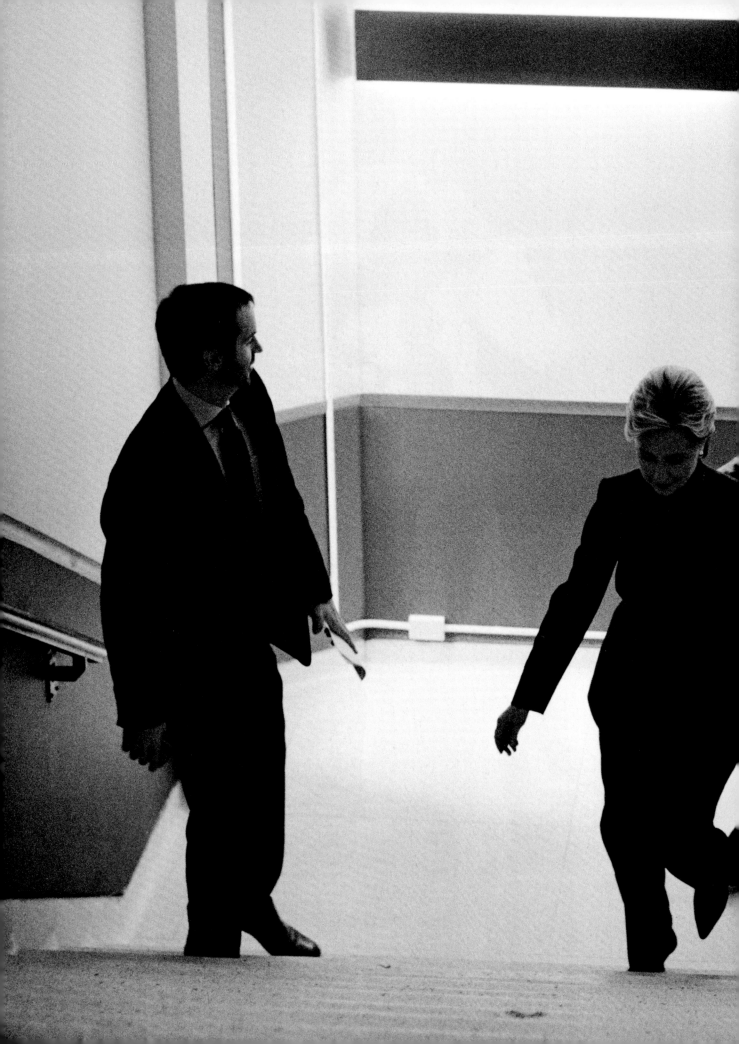

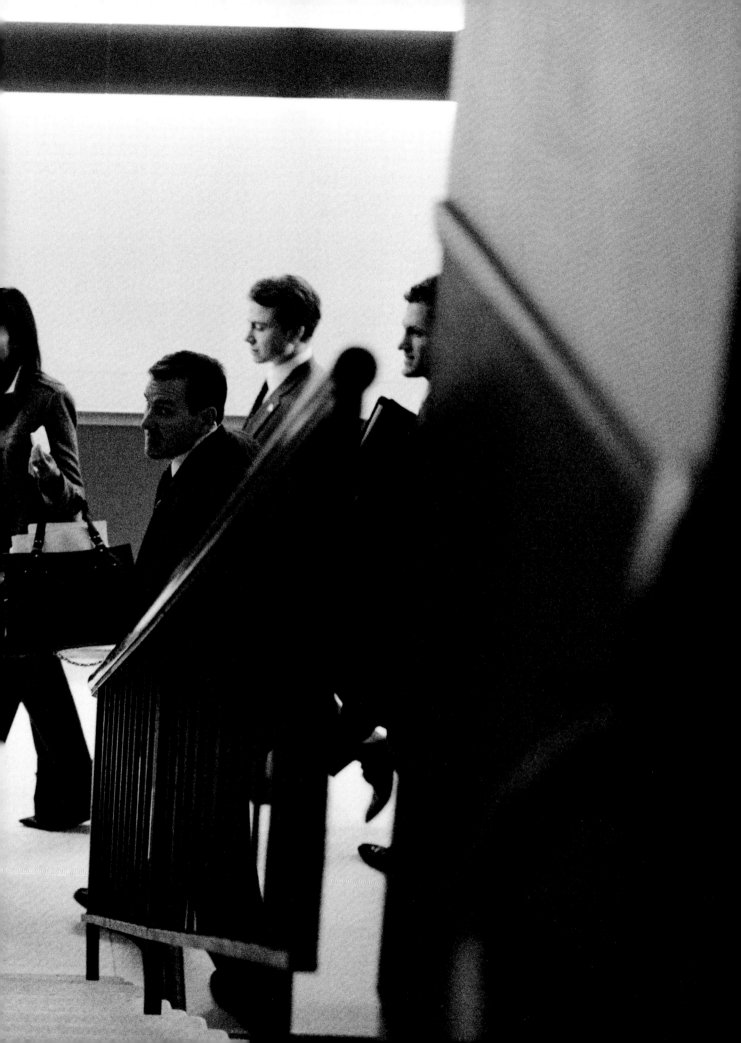

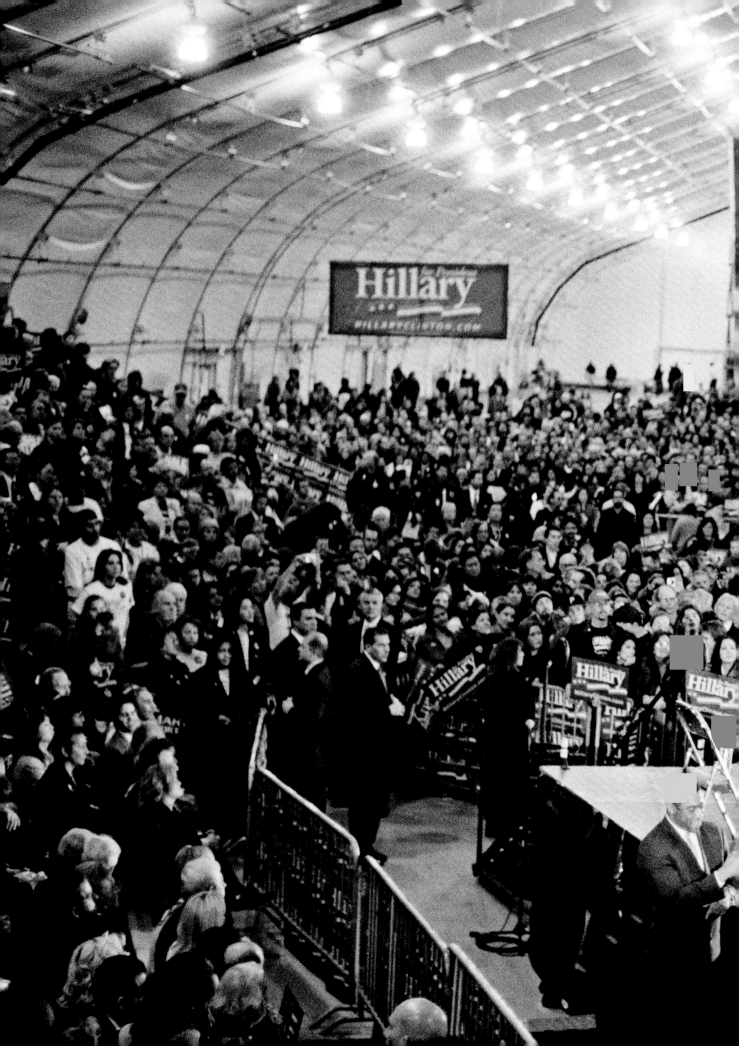

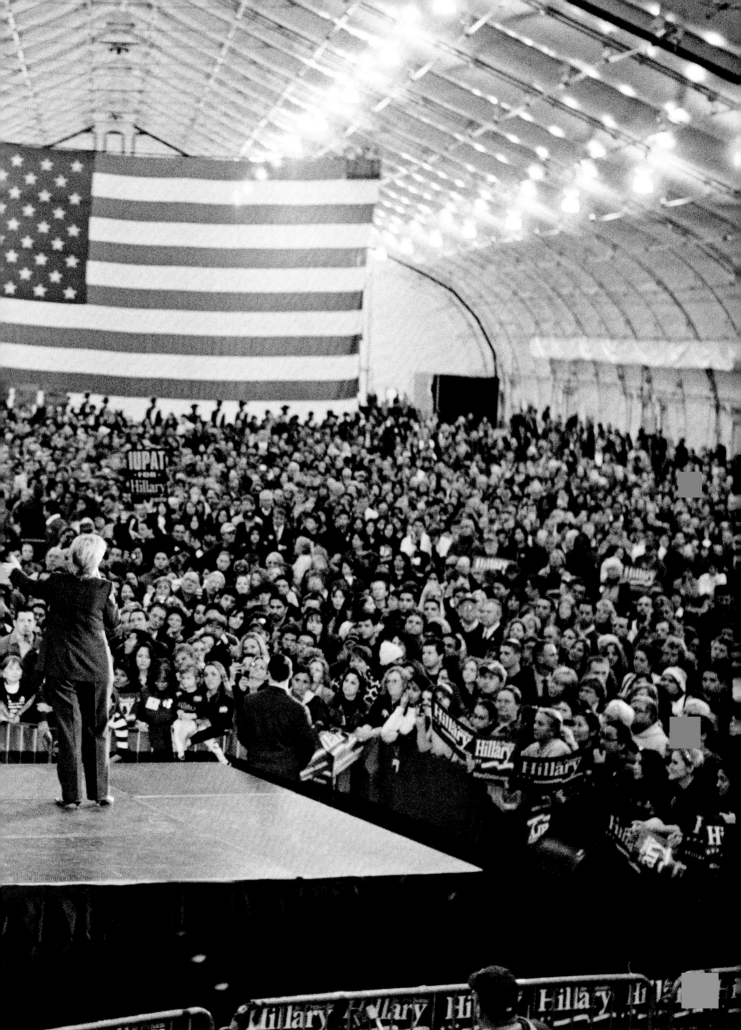

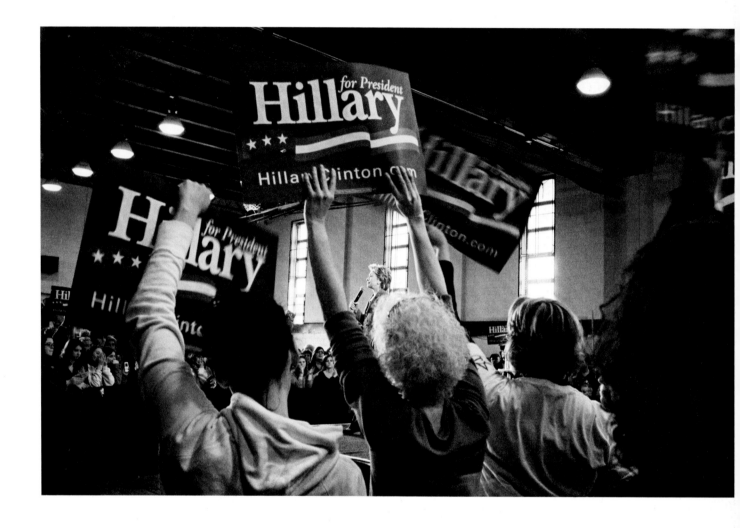

Previous spread: A larger-than-expected crowd of four thousand supporters gathers at California's San Jose McEnery Convention Center for a rally. — February 1, 2008

Above: Supporters raise "Hillary for President" signs at Montgomery County Community College in Blue Bell, Pennsylvania. — March 24, 2008

Opposite, top: As Governor Ed Rendell speaks in the ballroom, the Clinton family, including Hillary's mother, Dorothy Rodham, joins hands backstage at the Park Hyatt Hotel at the Bellevue, Philadelphia, moments before hearing that Hillary has won the Pennsylvania primary. — April 22, 2008

Opposite, bottom: Dorothy Rodham, with Bill and Chelsea, looks on as Hillary gives her victory speech. — April 22, 2008

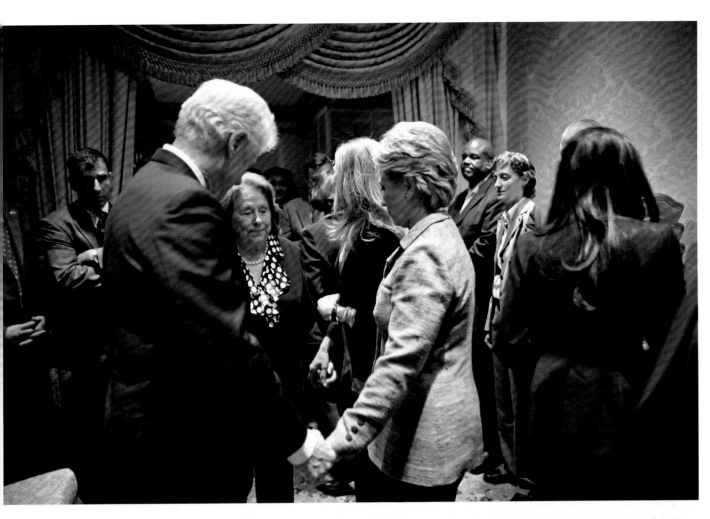

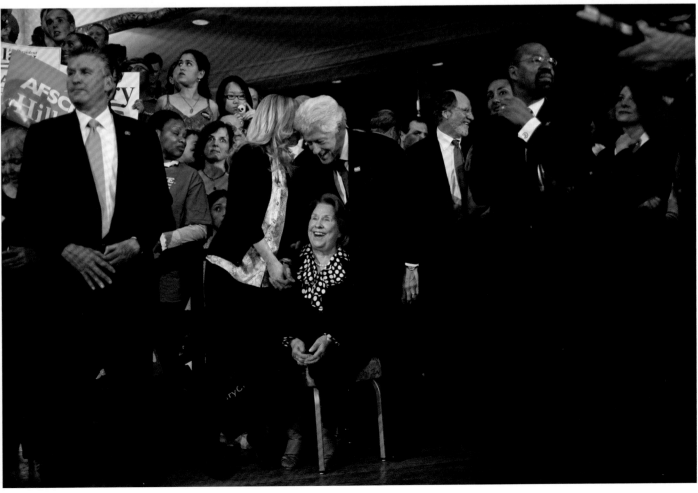

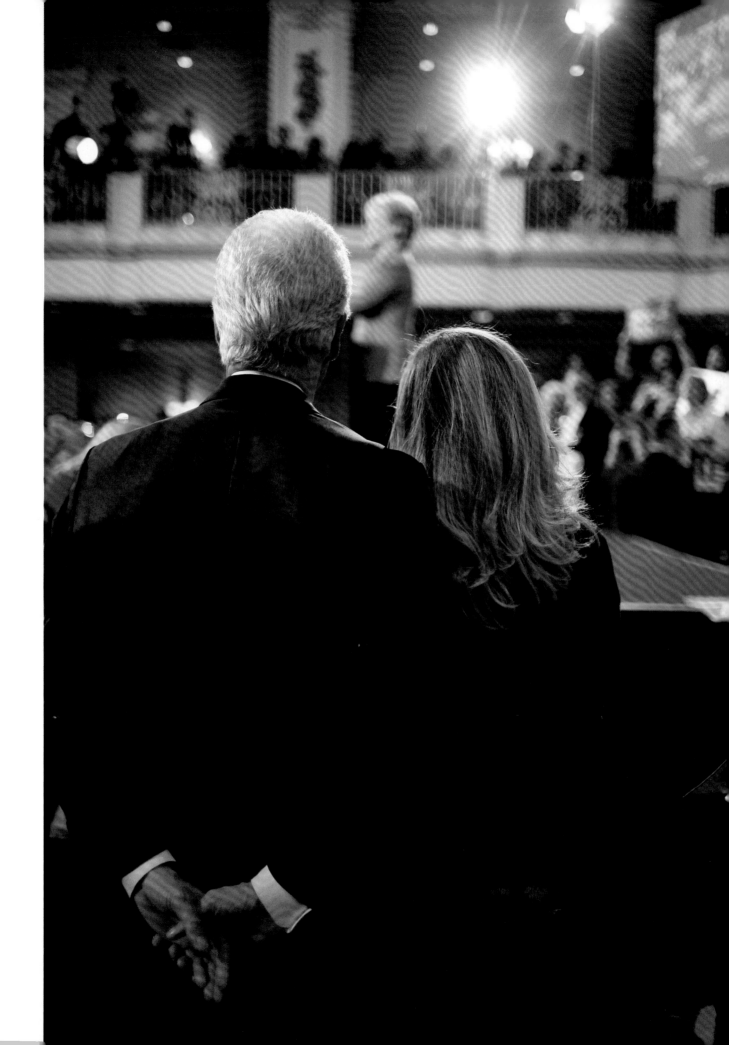

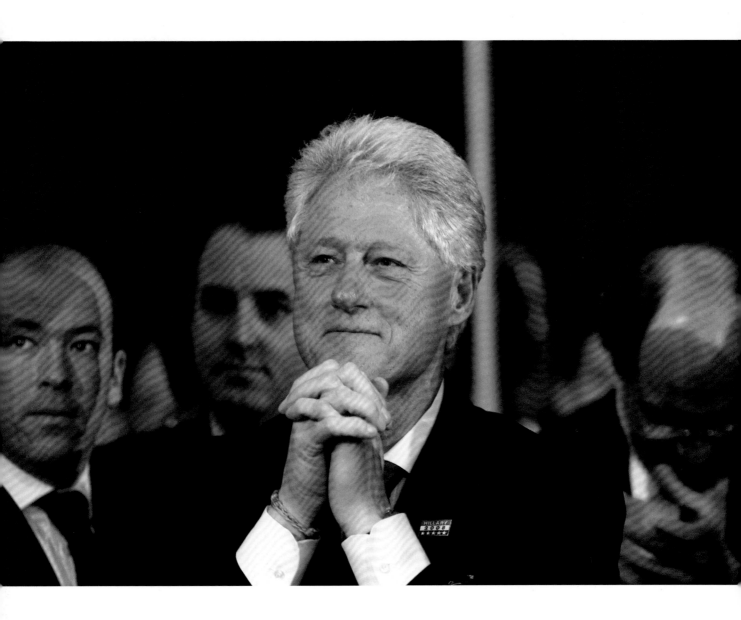

Opposite and above: Chelsea and Bill Clinton in the ballroom of the Park Hyatt Hotel at the Bellevue. "I believe with all of my heart that together we will turn promises into action, words will become solutions, hope will become reality," says Hillary after the Pennsylvania primary, which she won by nearly ten points. — April 22, 2008

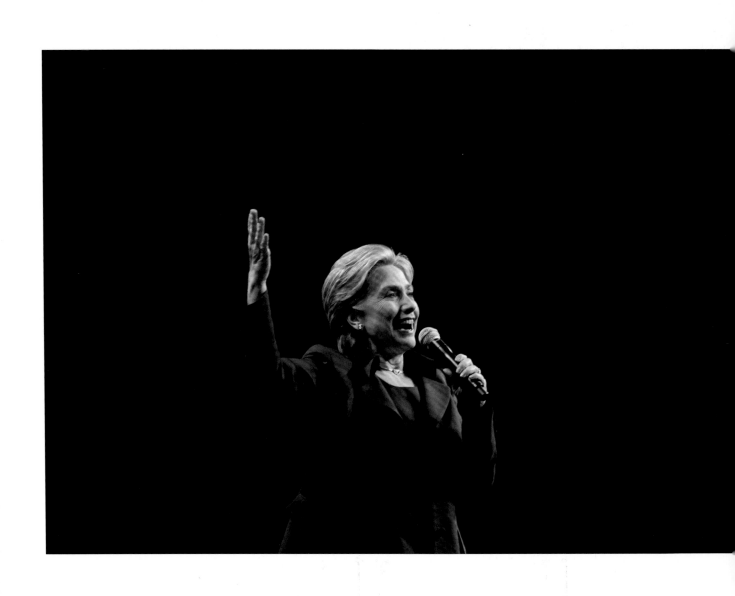

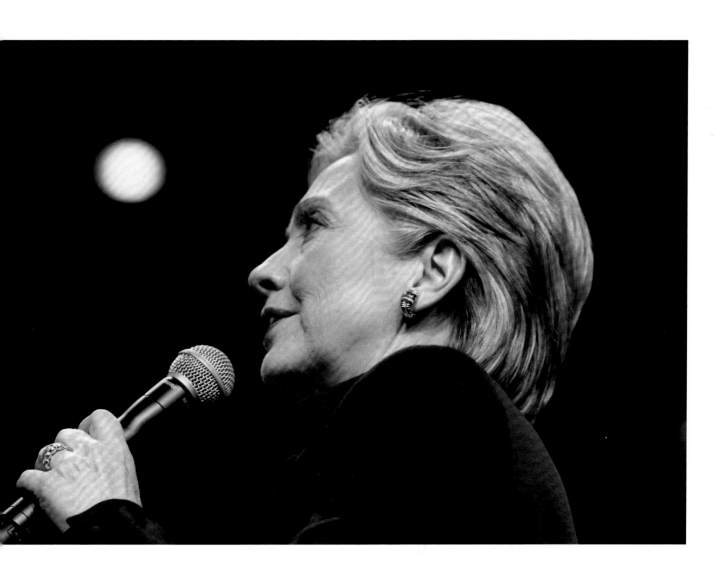

Previous spread: Weeks of campaigning end with a Super Tuesday rally in the
Grand Ballroom of the Manhattan Center. Hillary won two of the most coveted prizes:
New York and California. — February 5, 2008

Opposite and above: Hillary speaks at a Solutions for the American
Economy town hall meeting at San Diego State University with less than a week
before Super Tuesday. — February 1, 2008

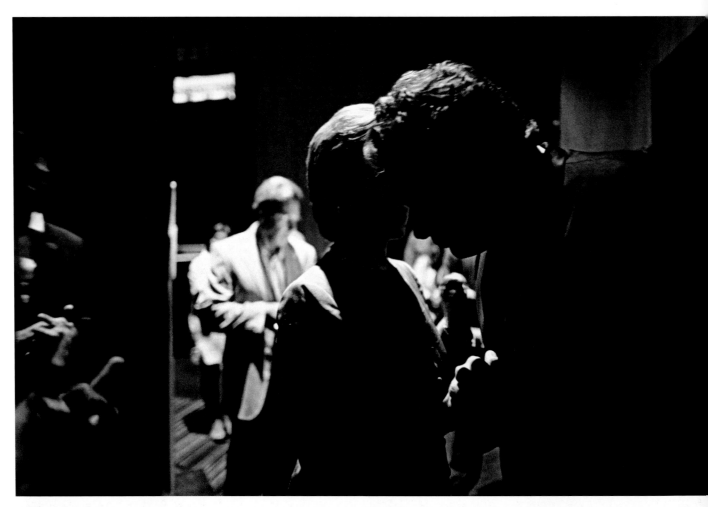

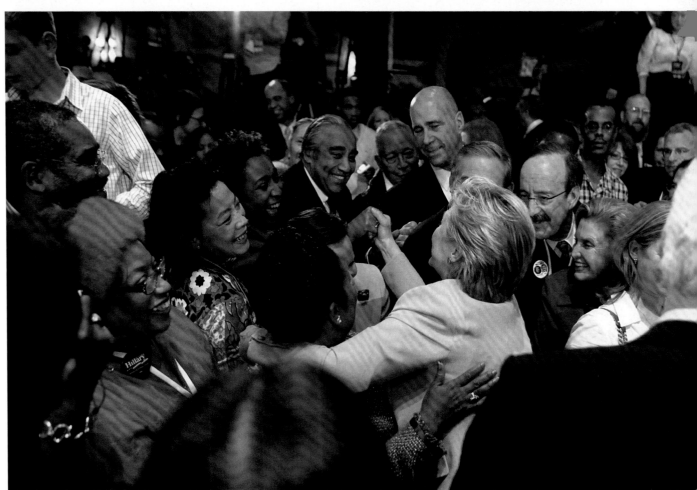

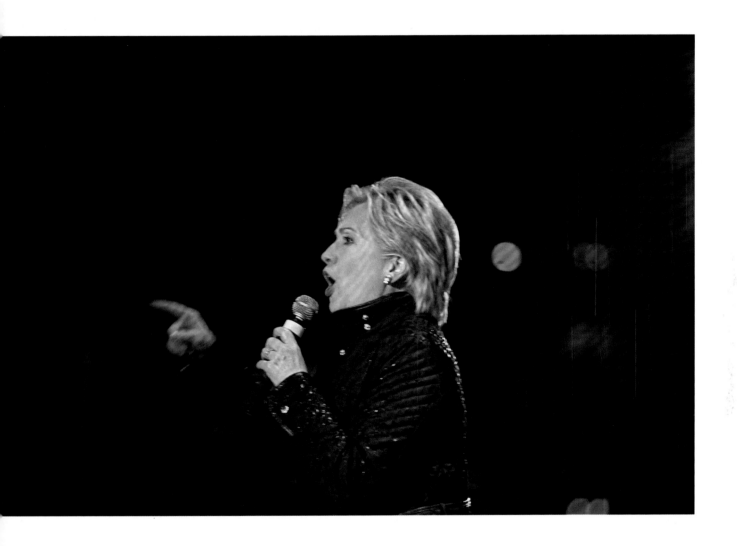

Opposite, top: En route to victory in the Puerto Rico primary, Hillary consults with her campaign chair, Terry McAuliffe, now governor of Virginia. — June 1, 2008

Opposite, bottom: Hillary greets New York congressman Charles Rangel (D-NY) at a Super Tuesday rally in the Grand Ballroom of the Manhattan Center. — February 5, 2008

Above: Rain-soaked supporters gather in McKeesport to hear Hillary as she barnstorms across Pennsylvania in the days before the primary. — April 19, 2008

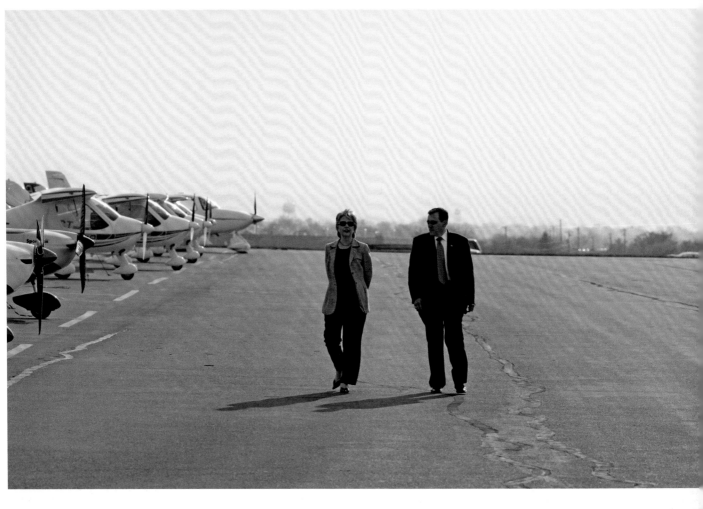

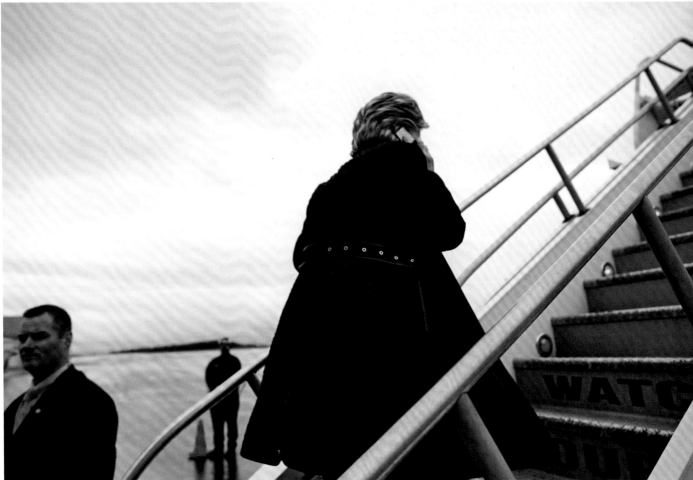

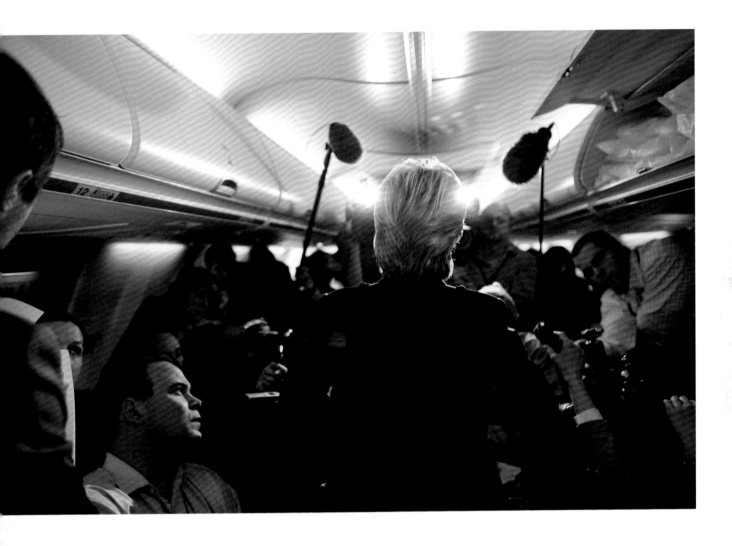

Opposite, top: In a brief respite from the intense Pennsylvania campaign, Hillary stretches her legs on the tarmac with her lead Secret Service agent. — April 20, 2008

Opposite, bottom: Hillary departs for State College after a stop in Johnstown, Pennsylvania. — April 20, 2008

Above: Hillary speaks to the press corps as her plane flies eastbound from Minnesota after a campaign blitz through multiple states. — February 3, 2008

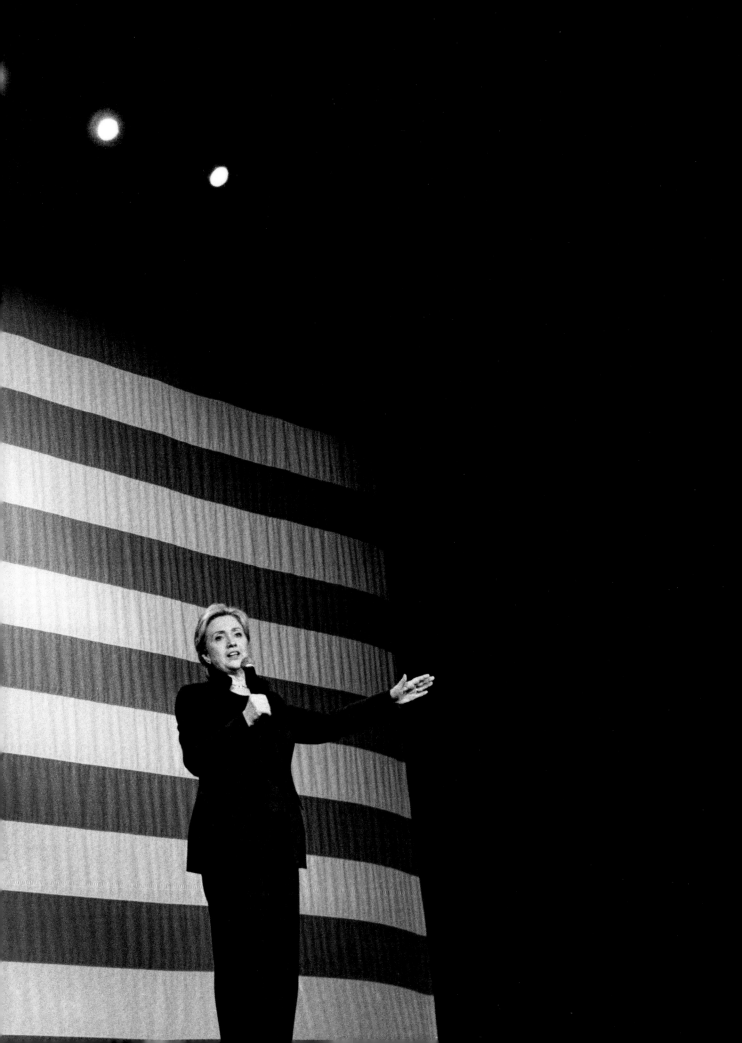

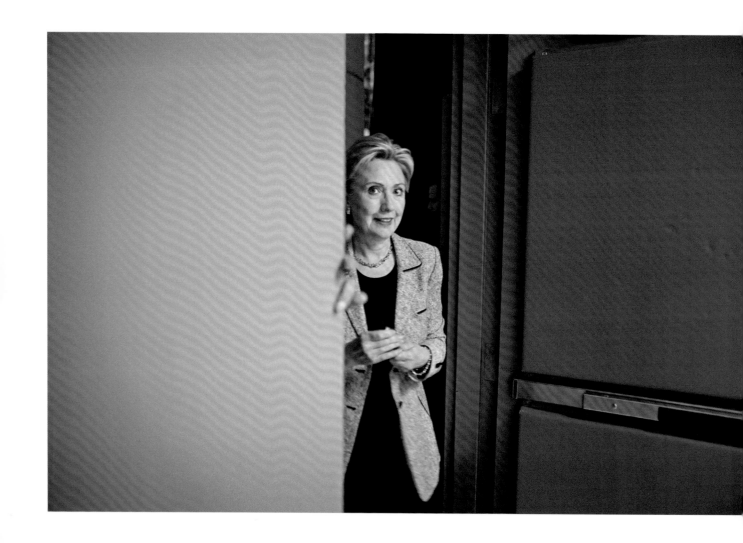

Previous spread: "That's what I want America to be again, to be a community where we each
are doing our part to lift each other up, to see each other, to hear each other."
Hillary Clinton, speaking at the Orpheum Theatre in San Francisco. — February 1, 2008

Above and opposite: Hillary and her aide Huma Abedin get their bearings at California University
of Pennsylvania. — April 19, 2008

Before an appearance
with David Letterman,
Hillary checks her
BlackBerry while Diana
Walker takes their picture.
— February 4, 2008

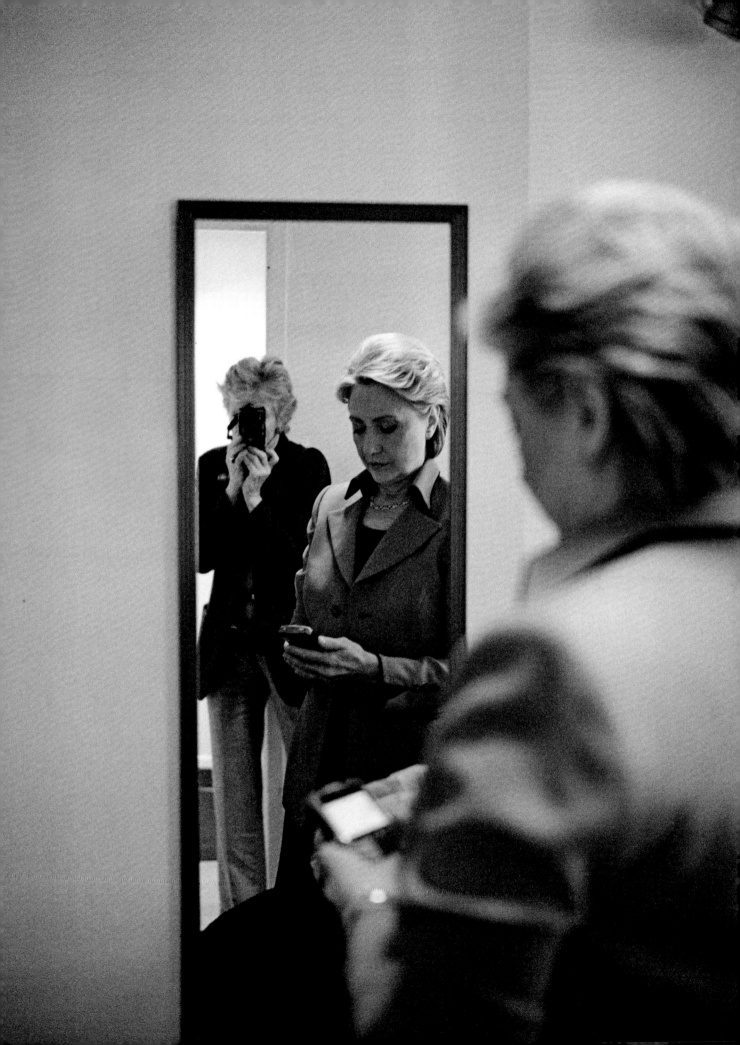

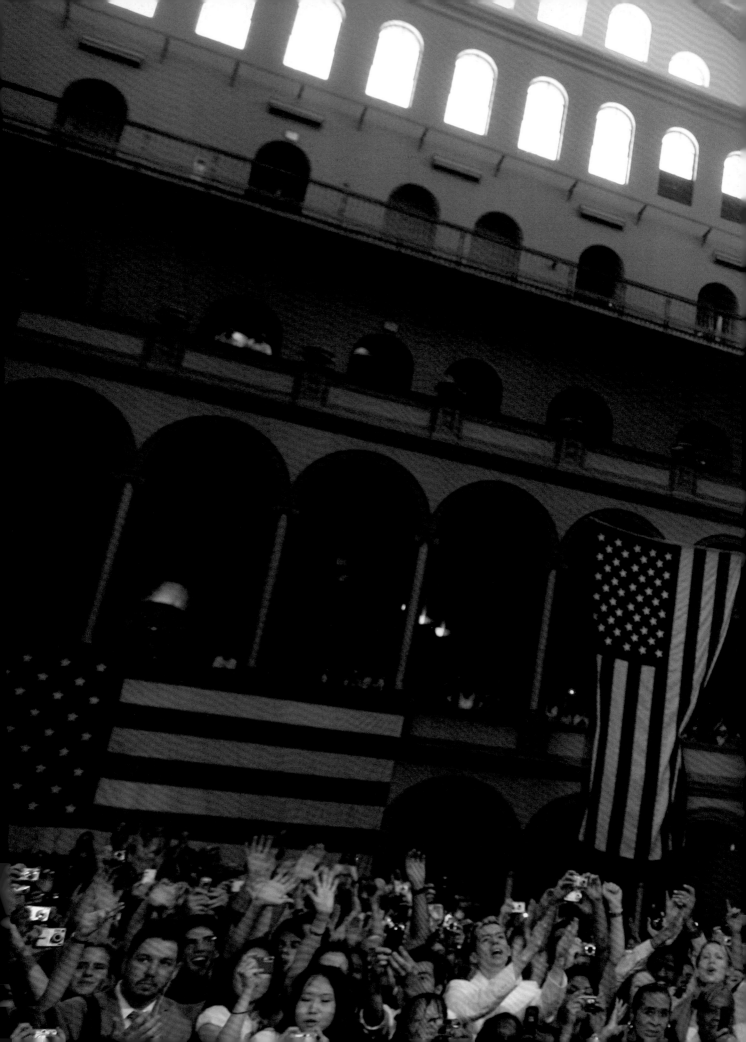

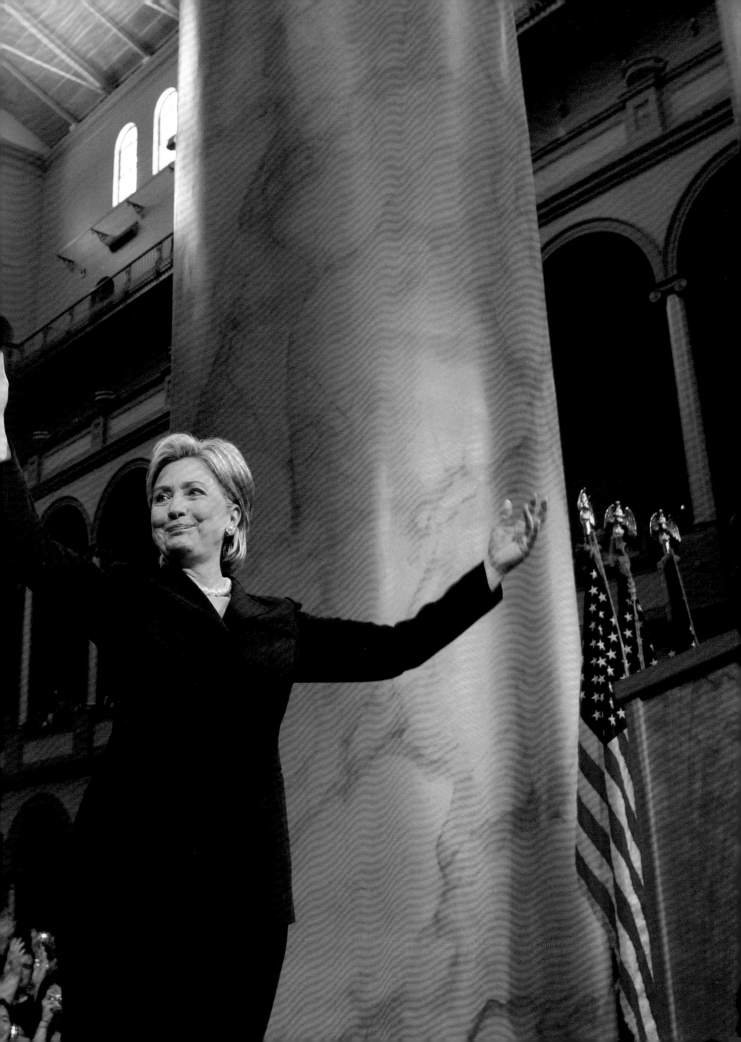

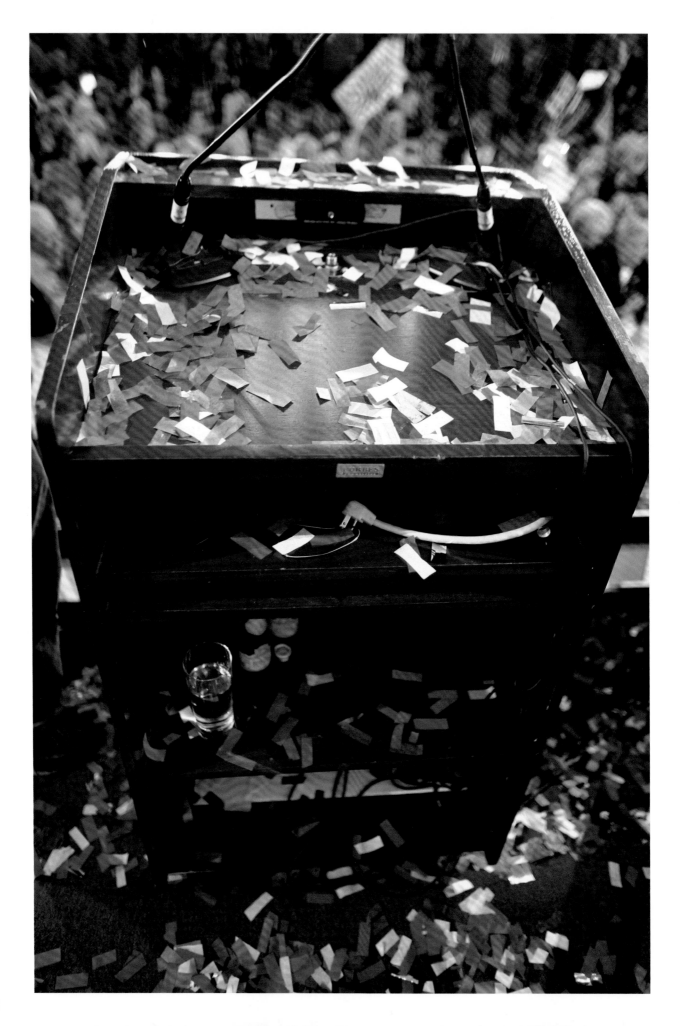

Previous spread: "Although we weren't able to shatter that highest, hardest glass ceiling this time, thanks to you, it's got about eighteen million cracks in it," Hillary said in her concession speech at the National Building Museum, Washington, DC. — June 7, 2008

Opposite: Confetti left on the lectern after the victory party celebrating Hillary's win in the Pennsylvania primary. — April 22, 2008

Above: Prior to the Iowa Caucus, bookplates await guests at a gathering in a private home in Cedar Rapids, Iowa. — January 27, 2007

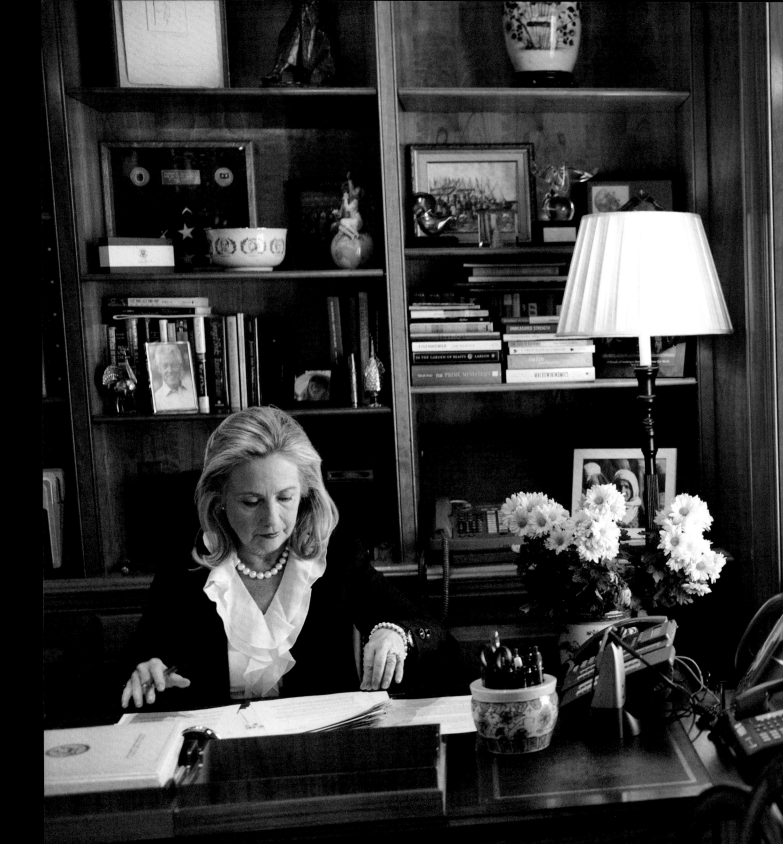

SECRETARY OF STATE 2009 – 2013

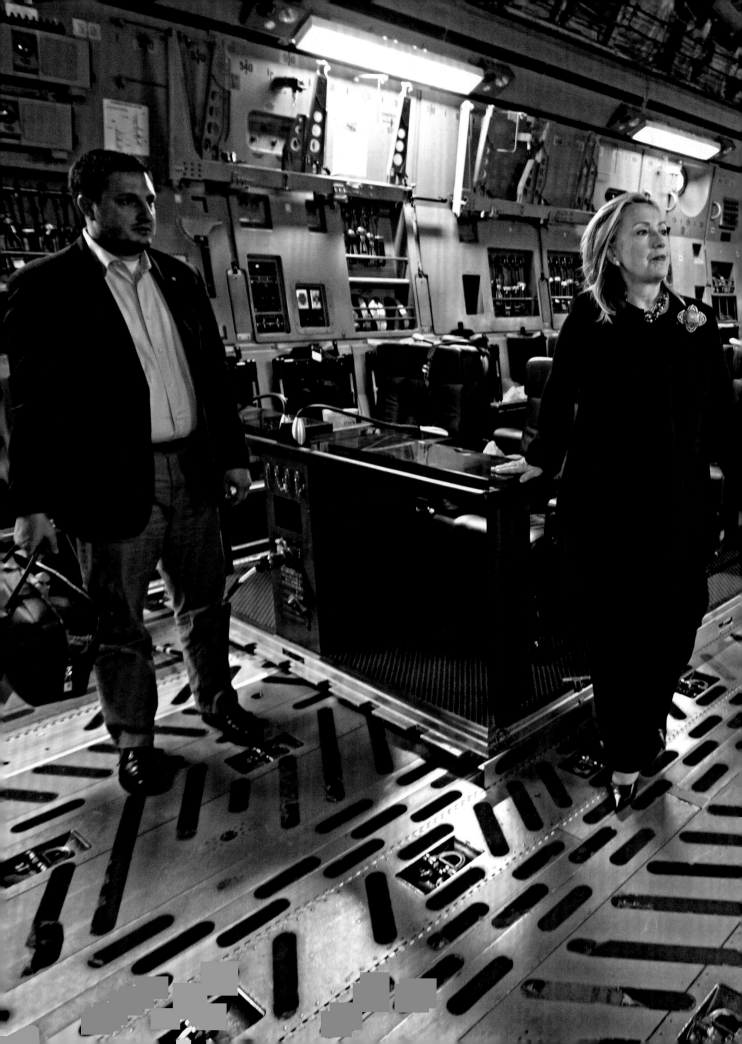

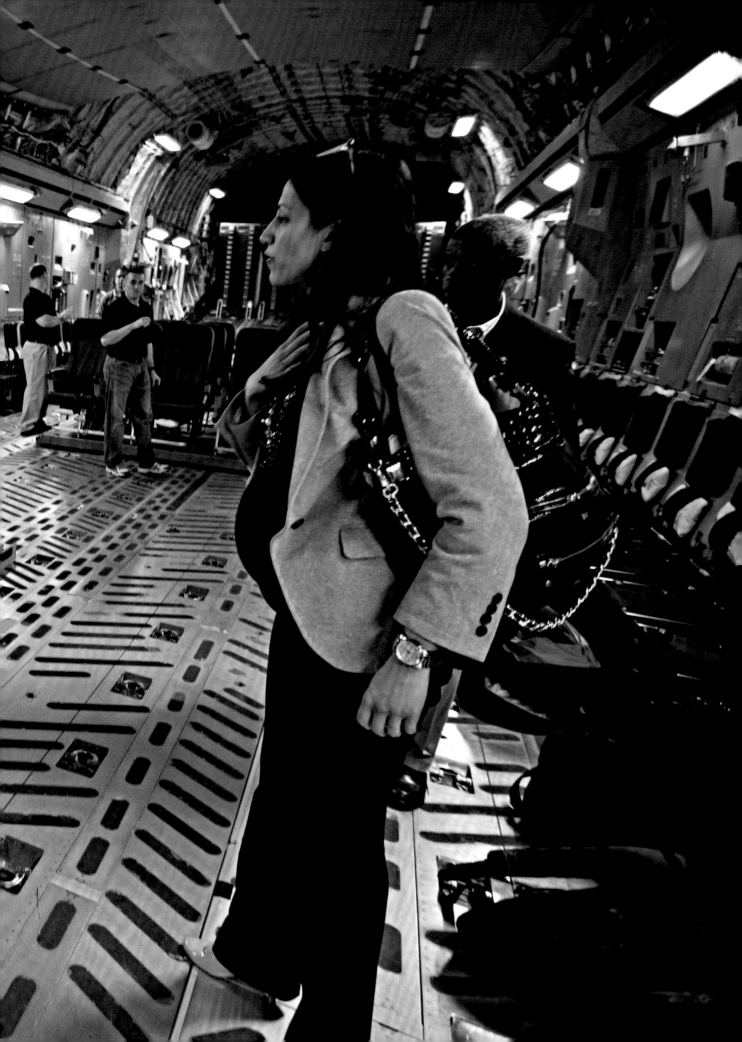

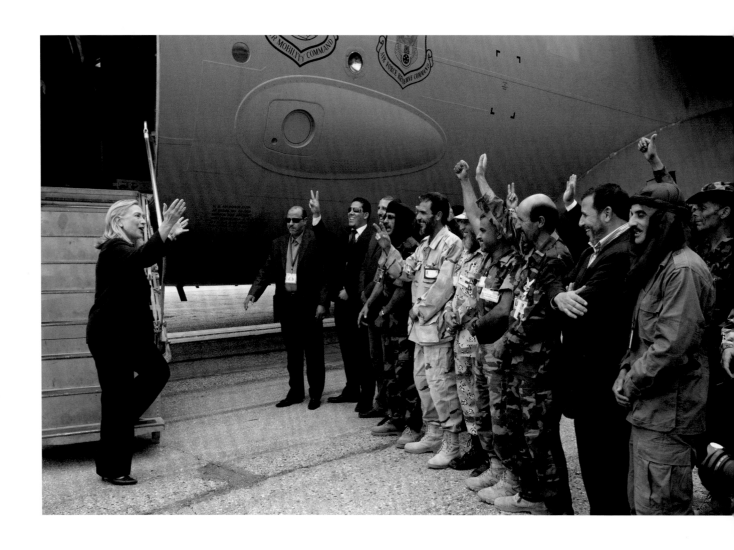

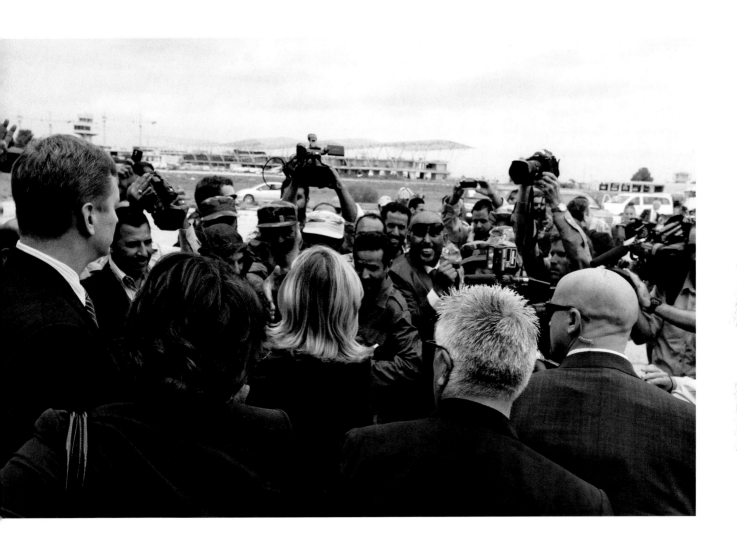

Pages 180–81: Hillary catches up with correspondence at her State Department desk after returning from travel to seven countries in as many days. — October 26, 2011

Previous spread: Hillary confers with top aides Huma Abedin and Philippe Reines minutes before exiting the plane to become the highest-ranking US official to visit Libya since the fall of the Gaddafi government. — October 18, 2011

Opposite: Hillary meets Libyan rebel fighters at the steps of her C-17 military transport upon her arrival at the Tripoli airport. Two days later, Muammar Gaddafi was captured and killed. — October 18, 2011

Above: Upon her arrival from Malta, Hillary is welcomed on the tarmac in Libya by anti-Gaddafi fighters. — October 18, 2011

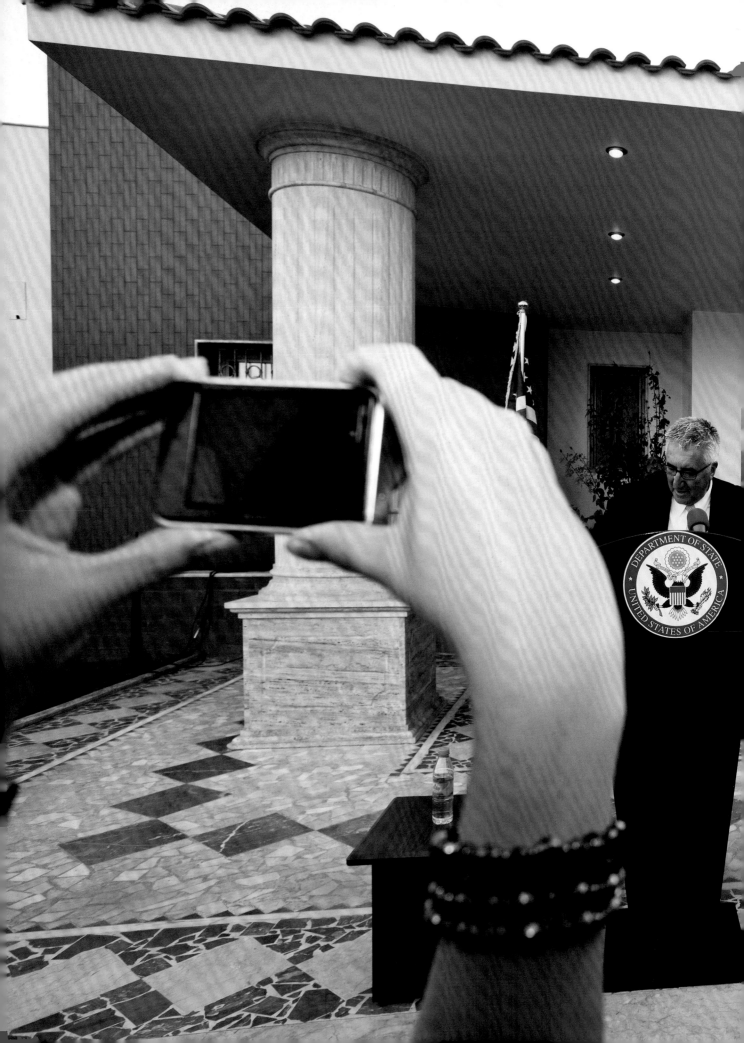

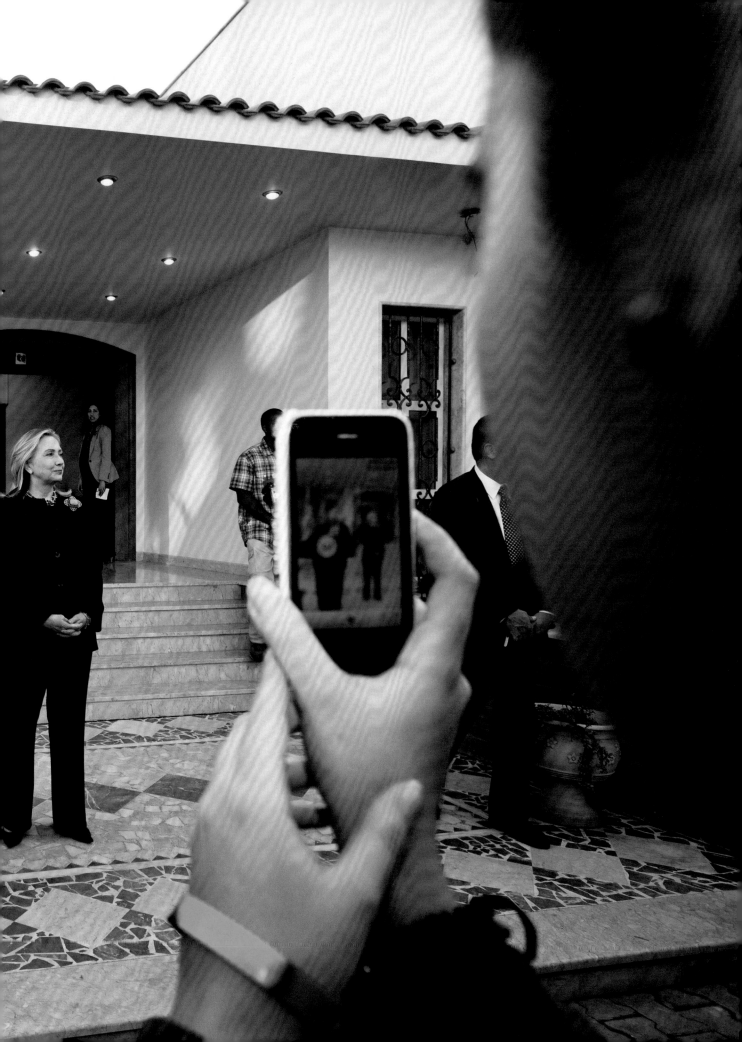

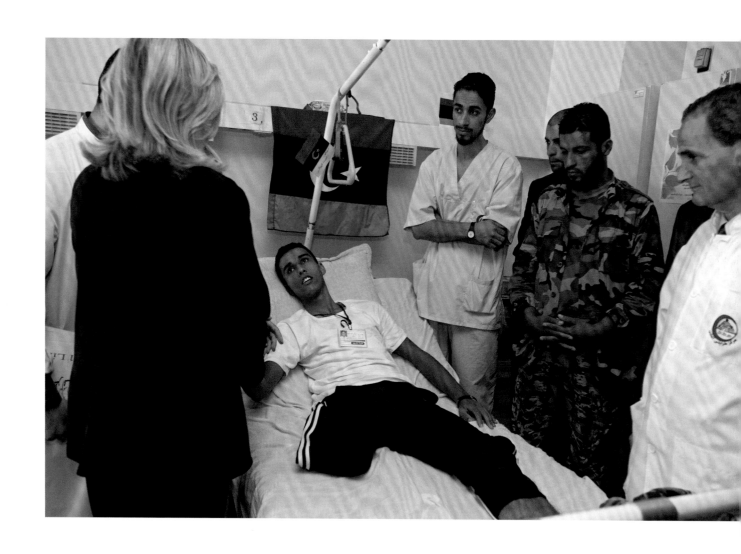

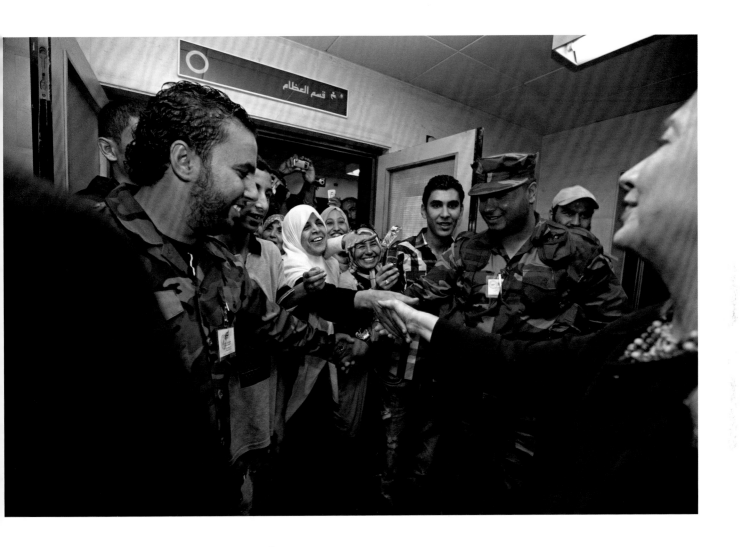

Previous spread: Ambassador Gene Cretz introduces Hillary to US embassy staff and families at the recently reopened mission in Tripoli. — October 18, 2011

Opposite: Hillary visits the bedside of a rebel amputee at the Tripoli Medical Center.
— October 18, 2011

Above: A crowd greets Hillary in the hallway of the Medical Center. — October 18, 2011

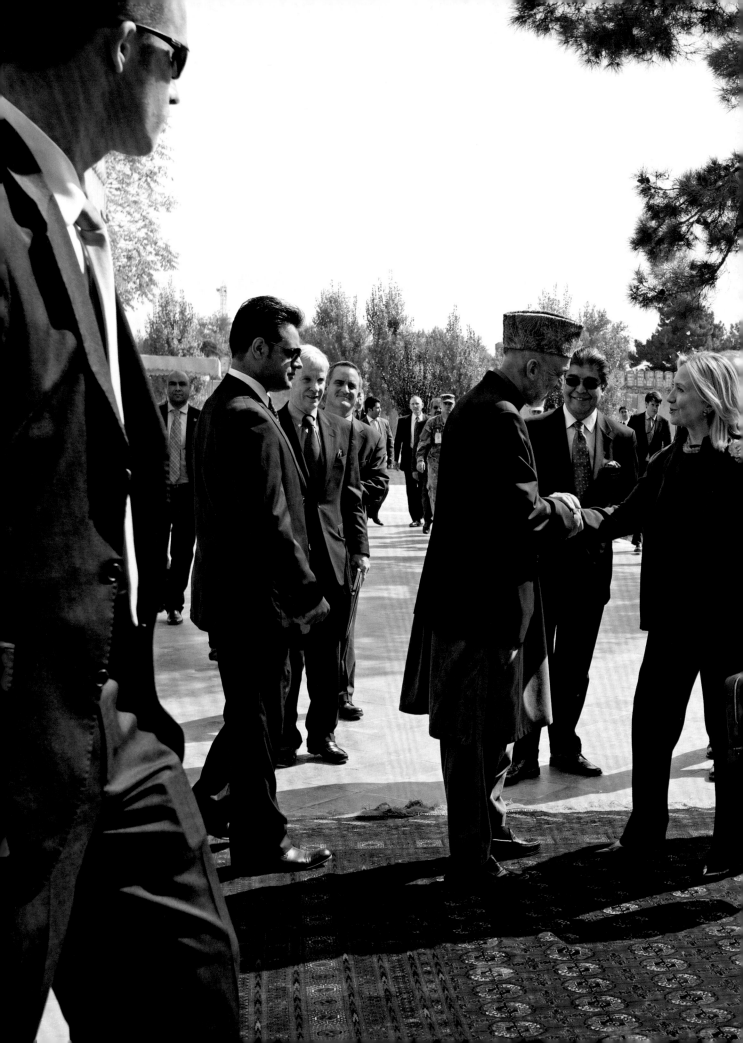

President Hamid Karzai
of Afghanistan greets
Hillary outside the
Presidential Palace in Kabul.
Foreign Minister Dr. Zalmai
Rassoul is on the right.
— October 20, 2011

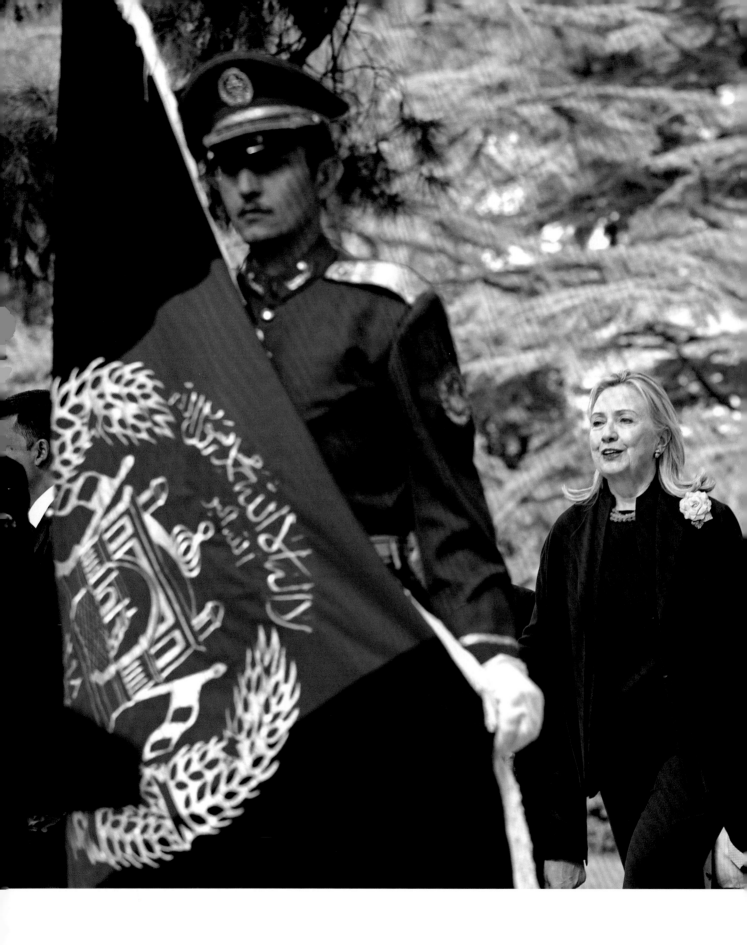

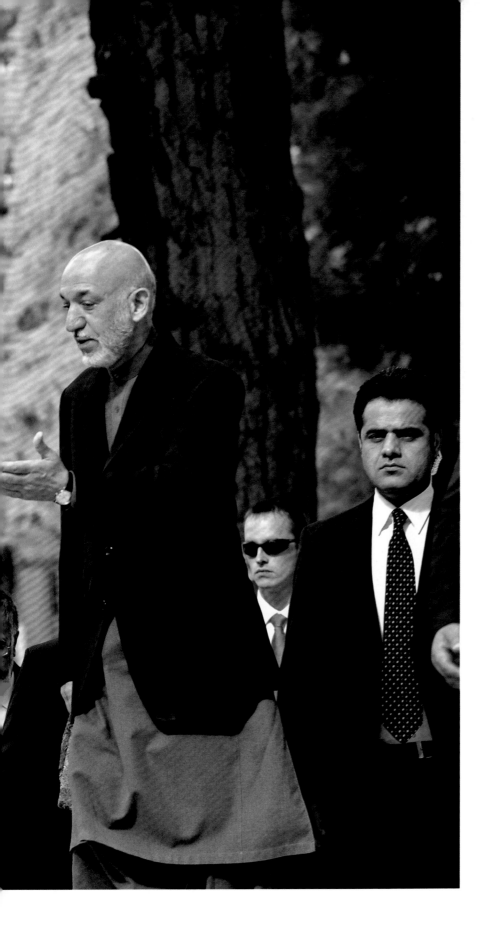

Hillary and President Karzai
walk to a joint press
conference in the garden of the
Presidential Palace, where she
called for better cooperation
with neighboring Pakistan and
affirmed the US commitment
to ending the war.
— October 20, 2011

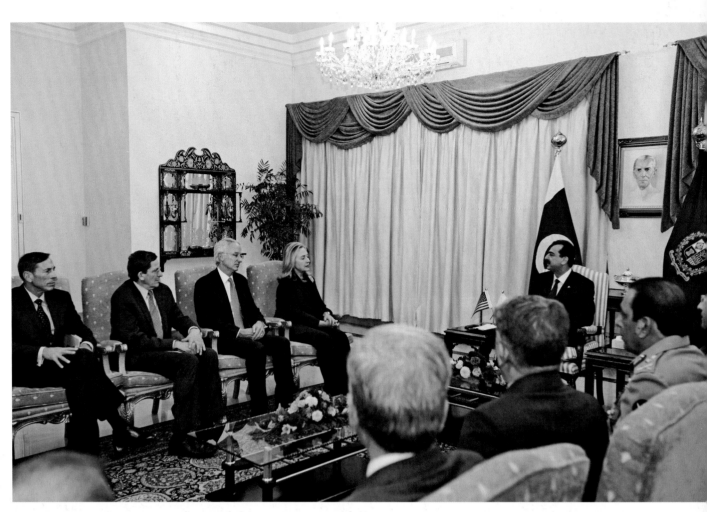

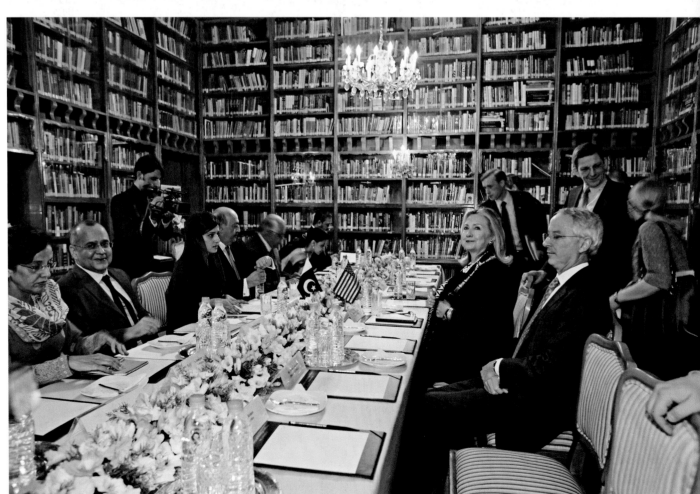

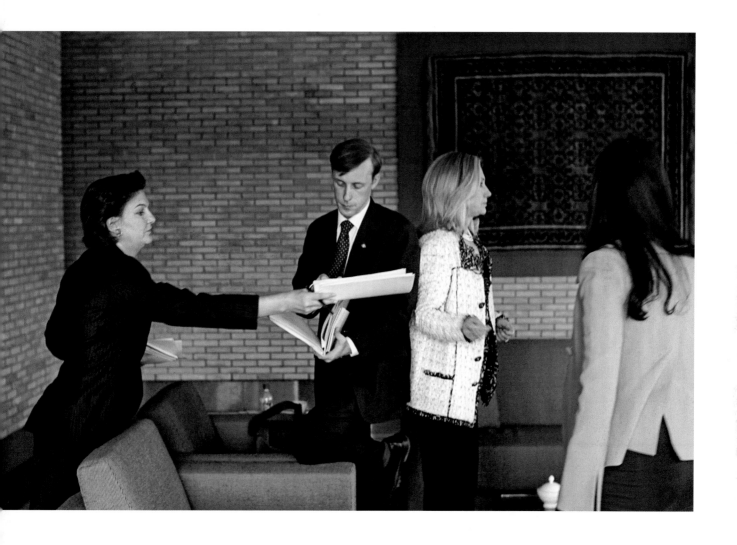

Previous spread: Hillary returns to her plane to depart for Pakistan following
tough talks in Kabul. — October 20, 2011

Opposite, top: Hillary meets with Prime Minister Yousaf Raza Gilani of Pakistan at his residence in
Islamabad. Among US officials were, from left to right, CIA director David Petraeus,
US Special Representative for Pakistan and Afghanistan Marc Grossman, and US Ambassador
to Pakistan Cameron Munter. — October 21, 2011

Opposite, bottom: Hillary sits across from her Pakistani counterpart, Foreign Minister
Hina Rabbani Khar, along with delegations from both countries, for a meeting in the library
of the foreign ministry. — October 21, 2011

Above: Hillary with spokesperson Victoria Nuland and Director of Policy Planning
Jake Sullivan in a holding room at the Ishmaili Centre in Dushanbe, Tajikistan, where she
participated in a town hall meeting. — October 22, 2011

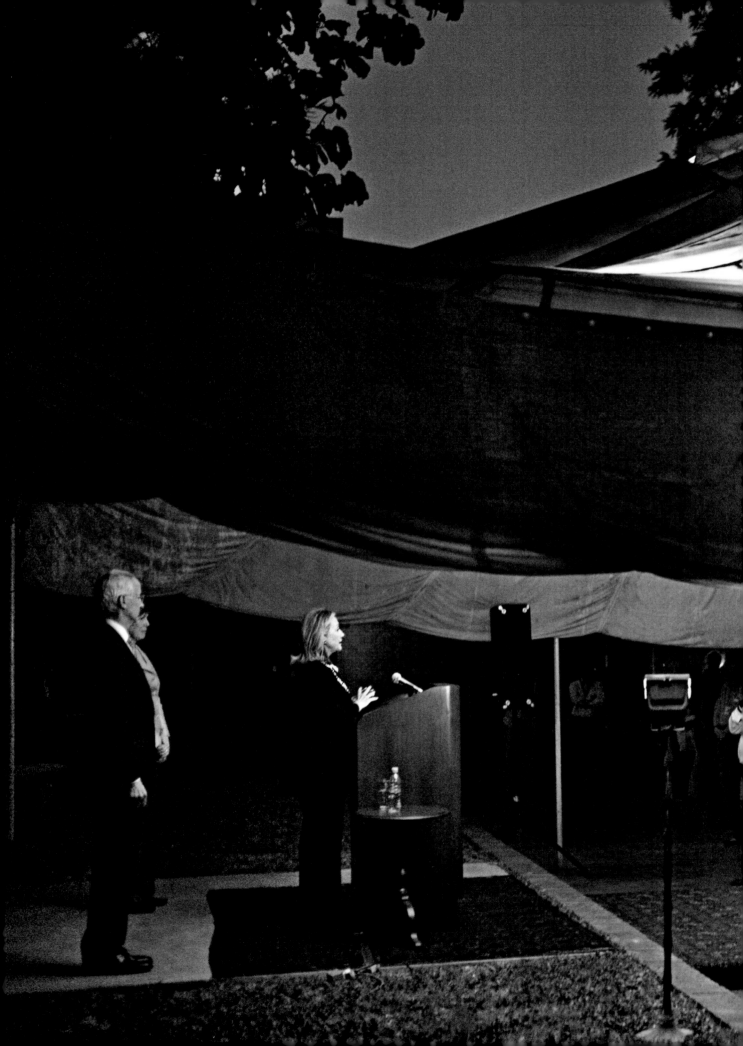

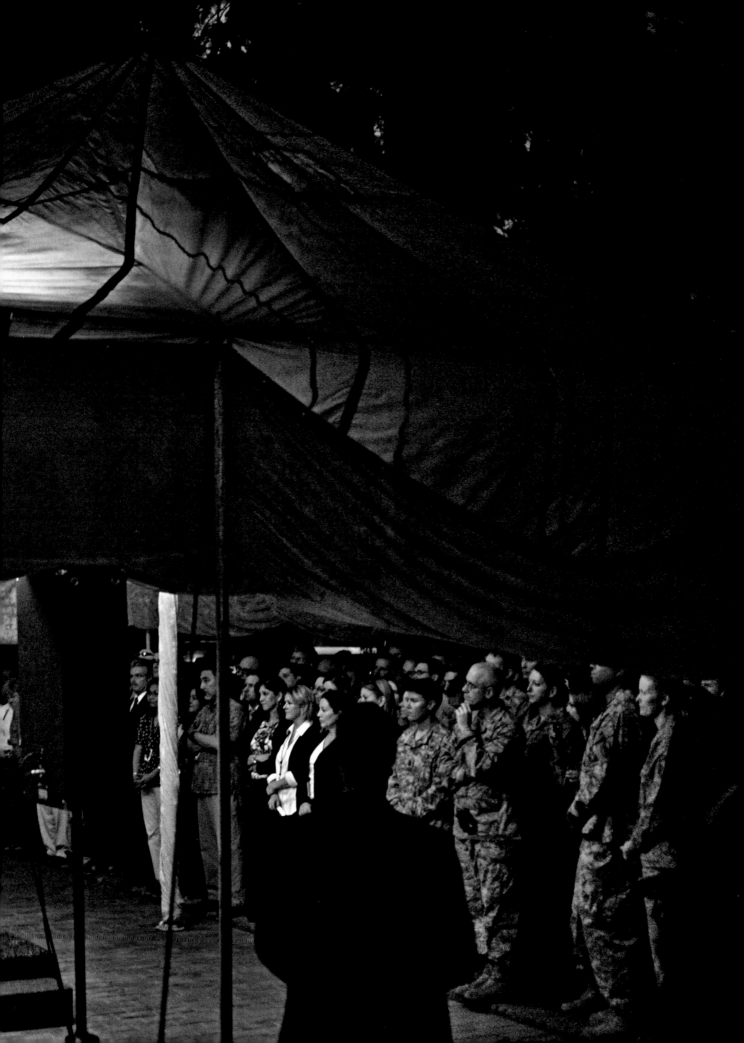

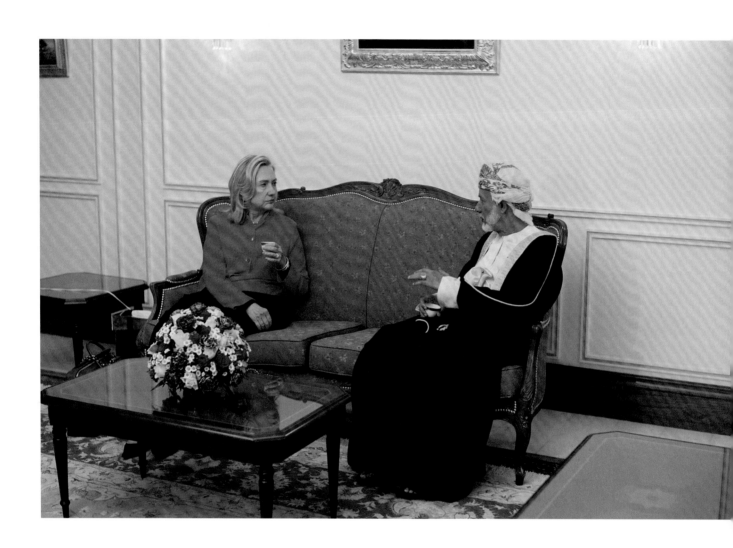

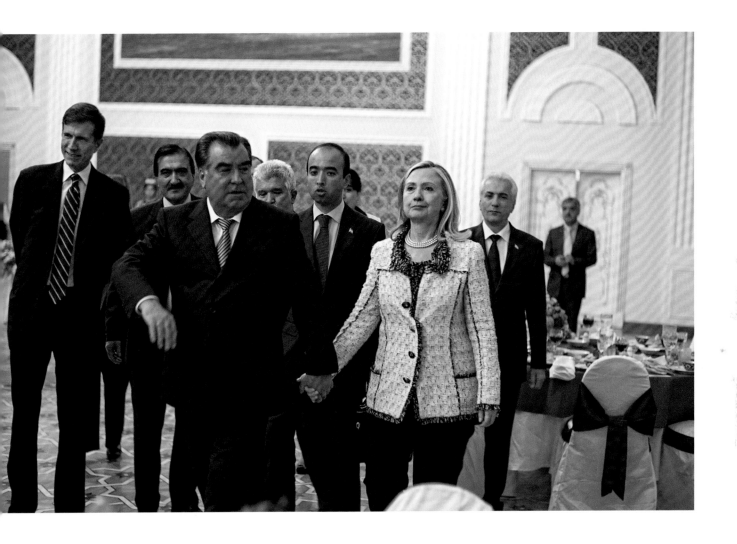

Previous spread: Hillary speaks to American and Pakistani staff at the US embassy in Islamabad.
— October 21, 2011

Opposite: Foreign Minister Yusuf bin Alawi bin Abdullah of Oman meets with Hillary in
Muscat, where they share coffee and dates. — October 19, 2011

Above: President Emomali Rahmon of Tajikistan walks with Hillary at the Palace of
the Nation along with staff including Assistant Secretary of State Robert O. Blake, Jr., at left.
— October 22, 2011

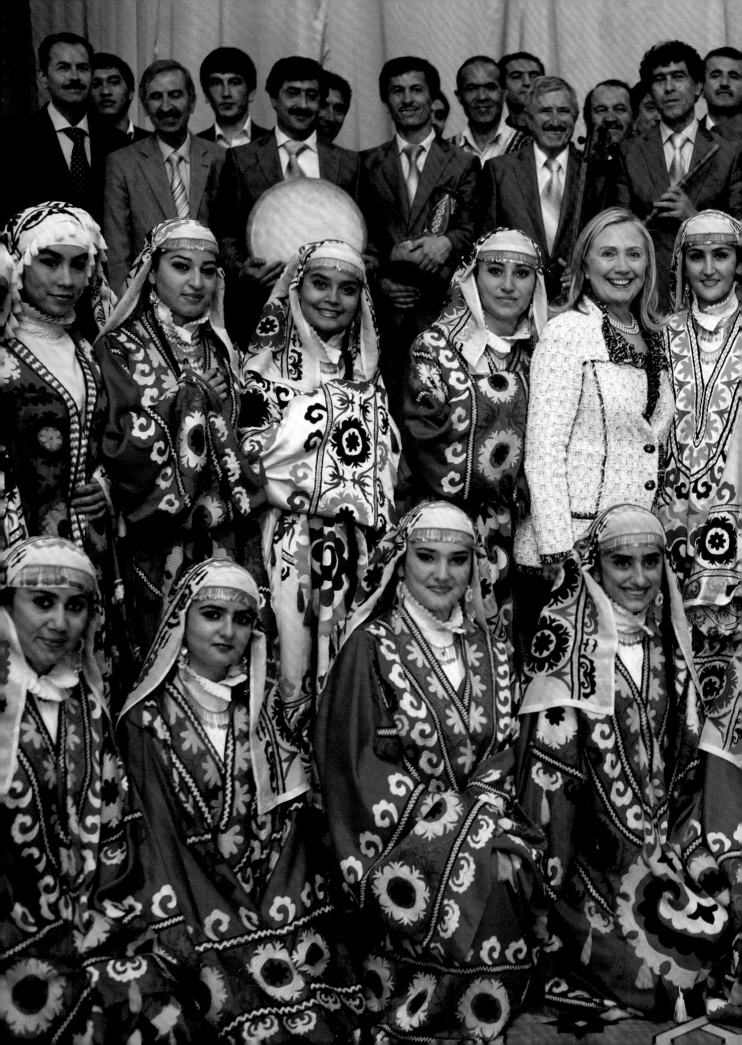

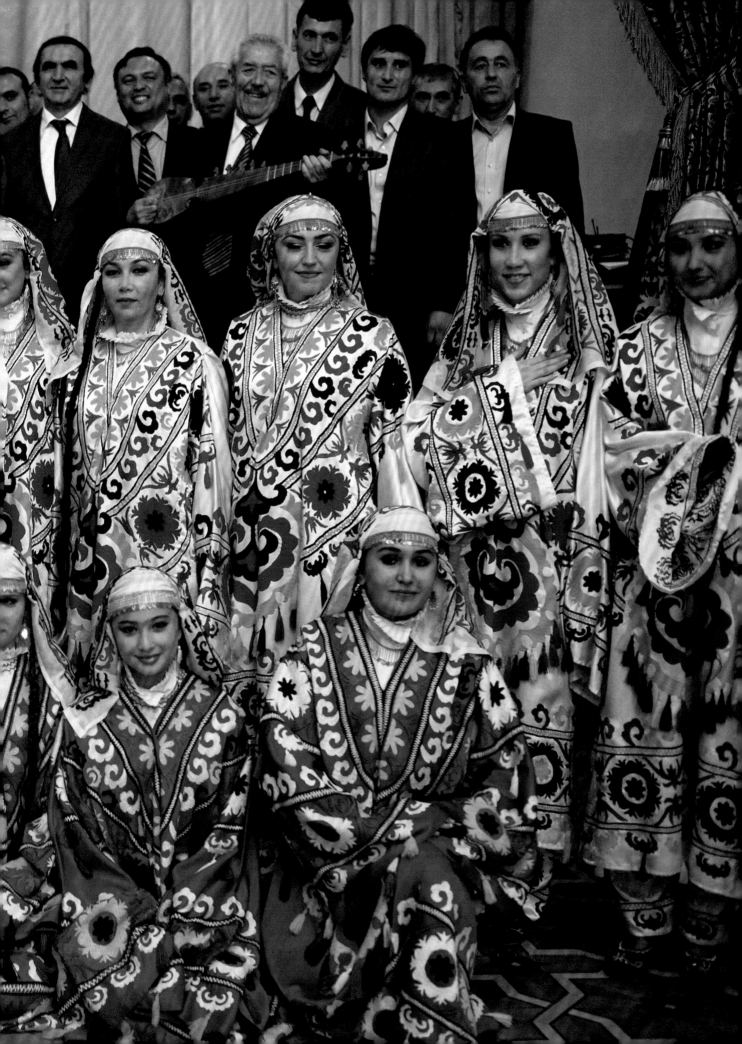

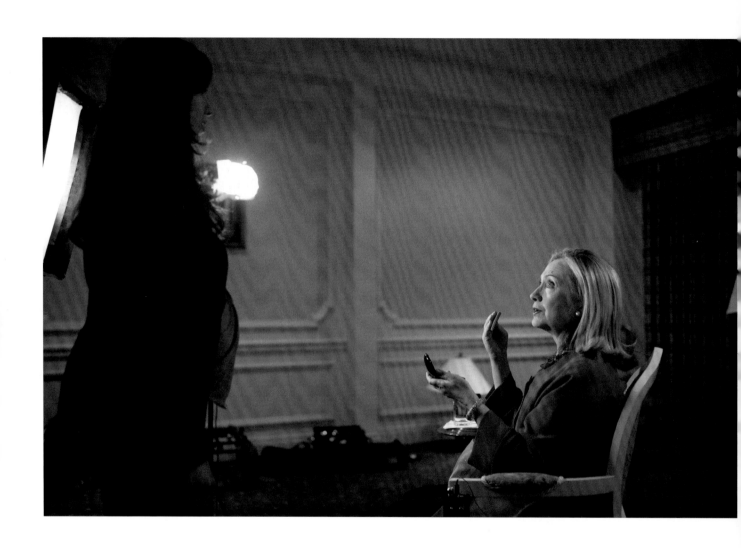

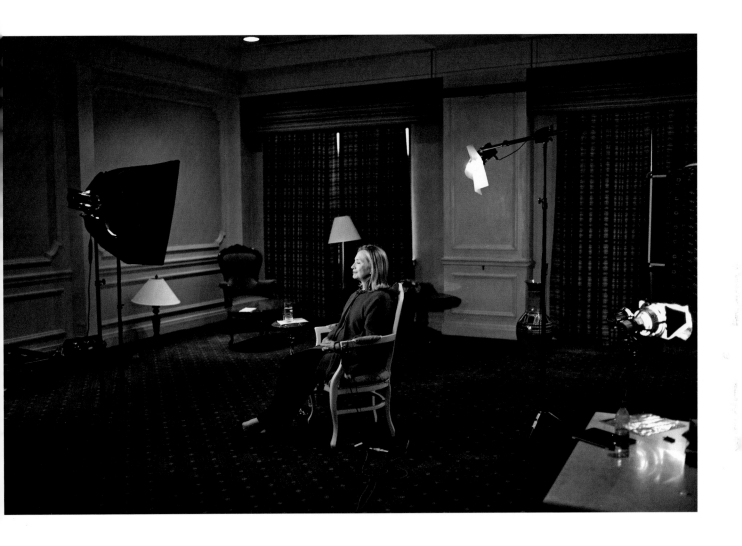

Previous spread: Hillary poses with performers dressed in traditional costumes of Tajikistan.
— October 22, 2011

Opposite and above: Secretary Clinton checks her makeup prior to taping an interview for
CNN from Tashkent, Uzbekistan. — October 23, 2011

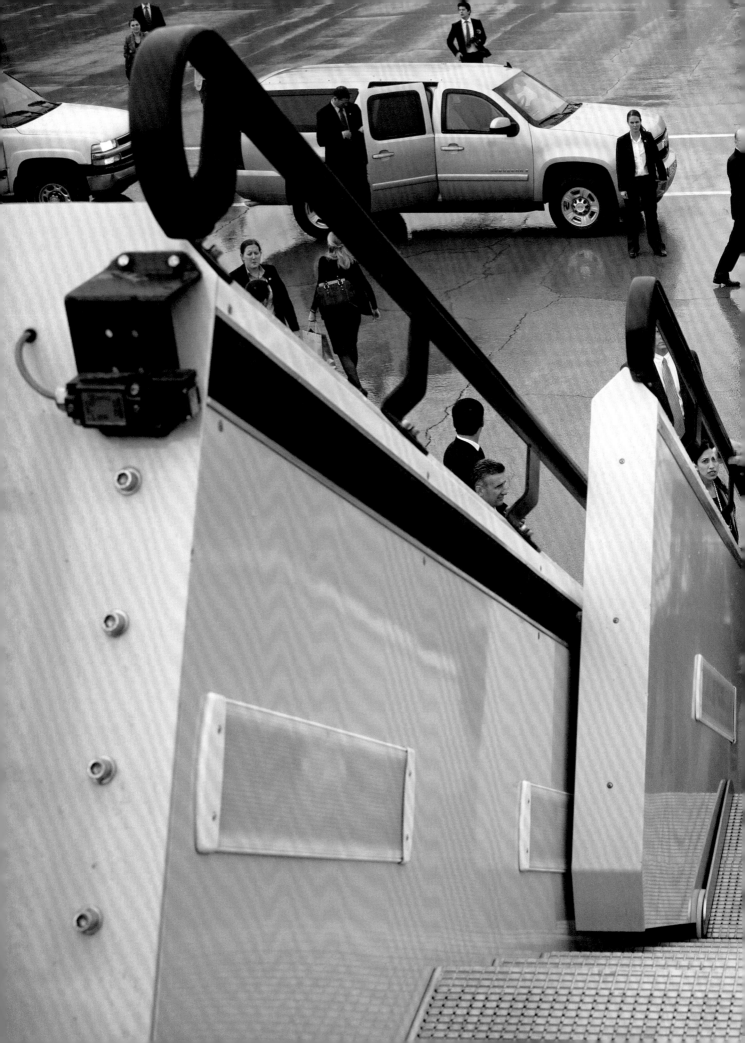

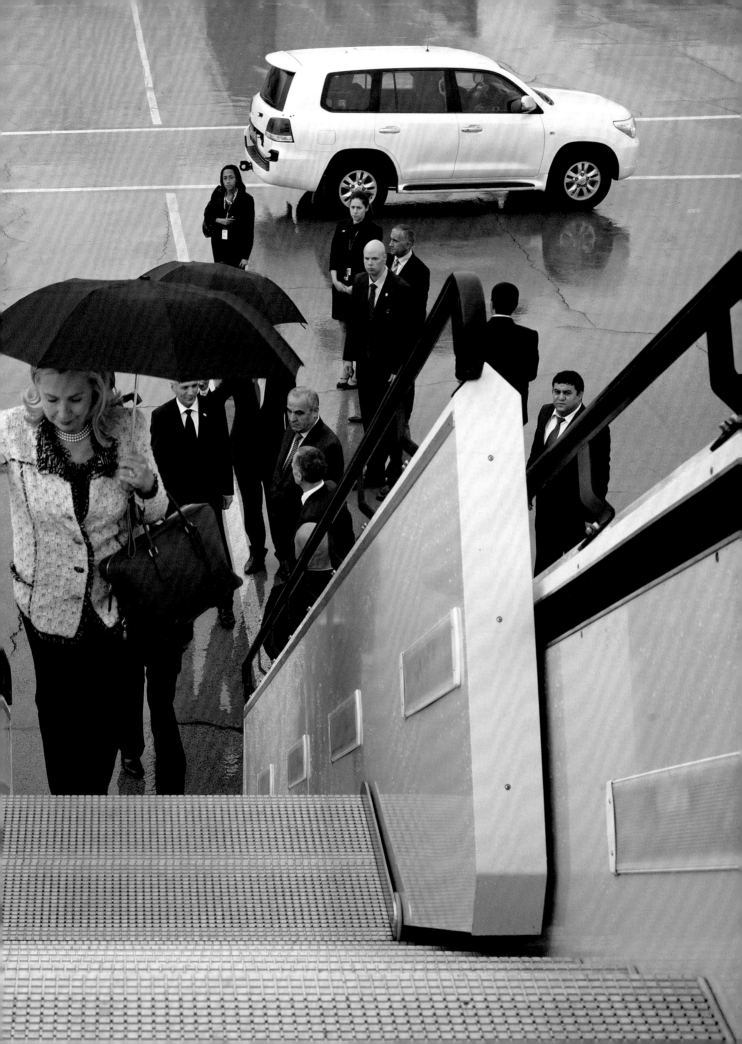

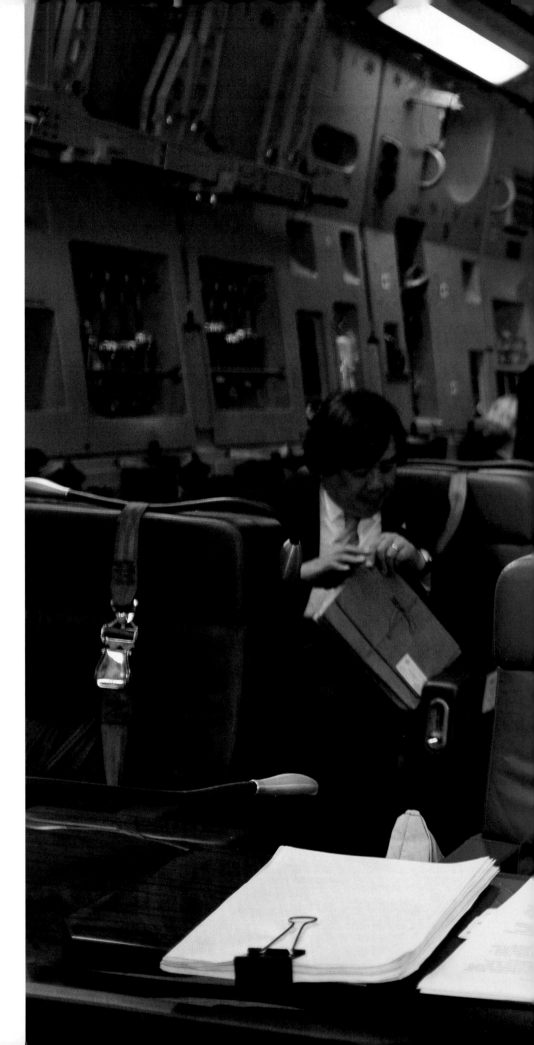

Previous spread: Hillary broke the record for most countries visited by a Secretary of State with a total of 112.
— October 22, 2011

Right: Hillary checks her messages upon departure from Malta for the as-yet-undisclosed location, Tripoli. This photo was turned into a meme that circulated around the world.
— October 18, 2011

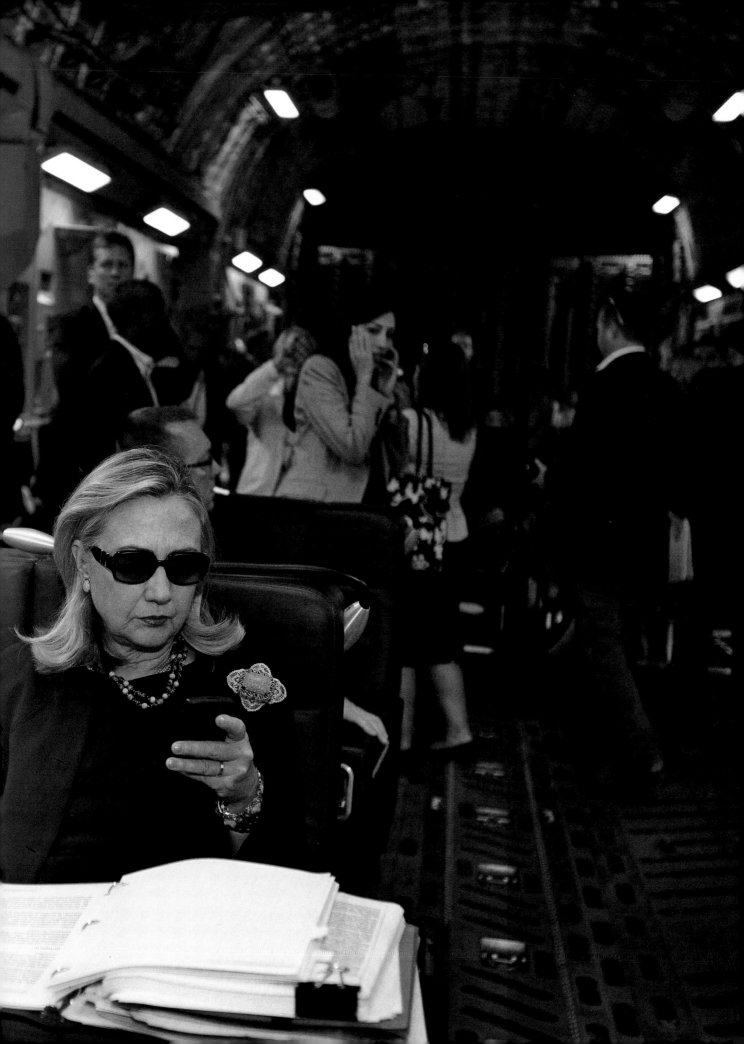

AFTERWORD

Time magazine assigned me to cover my first presidential inauguration as a photographer when Jimmy Carter came to town. I shot my last when the Clintons had a final handshake on the east side of the Capitol with President and Mrs. George W. Bush.

When the Clintons first walked into the White House on that cold day in January 1993, I just couldn't get over how young they looked. Having covered the White House for twenty-five years, starting with the Carters through the Reagans and the first George Bush, I assumed presidents could only be older than I was. The Clintons' youth made me realize my tenure would end someday and I should enjoy these years now.

And I did, especially when I was the only press photographer in the room and my subject was Hillary. To photograph a person, a public figure like Hillary Clinton, for a long time is a great gift to the photographer. I don't pretend to really know her; I have simply watched her through my camera lens. Hillary has become one of the most admired women in the world. For many people she represents the possibilities for women in America. Over the years in her different roles, I have seen Hillary display courage, discipline, complexity, competency, fortitude, indefatigability, disappointment, joy, and grace. I have also often seen her display humor, even if it was one of the hardest things for me to capture on film. It was not until one day when I asked permission to ride home from a children's event in her limousine that I truly saw it. I was crouched on the floor at chief of staff Melanne Verveer's feet when Melanne began to laugh uproariously, and I squeezed the shutter—bingo! There was Hillary's huge laugh too, right straight across the backseat (pp. 54–55). I knew *Time* had their lede picture for next week's story!

When a historic moment such as a bill signing or the swearing in of a president of the United States is being photographed, the facts are clear, and the truth lies in the eyes of the beholder. The photographer has sought out the moment when everything falls into place. But sometimes situations are taken for truth and they turn out not to be. How do we know the truth?

Over time, as I felt I gained her trust by respecting her boundaries offstage and trying to move soundlessly, I think I became more and more invisible to Hillary. In his foreword, Walter Isaacson comments on the photographs of President Clinton taking Hillary's hand on the deck of a boat on the Chobe River in Botswana (p. 43). He asks whether those sweet gestures were real, or simply for the camera, or a little bit of both. There were others who wondered the same thing. I have to say I was surprised that the authenticity of these images was being challenged. I think I was naïve to be surprised. Did I not know there are many truths in almost everything? My friend Jamie Lee Curtis speaks of photographer and subject like partners in a dance: who exactly is leading? Exactly! As a photographer, sometimes you can tell when you're being led, and you wait. Other times you shoot because you know it is just what you think it is. And then there are the times that are so true that you feel it in your bones and sometimes in your heart. You follow your instincts. You must, as this is who you are and why you are there. That day on the deck of the boat, I had moved away from the Clintons to the other side of the deck to give them some space. I suddenly saw what I perceived as a loving gesture. I lifted my camera with its 80–200mm lens and quietly made my pictures. Do I truly know whether this was spontaneous, or all for the camera—for *Time*'s next issue? I couldn't possibly know. But my instincts told me to hold my breath, stay calm, hold tight, focus, and squeeze the shutter. That's all. You be the judge.

I loved photographing Hillary. I remember back when she was First Lady; we were in a holding room at a New York TV studio, and she was enjoying some down time with her staff. Suddenly she looked up at me and said, "Diana, why don't you put your cameras down, come sit with us, and relax?" It was a lovely invitation. Soon it was time to pick up the camera as she moved onto the set and to the next interview. We resumed our roles, the best kind of professional relationship. She and President Clinton extended to me their kind cooperation, often letting me backstage, enlarging my photographic experience. I loved the work, and I hope the photographs in this book may enlarge your understanding of who this remarkable woman is.

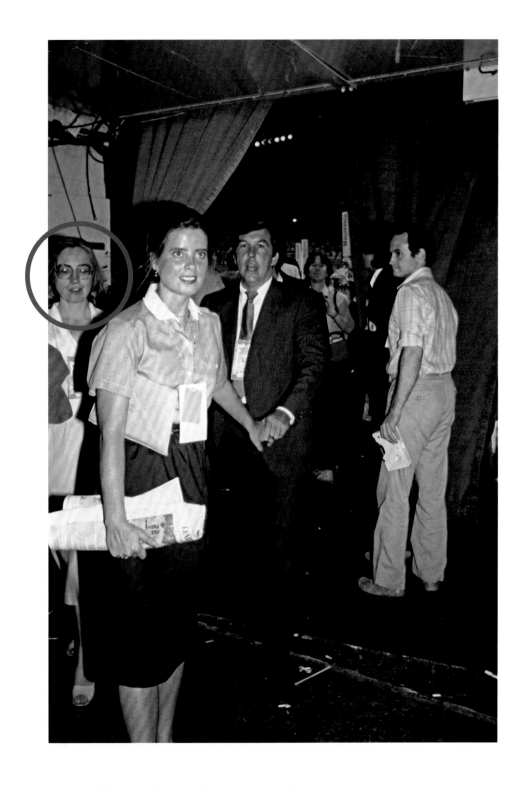

Hillary stands behind Hamilton Jordan, Jimmy Carter's campaign manager,
and Dorothy Henry, who became his wife in 1981. Diana Walker was
surprised to discover that she had taken this early picture of Hillary, one of the
first times she had photographed her. — August 1980

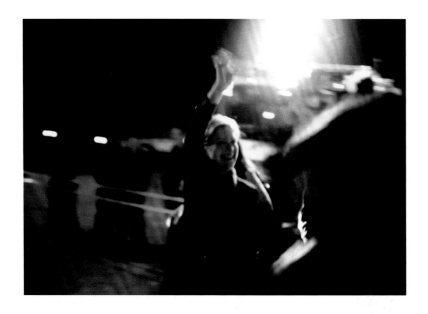

ACKNOWLEDGMENTS

I wish to thank the following people for helping me immeasurably with this book: my editor at
Simon & Schuster, Priscilla Painton; the designer of *Hillary*, Yolanda Cuomo; my counsel, Linda K. Smith;
and my picture editor not only for this book but throughout my career, Michele Stephenson.
They were ably assisted, as I was, by the following: Sydney Tanigawa, Sophia Jimenez, Bonnie Briant,
Vanessa Pares, and Sally Baghdassarian. Melissa August, Ellen Goldman Frasco, and Mary Wormley
produced the book's captions. My thanks also go to Howard Hull of National Geographic Imaging, and
particularly to David Findley for his masterful printing. It was a great team. Thank you all.

I would like to thank those who sent me out on assignment over the years to produce these pictures:
Arnold Drapkin, Michele Stephenson, MaryAnne Golon, Alice Gabriner, Kira Pollack,
Rick Boeth, Hillary Raskin, Crary Pullen, Leslie de la Vega, and Paul Moakley, all of *Time*; and Jodi Quon
of *The New York Times Magazine*. Thanks also to Bill Kalis and Miriam Winocur for their support.
To the managing editors of *Time* who published my Hillary work go my thanks: Walter Isaacson, Jim Kelly,
and Rick Stengel. Thanks also go to my agent, Elodie Mailliet, of Getty Images. Many of my
friends have been very helpful over the years, but for *Hillary*, I want to particularly thank for their patience
and advice: Jamie Lee Curtis, Leah Bendavid Val, and Betsy Karel.

Many on the staff of Secretary Clinton in the White House, the Senate, the 2008 campaign,
and the Department of State were tremendously helpful. I wish to thank especially the following people
for their cooperation and kindness: Tamara Luzzatto, Philippe Reines, Huma Abedin,
Melanne Verveer, Marsha Berry, Kelly Craighead, Lorraine Voles, and Nick Merrill. President Clinton's
aides Kris Engskov, Andrew Friendly, and press secretaries Mike McCurry and Joe Lockhart were invaluable.
The staff photographers at the White House were sometimes called upon to take me under their wing, which
could be a burden. They were never anything but gracious and helpful. Thank you Ralph Alswang,
Sharon Farmer, and Barb Kinney. You were great.

I would like to end with deep thanks to my husband, Mallory Walker; our sons, Taylor and Willy;
and their wives, Jane Timberlake and Sheila Ohlsson Walker, for enthusiasm and encouragement. Much love to
each of you, and to your children, who give us such joy: Jack, Zoe, Charlie, Wyatt, and Sam.